BUILDING A
CROSSING TOWER

A Design for Rouen Cathedral of 1516

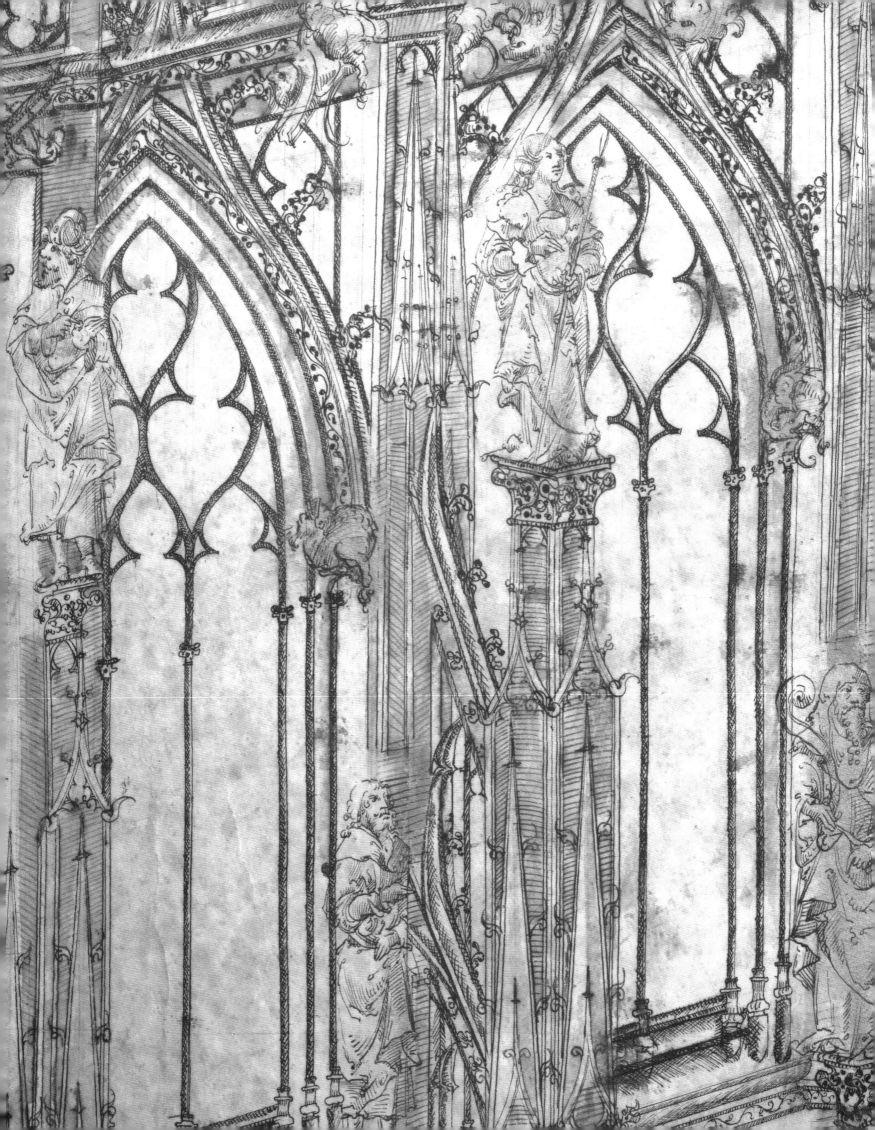

BUILDING A CROSSING TOWER

A Design for Rouen Cathedral of 1516

COSTANZA BELTRAMI

Sam Fogg
in association with
Paul Holberton publishing

Published by Sam Fogg Ltd
WWW.SAMFOGG.COM

in association with

Paul Holberton publishing
WWW.PAUL-HOLBERTON.NET

ISBN 978 1 907372 93 3

British Library Cataloguing in Publication Data
A catalogue record for this book is available from the British Library

Designed by Laura Parker

Photography of Rouen tower drawing by David Brunetti

Printed by e-Graphic, Verona

Contents

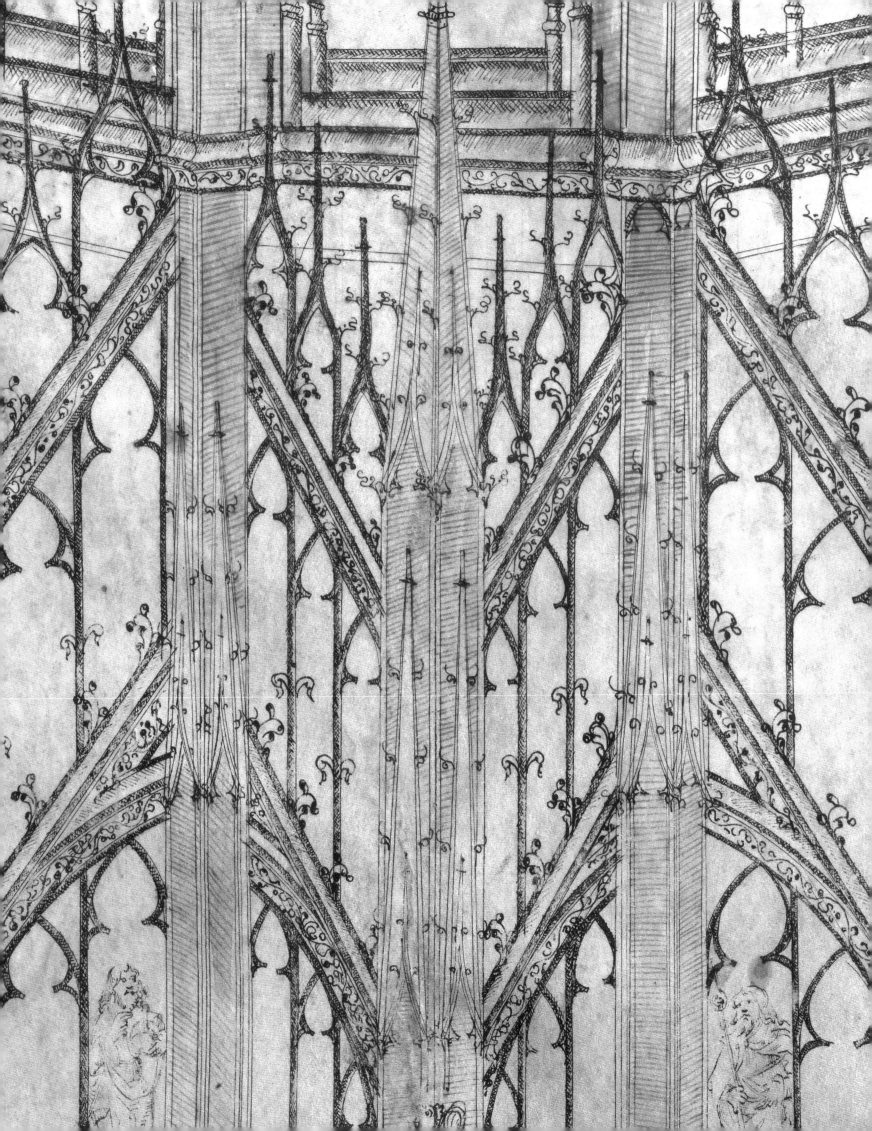

Acknowledgements

MY RESEARCH ON THE DRAWING THAT IS THE SUBJECT OF THIS BOOK begin in October 2014, when I discussed it in an essay for the MA History of Art degree at the Courtauld Institute of Art, suggesting a first identification of the drawing's author and date. Nevertheless, time and word-count limitations left many questions unanswered. Support and encouragement from the ICMA, which awarded the essay with a second prize in its Graduate Student Essay Competition, and, most importantly, from the Sam Fogg Gallery enabled me to travel to Rouen during the summer of 2015. This eye-opening research trip revealed the drawing to be a telling fragment of a vibrant age of innovation and exploration all too often straightjacketed between the stylistic behemoths of 'Gothic' and 'Renaissance'.

The desire to do justice to the drawing and its vibrant context motivated me to expand the initial essay into this book. This project was completed in a short time frame between the late summer of 2015 and the beginning of my PhD research, a circumstance which has limited its scope and depth. Many of the themes addressed in *Building a Crossing Tower* will be explored further in my PhD, where I will explore various developments of the 'Renaissance Gothic' period through study of the master mason Juan Guas (active 1453–96) and late fifteenth-century architecture in Castile. As the following pages illustrate, changes include the use of perspective in architectural drawings, as well as new relationships between patrons and successful master builders.

This book would not exist without the help, encouragement and expertise of Sam Fogg, who made it possible for me to research a previously unpublished Gothic architectural drawing despite my relative lack of professional research experience. I will never forget the sense of intellectual excitement that gripped me when I first saw this 3.5 metre tall drawing rolled out on the Gallery's floor, an excitement that never left me throughout the making of *Building a Crossing Tower*. Special thanks go to Matthew Reeves for always making me feel so welcome at the Gallery, and to Dr Paul Holberton and Laura Parker of Paul Holberton publishing, whose work and advice were fundamental in bringing this book to life. I am also indebted to all the institutions and individuals who provided images for this book, as listed in the image credits, and especially to Luke Vouckelatou and Ludovica Beltrami for creating elevation and plan drawings.

With regards to research and writing, the mentorship and day-to-day guidance that I received from my MA tutor and PhD supervisor Dr Tom Nickson were, as always, fundamental. I cannot thank him enough for enduring so many different versions of this text, and for helping me to solve countless conceptual and practical problems. I am also grateful to Lise Auber and Brigitte Lelievre for leading me 'behind the scenes' of Rouen Cathedral, and to Lloyd de Beer and Guillaume Gohon for accompanying me on these visits and helping with photography. Dr Ethan Kavaler, Nicolas Hatot and the Rouen Tourist Office kindly put me in contact with scholars and institutions in Rouen. In addition, Prof. Dany Sandron and Dr Florian Meunier generously shared their recent research on related topics. Transcribing the sixteenth-century documents presented in the Appendix was perhaps the greatest hurdle of this project, and I am grateful for the help of many people, although all remaining errors are my responsibility – Dr Nicholas Herman, Prof. Jenny Stratford, Oliver Norris, Prof. Christopher Wilson, Prof. Dany Sandron, Dr Cristian Ispir and Dr James Willoughby.

Last but not least, thanks to Emma and Amy for life and book advice, and to Massimo, Tiziana, Ludovica and Yutetsu for always being such a great team.

FRANCE, ROUEN, 1516

The Rouen Tower Drawing

Attributed to Roulland le Roux (master mason of Rouen Cathedral, active c. 1500–20) and a collaborator, probably Pierre des Aubeaux (active Rouen 1511–23)

Pen and ink with stylus and compass marks on parchment attached to a later wooden spool, 340 × 52.5–64.5 cm

PROVENANCE

Probably presented by Roulland le Roux to the chapter of Rouen Cathedral on 8 March 1516; 1726, given to Jacques-Alexandre-Henry du Moucel, Lord of Louraille, 'président à mortier' of the parliament of Rouen 1718–42; private collection, France, until 2014

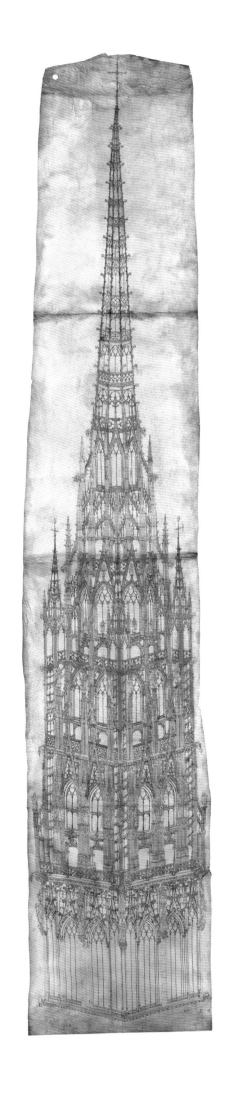

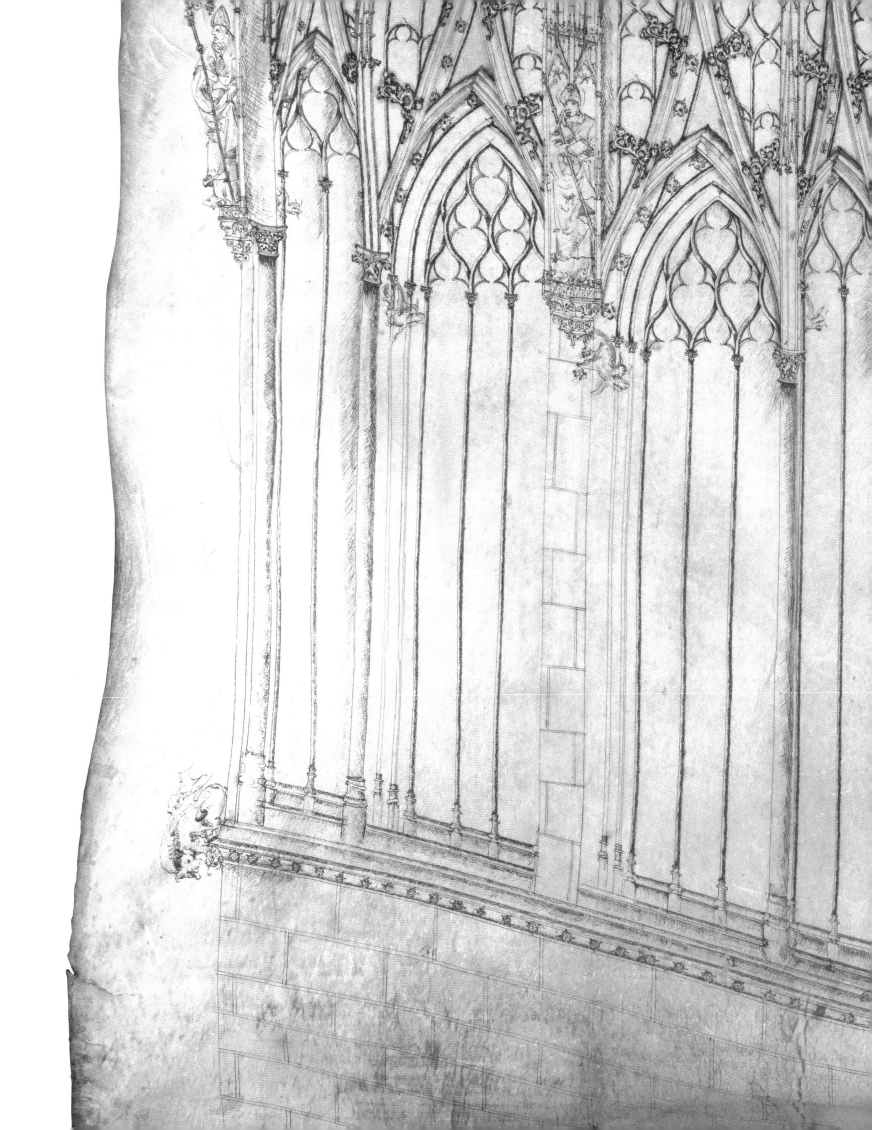

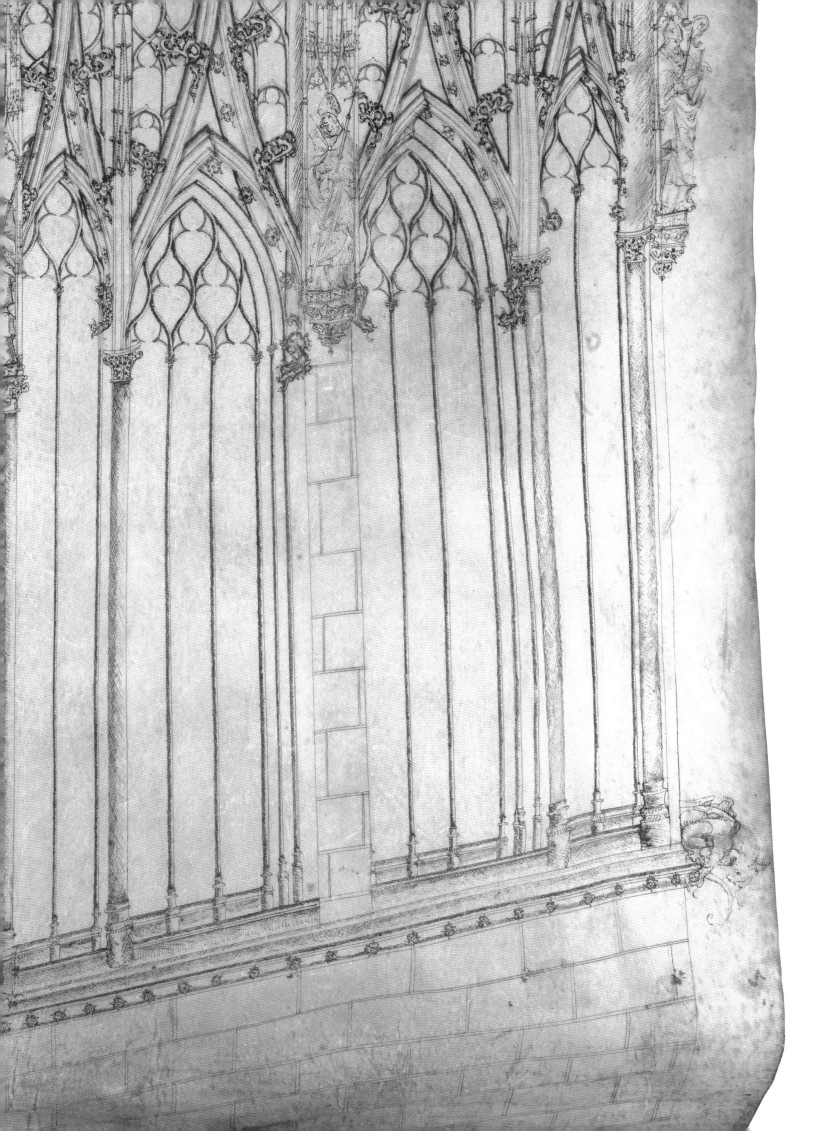

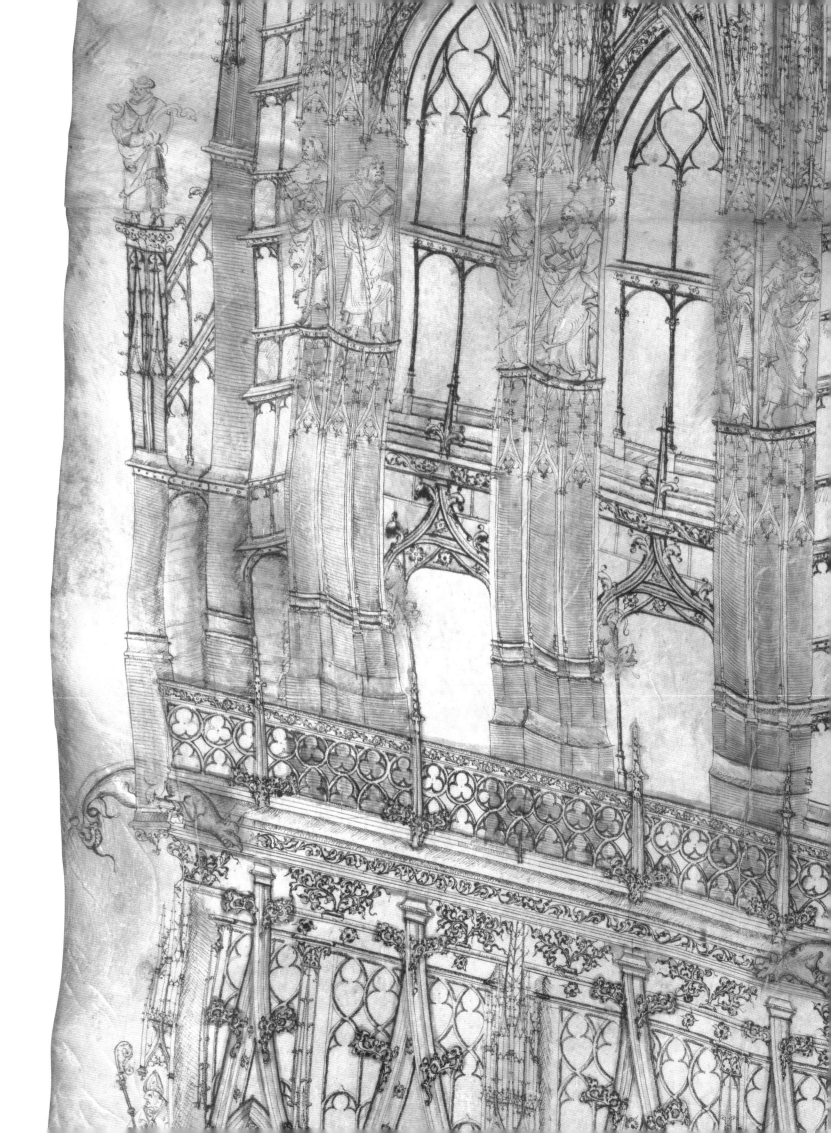

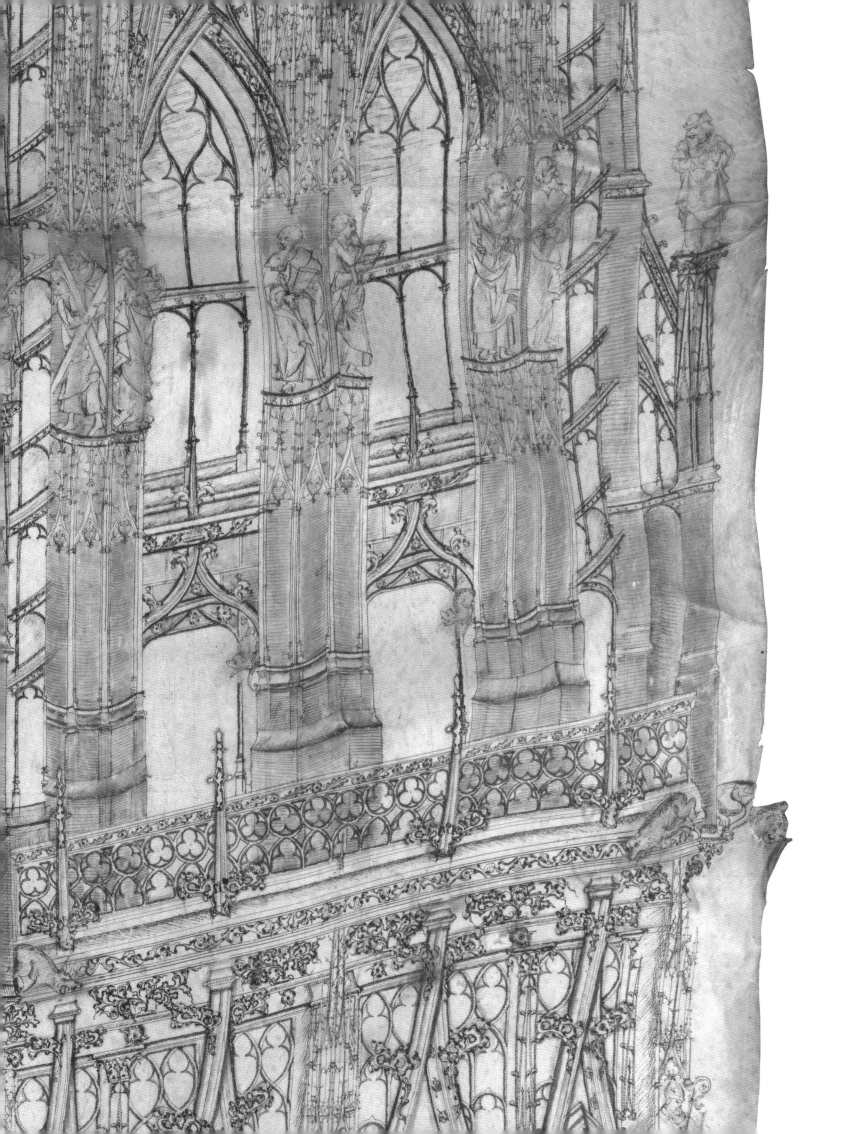

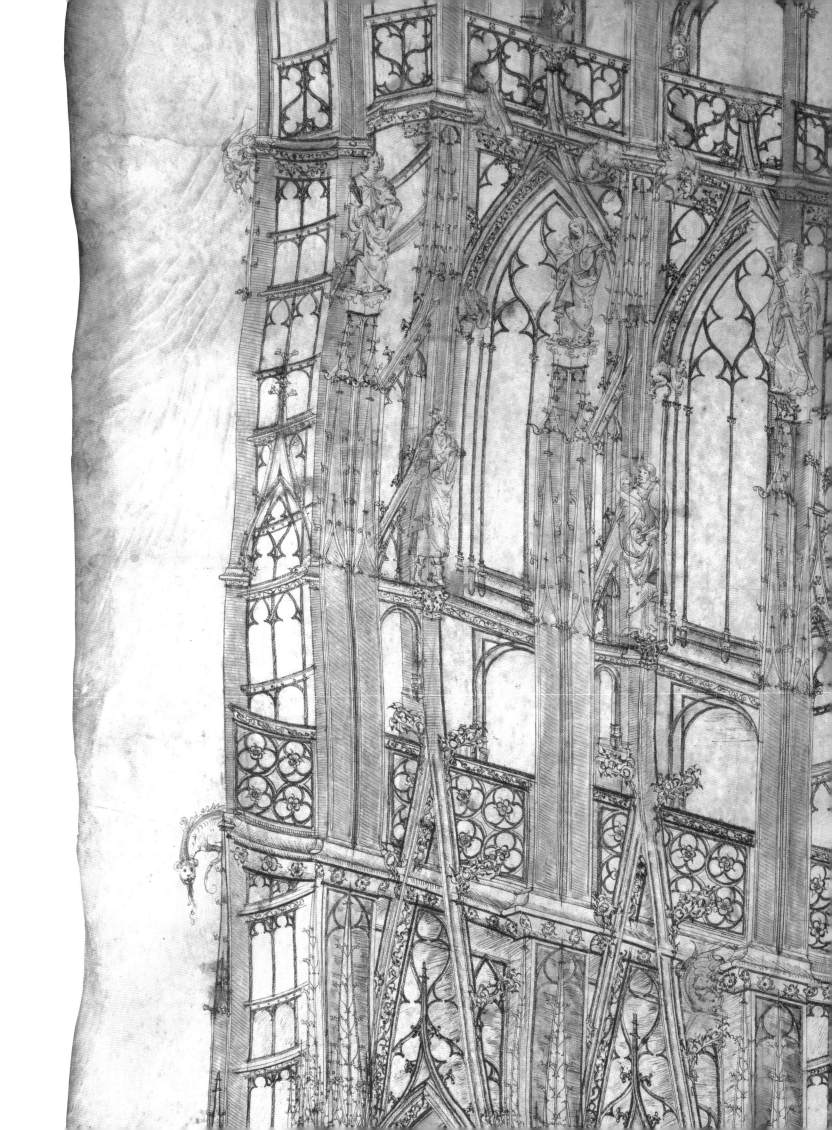

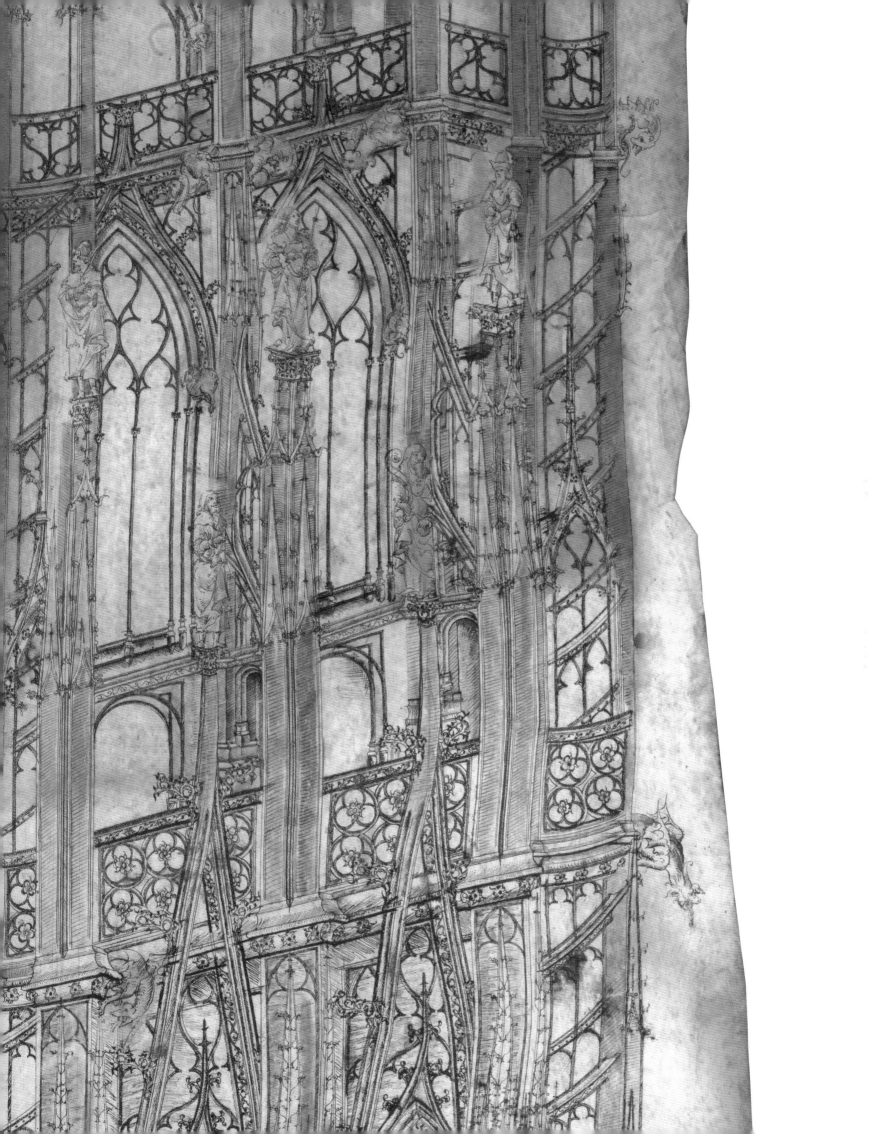

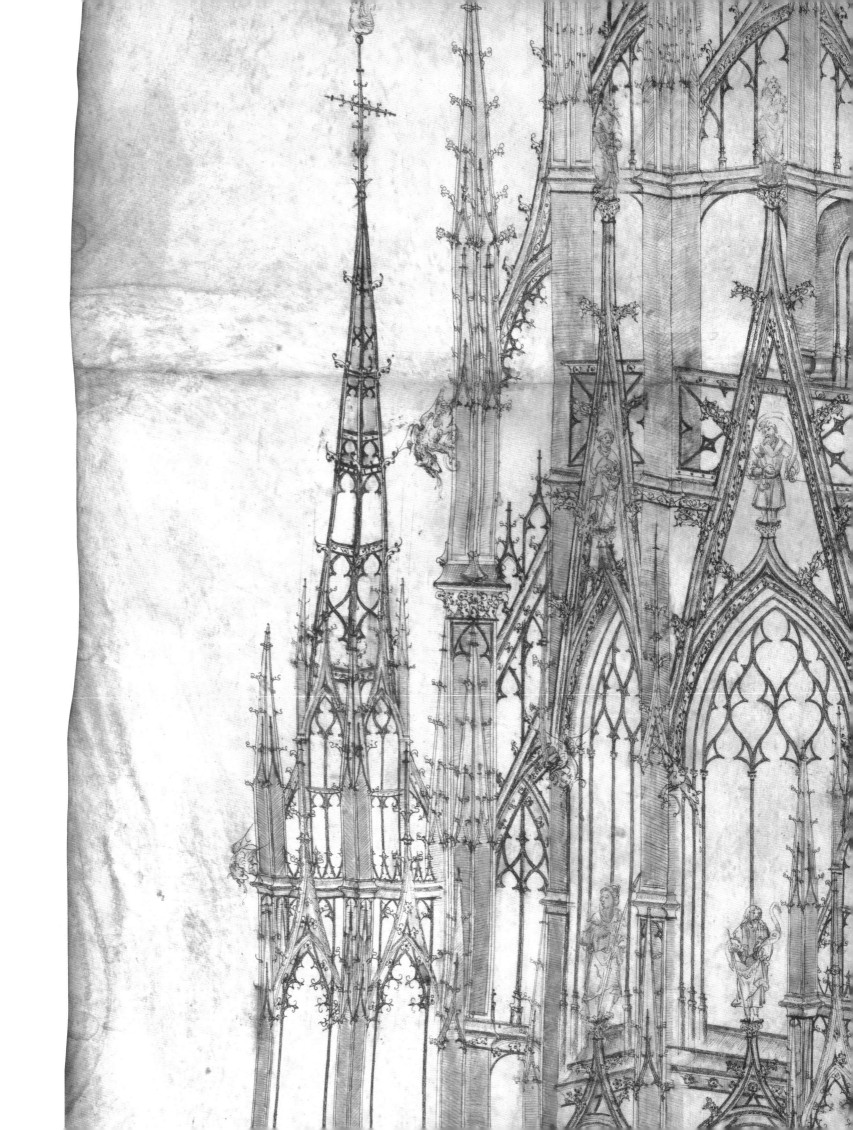

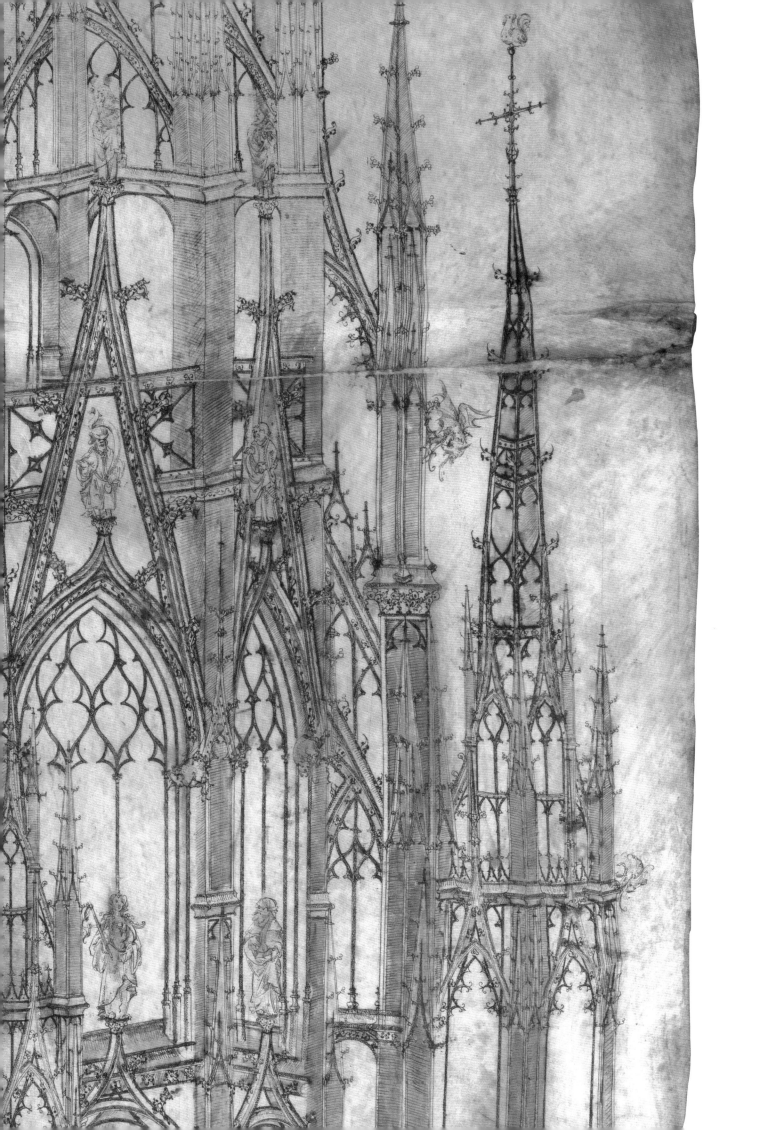

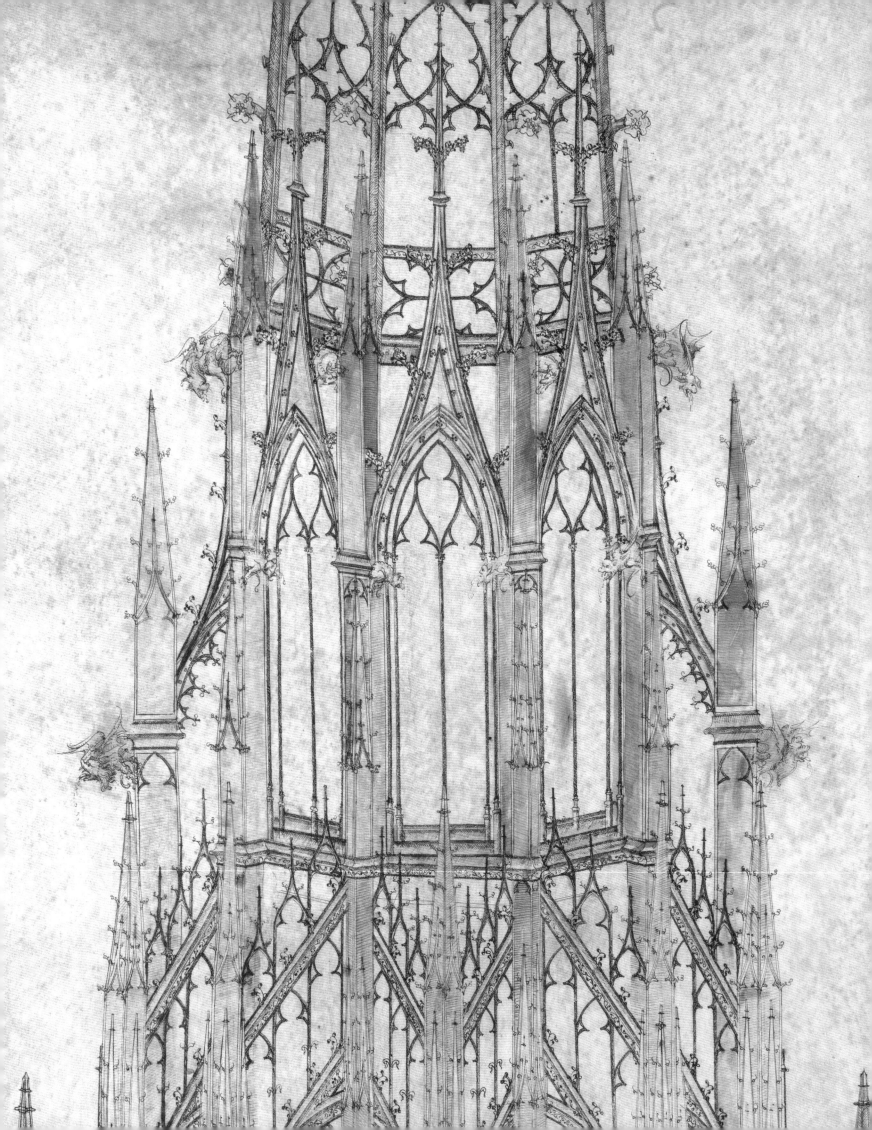

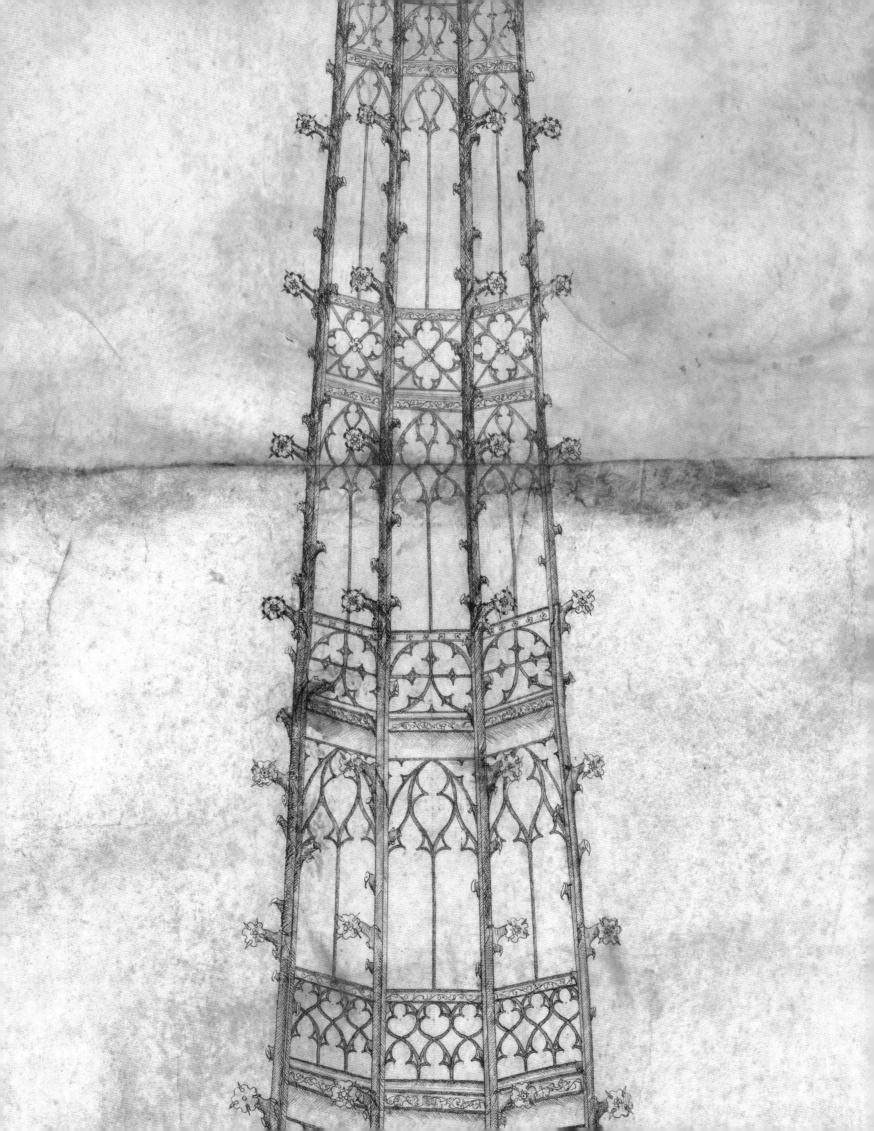

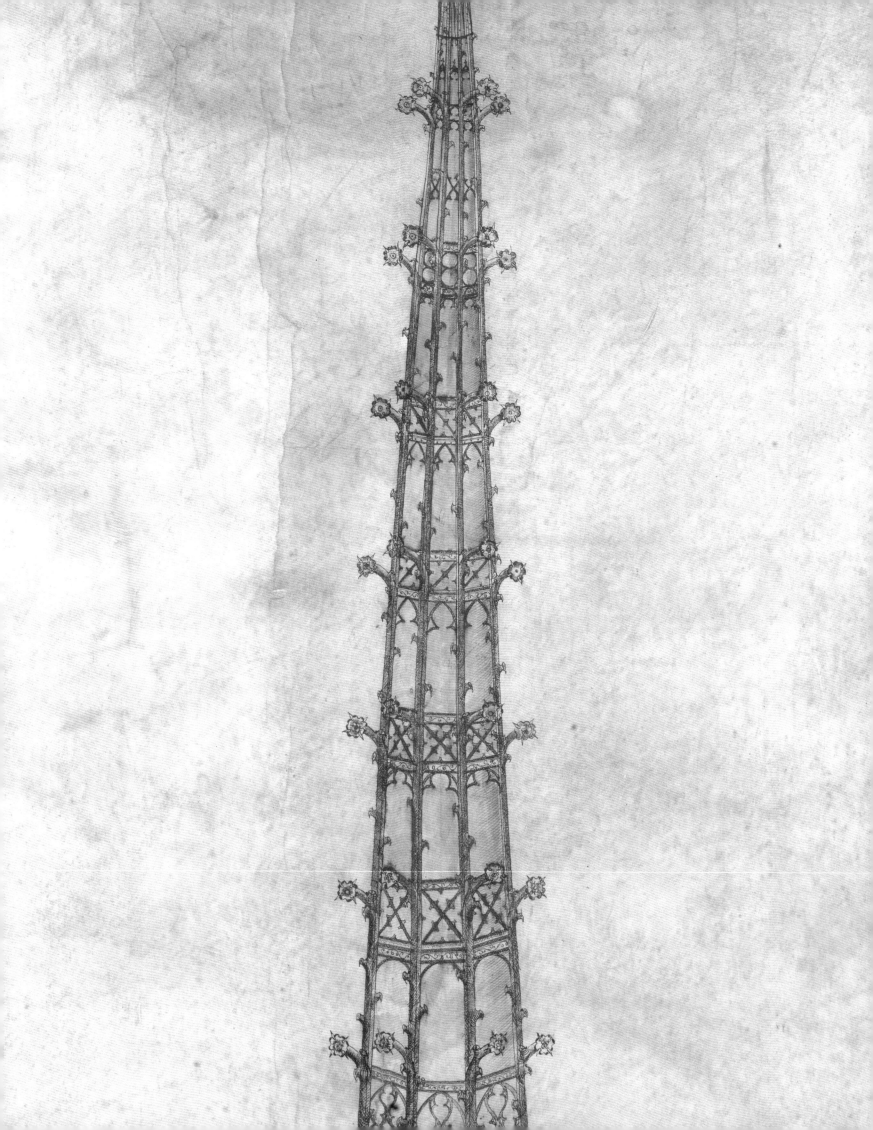

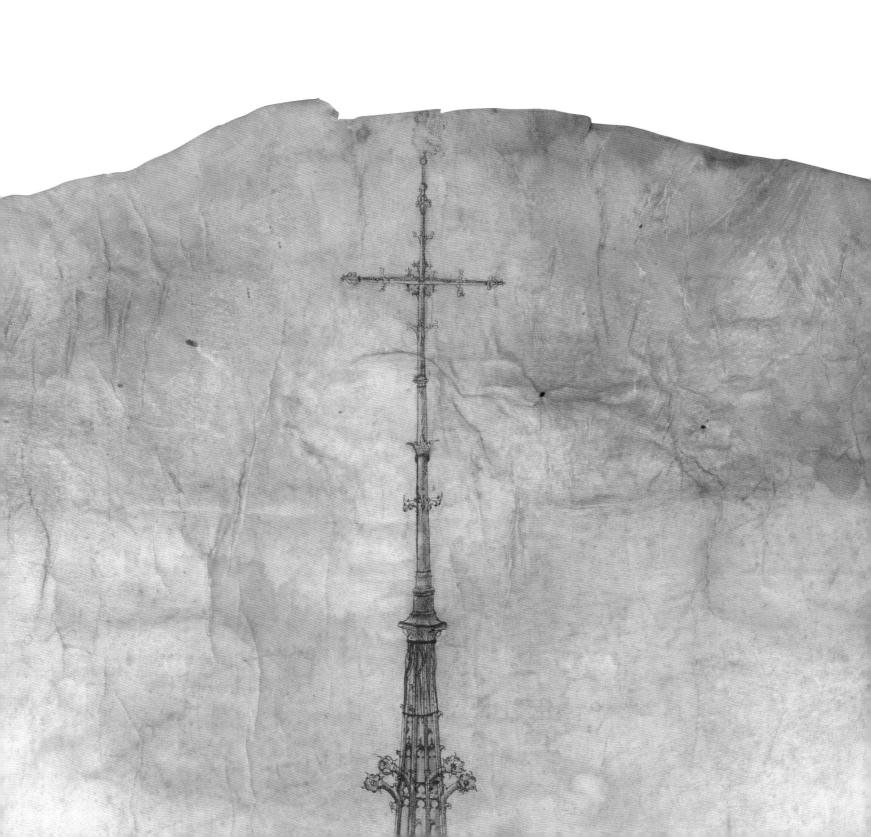

Introduction

A FEW SPIDERY LINES MARK RENZO PIANO'S ORIGINAL DESIGN
for the iconic Shard building in central London (fig.1). Reputedly
sketched in a few minutes on the back of a napkin, the drawing offers
a moment of spontaneous creativity, the whirring of Piano's mind
captured forever on fragile tissue. This 'back of an envelope' cliché
promises intimacy with the architect's mind, with the flash of human
genius that prompted a thousand computer-generated drawings, the
transfer of millions of pounds, and the precision engineering of this
towering monument to a great trading city.[1]

The newly discovered Gothic architectural drawing – the focus of this
book – is both very different and much the same. Almost four metres
high, it represents a Gothic tower topped by an immense spire. Shown
at an angle of 45°, the tower seems to project from the parchment page,
creating a vivid three-dimensionality suggestive of a real and complete
building. Although much more finished than Piano's sketchy lines, this
tower drawing has a similarly persuasive power, making the viewer feel
'there', before the awe-inspiring creation of the architect's mind. But
while Piano's fragile sketch is rather carefully signed, dated and framed
in its bottom left corner, the tower drawing – like most Gothic artworks
– does not contain such marks of authorship and identification. All
knowledge as to where, when and why it was made was lost, and the
drawing's very existence fell into oblivion until it was rediscovered
in 2014.

This study reconstructs the circumstances in which the tower
drawing was created with a precision that is rarely possible in the
analysis of Gothic artworks. Following clues offered by the drawing
itself and by an eighteenth-century annotation on its reverse, it will
be shown that the drawing was made in the city of Rouen in the early
sixteenth century. At that time, the architectural profile of this thriving
and populous port was changing under the creative direction of
Roulland le Roux, the city's leading master mason and probable author
of the newly discovered drawing. His role in the drawing's creation can
be proven thanks to the survival of minutes of the chapter meetings
held by the canons of Rouen Cathedral in the years 1514 to 1517,
preserved in manuscript G 2149 of the local departmental archives, of
which the relevant passages are published here in full for the first time.
These minutes reveal how the canons questioned Roulland's ability to
complete the ambitious tower he had already begun, and how he was
never allowed to build what would have been his masterpiece.

The drawing and related documents shed light on a little-known
but significant feature of medieval building projects – the debates,
aspirations and all-too-real fears which accompanied pre-modern
construction, but are now usually impossible to reconstruct. Offering

1

RENZO PIANO
Sketch for The Shard, 2000
Pen on paper napkin
Private collection

2

RENZO PIANO
Working drawing for The Shard:
section through west façade 1, 2010
CAD drawing
Private collection

an unprecedented insight into Late Gothic French building, study of the Rouen tower drawing significantly nuances understanding of early sixteenth-century architecture, and suggests the existence of a hitherto neglected tradition of Gothic architectural draughtsmanship. But before turning to this unique drawing, it is useful to introduce Gothic drawing techniques, the particular features of the period of transition from the Middle Ages to the Renaissance, and the importance of towers in the medieval landscape.

Late Gothic drawing methods

Piano's quick sketch may have initiated the design of the Shard, but only the painstaking precision of his studio's blueprints made its construction possible (fig. 2). Working drawings are the 'acid test' of the architect's work; in their making, "every stroke counts, every screw has to be in the right place, every specification is binding". A hundred working drawings are not enough to build even a small house, yet just one makes the architect's presence on the worksite redundant: it is a whole building manual, and it needs no language to be understood.[2] Each blueprint for the Shard is dedicated to a particular sub-section of

3
Ground-plan of a tower (possibly
Strasbourg Cathedral), c. 1470s
Pen and ink on parchment,
40.1 × 38.8 cm
Victoria and Albert Museum,
London, inv. no. 3550

the whole building, and only when all the blueprints are seen together
does the spectacular image of the Shard itself emerge. The blueprints
subdivide the building into sections of less than one floor, but are all
carefully numbered in relation to their position within the whole,
which they represent without omissions. Thorough annotations and
hair-splitting measurements are offered to guide the builder in his
work. "Do not scale drawings. Dimensions govern", insists a note in
the margins.

In contrast, Gothic drawings are rarely comprehensive, and hardly
ever include dimensions. A ground plan at the Victoria and Albert
Museum, dated to the 1470s, may show one of the spires of Strasbourg
Cathedral (fig. 3), but the absence of annotations or measurements
makes it difficult to attribute the drawing securely. Nor is scale the only
problem here: the plan represents every level of the spire at the same

INTRODUCTION

4
Verso of fig. 3: Design for
the base of a chalice, c. 1470s
Pen and ink on parchment
Victoria and Albert Museum,
London, inv. no. 3550

time, and it is difficult to see how its complexity could be disentangled
into buildable sections. Nonetheless, Gothic drawings contain valuable
architectural information, even for modern times. For example,
following the rediscovery of three Gothic drawings of the façade and
towers of Cologne Cathedral in 1814, the building, which had stood
unfinished for five centuries, was completed more or less according to
the vision of its medieval architects.[3]

What tools were required to realise such designs? Consider Ludger
tom Ring the Elder's portrait of a sophisticated Late Gothic architect
(fig. 5): the architect holds a compass in his hand, while a measuring stick
and wooden templates hang on the wall behind him. Gothic architects
used these deceptively simple tools to obtain complex designs through
hands-on manipulations. The compass and measuring stick were used
to transform basic shapes such as the square, triangle and circle into

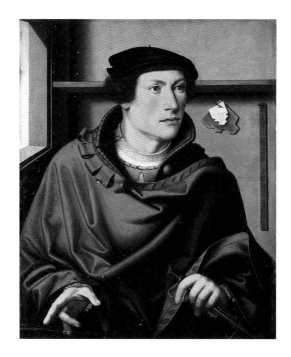

5

LUDGER TOM RING THE ELDER
Portrait of an architect, 16th century
Oil on panel, 53 × 43 cm
Gemäldegalerie, Staatliche Museen,
Berlin, inv. no. 629A

6

ERHARD HEINDENREICH (ATTRIB.)
Drawing of a façade tower for the
Liebfrauenmünster in Ingolstadt, c. 1520
Black and brown tusche on paper
mounted on canvas, 238 × 46 cm
Stadtarchiv, Ingolstadt

complex designs on paper, parchment or other flat surfaces through geometrical processes which required no arithmetic. But they were also used on the building site to transform two-dimensional designs into three-dimensional reality, providing a means of checking and regulating the cutting of stone. Templates fulfilled a similar function: common on all pre-modern building sites, they were used to communicate the profile of individual mouldings to stone cutters, and could be used over and over again.[4]

Geometrical manipulations could be as simple as the extraction of the diagonal from a square, or as complex as *Auszug*, the process of 'pulling out' a structure's elevation from its ground plan. Late fifteenth-century sources suggest that the technique of *Auszug* was introduced by the Parler family in Prague in the latter part of the fourteenth century, so both this complex geometrical technique and simpler processes were well-established components of a Late Gothic mason's basic toolbox. This is demonstrated by the Regensburg Ordinances, a set of rules of the craft established in 1459 by the masons of various German cities, which declare that "if someone wants to undertake stonework ... through extrapolation [*Auszug*], which he does not know how to take out of the base plan ... then he should not in any way undertake the task".[5] By implication, most masons must have been well-acquainted with the technique – able, for instance, to extrapolate an elevation from the apparently cryptic plan in the Victoria and Albert Museum (fig. 3), and to understand the three-dimensional form of the structure this produced.[6]

The flexible geometrical system which underpins Gothic design can be detected in most of the six hundred or so drawings that survive from the Gothic period. Indeed, it has recently been argued that study of the geometry of drawings helps to 'capture' Gothic design in its ideal stage, before practicalities obfuscated the designer's original conception.[7] Such drawings sometimes feature compass pricks and un-inked construction lines that betray the geometric processes used to create them, but are extraneous to the finished representation. Moreover, geometrical design influenced the overall appearance of Gothic drawings: as geometrical manipulations employed two-dimensional shapes, geometrically constructed 'working drawings' – drawings containing information useful to architects or builders – were orthogonal by necessity, and represented a three-dimensional building through flat, two-dimensional representations, without the spatial recession typical of perspective views.

Whilst working drawings were completely orthogonal, minimal perspectival clues were sometimes introduced in 'presentation drawings'. Such drawings were drafted to give patrons some sense of the appearance of buildings prior to construction. As patrons rarely

INTRODUCTION

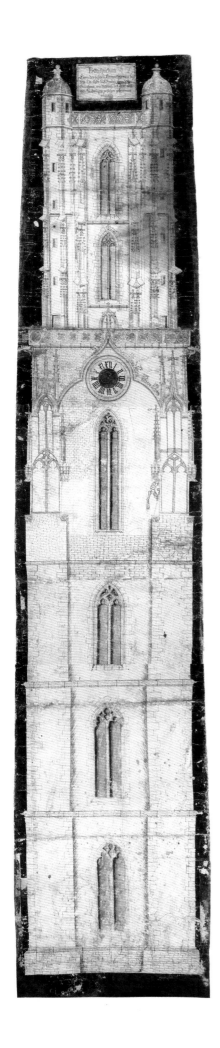

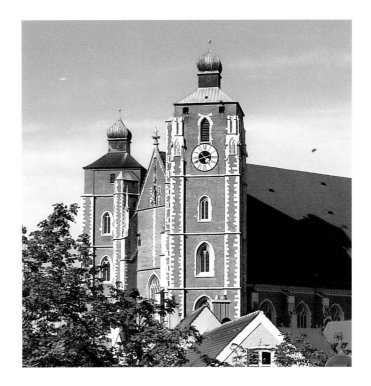

7
Ingolstadt, Liebfrauenmünster,
founded in 1425; façade begun c. 1441

possessed technical building knowledge, subtle perspectival clues in
orthogonal drawings could help them understand a building's overall
form. One example is the representation of one of the façade towers
of the Liebfrauenmünster in Ingolstadt, made in the 1520s when the
towers' upper levels were still to be completed (fig. 6). Shading is used in
this drawing to suggest the depth of windows and the different planes
of the tower's elevation. Moreover, a bold dark background contributes
to the piece's readability and impact. Nevertheless, these colour touches
were added on a perfectly flat drawing, requiring no modification to the
design's underlying geometry.

The power of the tradition of orthogonal representation is especially
clear when the Ingolstadt drawing is compared with the tower it
represents. In 1441 it was decided to build the western towers of the
Liebfrauenmünster at a 45° angle to the main façade, so that anyone
standing before the west portal would see the corners of the towers,
rather than their sides flat on (fig. 7). Nonetheless, master Erhard
Heydenreich, the probable author of the Ingolstadt tower drawing,
did not try to replicate the three-dimensional effect of the façade, but

preferred the orthogonal representation of one side of the towers only, lightly amended with perspective clues.[8]

As in the Ingolstadt piece, hatching and colour are used in the Rouen tower drawing to suggest spatial recession. But, rather than a last-minute addition, in the Rouen drawing perspective is a key organizing principle: a corner of the tower has been placed at the centre of the drawing, and its two sides are represented receding away from this corner in reverse perspective. This unusual choice raises many questions. Why was such an unusual point-of-view chosen? Does it reflect the structure of the building represented, or does it form part of a strategy to make the piece more appealing to the patron? What are its implications for the drawing's geometrical construction? As will become apparent in this study, the Rouen tower drawing conforms neither to the Gothic tradition of geometrical draughtsmanship nor to the scholarly paradigm which identifies the study of geometry as the chief means of understanding the original conceptions of Gothic designers.

Entirely unknown to previous scholarship, the Rouen tower drawing calls attention to other outliers in the corpus of Gothic drawings. That corpus is largely formed of German and Central European examples: of about 600 surviving pieces, 428 (80%) are found in a single collection in Vienna.[9] Although a variety of different structures are represented – from portals to furnishings, from ground plans to vaults – the corpus is relatively homogenous in the monochrome and two-dimensional appearance of its drawings. Nonetheless, there are some divergences – from Germany, a drawing of the hospital chapel of Esslingen am Neckar (attributed to Hans Böblinger, 1501); from Spain, a drawing of the Church of San Juan de los Reyes in Toledo (attributed to Juan Guas, c. 1479–80; fig. 39); from France, an unexecuted project of a tower, previously connected to the Sainte-Chapelle in Paris and dated to 1480s, and a painterly view of the ramparts of Méaulens in Arras (attributed to Vincent Corroyer, 1510; fig. 38).[10] Together with the Rouen tower drawing, these examples from a variety of European regions reveal the existence of a tradition of perspectival architectural drawings, one that partly depended on the design conventions of wall paintings, manuscript illuminations, stained glass and metalwork, and that offered an alternative to the more common tradition of orthogonal drawings.

INTRODUCTION

8

Caen, Église St-Pierre, apse, 1518–45

Renaissance Gothic and the 'communications war'

The Gothic of the late fifteenth and early sixteenth centuries is often disparaged according to an historical paradigm whereby 'Renaissance' is equated with innovation and progress. The idea is first traceable in fifteenth-century Italy. For example, in the 1460s, the Italian sculptor, architect and theorist Filarete (c. 1400–c.1469) urged his contemporaries: "… abandon modern [i.e. Gothic] usage. Do not let yourself be advised by masters who follow such bad practice! Cursed be he who discovered it!"[11] Almost a century later, Giorgio Vasari (1511–1574), one of the founding fathers of art history, derided Gothic buildings for having "no sense of order, bad methods, poor design, bizarre inventions, a shameful lack of grace, and the worst kinds of decoration" and described the architect Filippo Brunelleschi (1377–1446) as "sent to us by Heaven in order to give new form to architecture".[12]

Hundreds of Gothic structures throughout Europe show that Late Gothic architecture was anything but monstrous and barbaric. Not only did this style remain the dominant architectural system outside central

9

Caudebec-en-Caux, Église Notre-Dame,
Lady Chapel, pendant vault, 1426–84

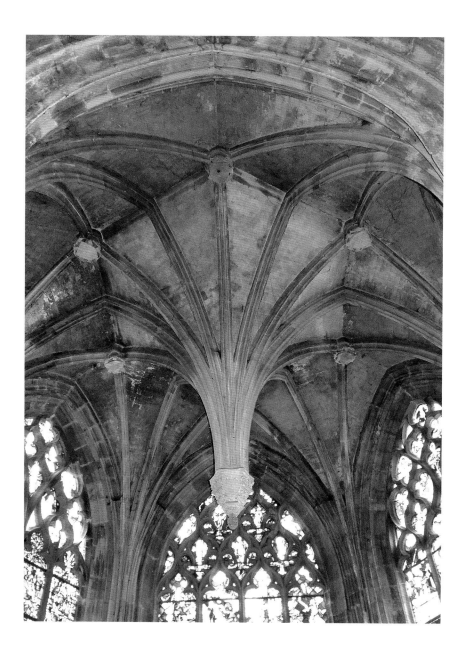

and southern Italy until at least 1540, it also flourished, and from it
emerged masterly technical and creative innovations such as the vault of
the Henry VII Chapel in Westminster Abbey (1507–10). Far from being
provincial or reactionary, the 'Renaissance Gothic' of c. 1470–1540
was effectively a new style for a new age. Daring and sophisticated, its
architects were fully able to embrace new Renaissance designs, as in
the church of St-Pierre in Caen, in Normandy (fig. 8), but could also
respond creatively to the spread of such designs, as through the ludic
and intentional deconstruction of Gothic structural elements in the
cloister of Utrecht Cathedral, where the tracery of a window seems
fastened together with rope.[13]

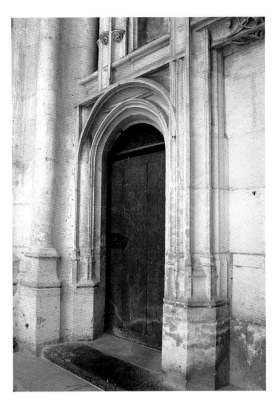
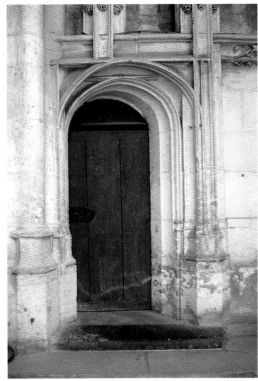

10, 11

Beauvais, Cathédrale St-Pierre, door in the western buttress of the main aisle of the north transept, side and front views, early 1510s

Materials and perception were also manipulated playfully. The pendant vault of the Lady Chapel of the church of Caudebec-en-Caux, also in Normandy, descends one third of the way to the ground (4.30 m), imitating carpentry in its construction and apparent lightness. Yet it is actually a stone boss weighing seven tonnes (fig. 9). A door added around 1510 to the north transept of Beauvais Cathedral has an equally disconcerting effect. Although it appears perfectly symmetrical when viewed from an angle (fig. 10), it is revealed as lopsided when seen from the front (fig. 11). A similar play of perception can be seen on a much larger scale in the vault of the Vladislav Hall (1493–1503) in Prague Castle, where ribs twist and break into smaller components, and join with the wall buttresses in unexpected and seemingly illogical ways (fig. 12). The conventions of Gothic vaulting are cleverly undermined, and it is difficult to distinguish structure from decoration.[14]

The importance of decoration is a distinguishing feature of Renaissance Gothic. Ornament could create geometrical patterns, as in the south aisle vault of the church of Sts Ulrich and Afra in Augsburg (figs. 13, 14), or it could imitate vegetation, a feature known by the German term *Astwerk* (branch tracery), but found all over Europe, as on the façade of the Colegio de San Gregorio in Valladolid (completed c. 1496; fig. 15, 16). Each type had the potential to express specific metaphysical and religious meanings. Generally speaking, geometry

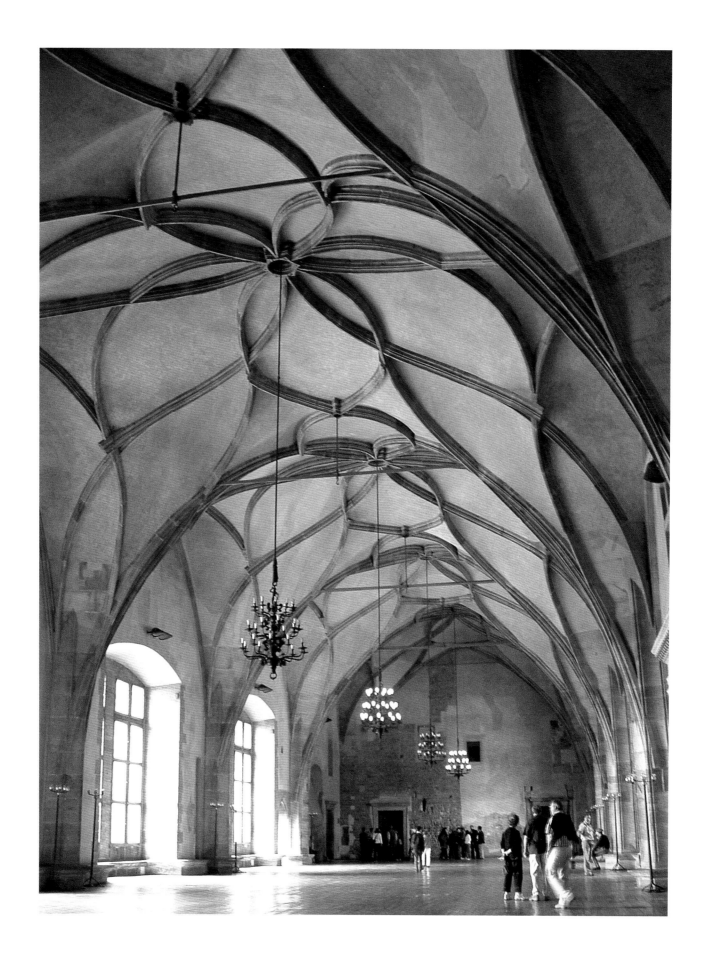

INTRODUCTION

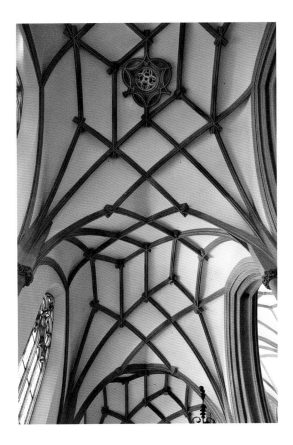

13, 14
Augsburg, Basilika St. Ulrich und Afra,
southern aisle and vault, c. 1478–93

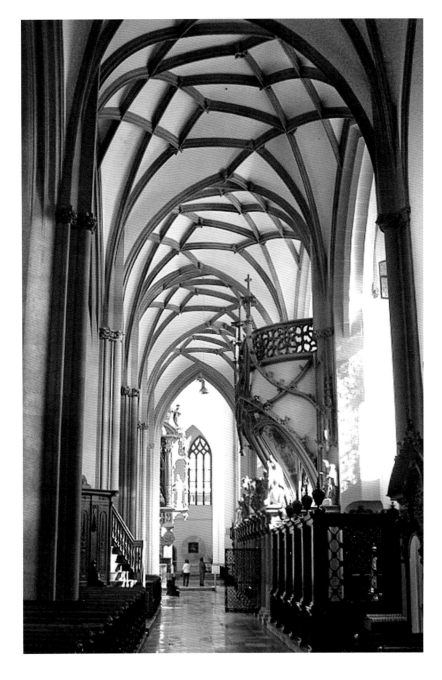

12
Prague, Hradchin, Vladislav Hall,
1493–1503

referenced a superior divine order, while natural forms could emphasize the power of God in shaping and reshaping the world, or else point to the danger of a wayward, postlapsarian nature. Both types could also carry local meanings, differentiating key structures from the surrounding built environment, imposing hierarchies and creating choreographed urban vistas.[15]

Moreover, particular decorative patterns could express corporate or individual identity at a time when the conventional heraldic language was breaking down and being replaced by more personal and adaptable

15, 16
Valladolid, Colegio de San Gregorio,
façade (with detail), c. 1496

signs. Specific patrons or makers could therefore be referenced by a particular design feature, repeated in different parts of a building or across several buildings. For example, in the chapel of Sts Peter and Paul at the Abbey Church of Fécamp (Normandy), the patron Robert Chardon (died 1510) is identified by sculpted Rs, Cs and thistles (in French, *chardons*; fig. 17). Less obvious 'signatures' in ornament include the bell-arch tracery motif on buildings attributed to the Keldermans, a Late Gothic Netherlandish dynasty of architects, and the skewed trefoil motif introduced by Martin Chambiges on the inside of the

INTRODUCTION

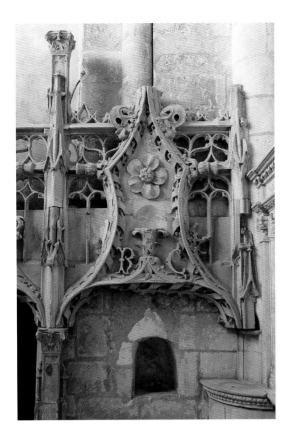

exterior portal of the southern façade of Sens Cathedral around 1490 (fig. 18), and repeated in the façades he designed for Troyes and Beauvais Cathedrals.[16]

Artists such as the Keldermans and Chambiges were valued for their ability to invent skilful and inventive decorative patterns, and this contributed to a growing awareness of artistic identity. Such interest also elevated the status of drawings and their designers. The problem was that the geometric clarity of drawings could be disrupted by the spatiality of buildings, as revealed by the contrast between a straight-on view of the south aisle vault of Sts Ulrich and Afra and a longer view down the church's south aisle (figs. 13, 14). Thus, increasingly it was drawing, rather than building, that was thought to communicate the master's skill, as testified by the increasing popularity of experimental vault designs, for example those found in the German pattern book of Master WG (c. 1572).[17] More and more the master builder was

17

Fécamp, Abbaye de la Trinité, fragments of the Easter Sepulchre now in the chapel of Sts Peter and Paul, 1495–1510

18

Sens, Cathédrale St-Étienne, south transept portal, c. 1490

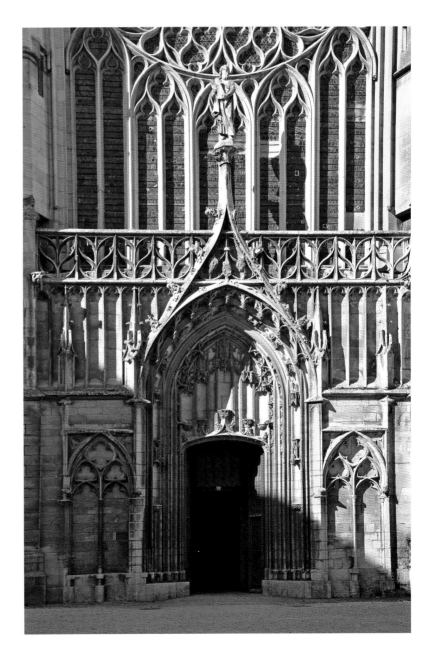

Gaillon, Château de l'Archevêque de
Rouen, interior façade of the Grand'
Maison, begun 1502

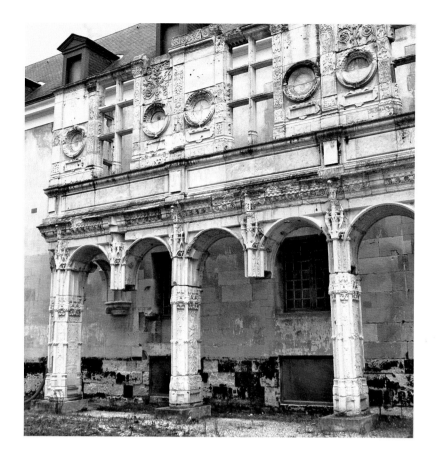

valued for his skills as a designer, rather than for his managerial
abilities in directing the worksite, or in offering ad hoc solutions to
daily problems: he started to resemble the modern concept of 'architect'
in important ways.

The value of design skills had been growing since the late thirteenth
century, when scale drawings seem to have become established as a tool
of architectural planning: the earliest surviving examples are Villard
de Honnecourt's famous 'Portfolio' of the 1230s and the rather more
precise drawings in the Reims Palimpsest of c. 1240–60, which probably
show designs for an architectonic metalwork shrine.[18] Scale drawings
allowed buildings to be designed by 'remote control', without the
necessary presence of the master who conceived them on the building
site.[19] As the status of artists grew, masters became freer to choose
whether or not to oversee their building projects in person. Martin
Chambiges can again be cited as an example: he designed the Cathedral
of Troyes and directed its early stages with regular visits between 1506
and 1515, but later settled in Beauvais and never again set foot in Troyes,
despite the pleas of the Troyes Cathedral canons. Martin Chambiges and
other prominent Late Gothic architects enjoyed unprecedented leverage
with their patrons. Their status had changed, and the long-forgotten

term *architectus* – used by the Roman theorist Vitruvius to refer to a master possessing both technical knowledge of building and theoretical knowledge of the arts, including music, medicine, law and astronomy – re-appeared at this time, especially within learned milieus inspired by the spread of humanist culture.[20]

The new popularity of the term *architectus* is one of many 'Renaissance Gothic' phenomena which seem directly influenced by a burgeoning humanist culture. As Henri Zerner has recently emphasized, earlier generations of scholars typically described encounters between Gothic and Renaissance through "economic and gastronomic metaphors" which stressed the passive role of Northern Europe and Iberia: borrowing and theft, or absorption, digestion, regurgitation.[21] According to this model, the sophisticated artistic and theoretical system of the Renaissance was initially misunderstood or badly imitated across the Alps: witness the mix of Gothic and Italianate elements at the château of Gaillon, which has been described as the first Renaissance building erected in France, whose courtyard façade featured both nodding ogee arches and a series of marble portraits of Roman emperors in classicizing roundels (fig. 19). However, more recent and nuanced views explain the juxtapositions found at Gaillon and elsewhere as a sign of the active discrimination of northern patrons and architects in response to the spread of new fashions.[22]

This active role is also reflected in the production of texts on Gothic design practice. Notable amongst these is the *Büchlein von der Fialen Gerechtigkeit* or 'Booklet concerning Pinnacle Correctitude', written and printed by the German master Mathes Roriczer in 1486, and probably commissioned by the Prince-bishop Wilhelm von Reichenau, to whom it is dedicated. Described by contemporaries as a great builder, Wilhelm also had broad humanist interests; he may therefore have encouraged Roriczer to produce his text in response to classical and Renaissance architectural theory, for example Vitruvius's *De architectura libri decem* and Leon Battista Alberti's *De re aedificatoria*, both printed for the first time around 1486.[23]

With these texts, Gothic and Renaissance engaged in a 'communication war', to borrow Robert Bork's memorable conception.[24] Gothic would eventually lose out to classicism, but not because it lacked order or method, as Filarete and Vasari suggested. Rather, its principles were 'unspeakable': its geometric construction process was too difficult to verbalize, and could be taught easily only through practical demonstration in a workshop culture. Literary and relatively straightforward Renaissance architectural treatises could more easily appeal to patrons, whilst Roriczer's booklet, of necessity, was technical and minutely detailed, and difficult to follow as a result.[25]

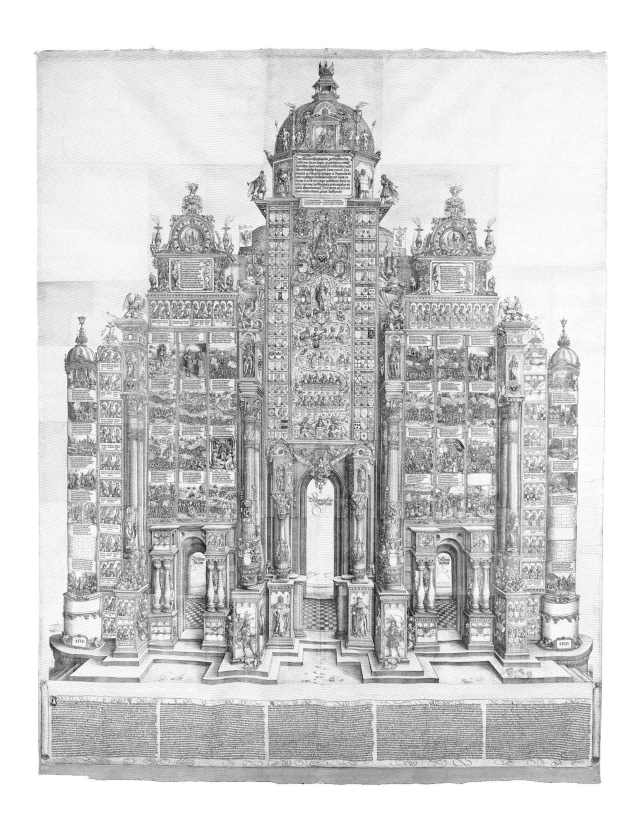

20

ALBRECHT DÜRER, WOLF TRAUT
AND HANS SPRINGINKLEE
The Triumphal Arch of Maximilian I, c. 1515
Woodcut, 357 × 295 cm
British Museum, London, inv. no. E,5.1

INTRODUCTION

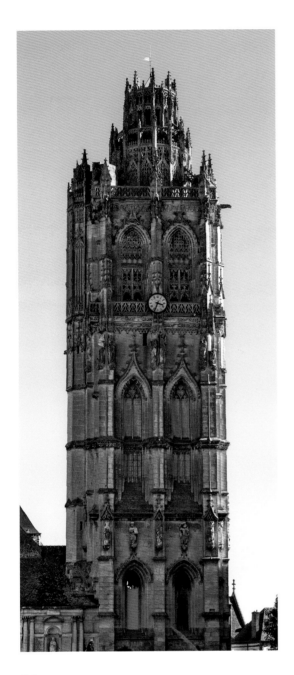

21
Verneuil-sur-Avre, Église Ste Marie-Madeleine, tower, 1st quarter of the 16th century

The use of historicizing ornament represents another front in this 'war' between Gothic and Renaissance. While Renaissance architecture borrowed from antique models, *Astwerk* decoration may in some cases refer to primitive huts made from trees and branches, as described by Vitruvius and by the Roman historian Tacitus.[26] Yet the notion of a Gothic-Renaissance 'war' is perhaps a little extreme, for the two types of ornament could also be used together, as in the monumental woodcut of *The Triumphal Arch of Maximilian I*, where *Astwerk* was used to frame individual scenes within a grand classicizing structure represented in careful perspective (fig. 20). Measuring 3.57 × 2.95 m and printed from 195 blocks, the *Arch* was designed around 1515 by Albrecht Dürer, Wolf Traut and Hans Springinklee for the Holy Roman Emperor. It was distributed by Maximilian to members of the imperial aristocracy as a billboard advertisement of imperial power, but could also reward close looking, as it contains miniature historical scenes describing the achievements of the Austrian Habsburgs and representations of many other aristocratic families.[27] The immense size of the *Arch*, its bold rhetoric, and its invitation to close inspection parallel many features of the Rouen tower drawing, as we will see.[28]

Objects for the gaze: macro- and micro-towers

Towers such as that represented in the Rouen tower drawing – especially towers with large spires – were particularly expensive, structurally demanding and symbolically charged buildings. Spires only appeared on towers in the twelfth century, but then quickly became established as urban symbols marking the 'spiritual centre' of a community and defining its identity. An example is Strasbourg, where the north spire of the Cathedral was erected in the fifteenth century as a symbol of civic independence and unity. Such spires were symbolic rather than functional: although their lower storeys could contain bells, their upper structure had no direct practical utility, but existed mainly "to be seen".[29] Maximizing their visual impact was therefore important, and could sometimes lead to interventions in urban planning, as in Florence, where houses were demolished in 1367 and 1376 with the explicit intention of promoting the beauty of the Cathedral's bell tower. Given their visibility, spires were also ideal sites to display munificent patronage, as in the church of Mary Magdalene in the Norman village of Verneuil-sur-Avre, where Artus Fillon, native of the city and later Bishop of Senlis (1522–26), commissioned a soaring and highly decorated Flamboyant tower completely out of scale with the simplicity of the rest of the construction (fig. 21).[30]

22

POL DE LIMBOURG
The Temptation of Christ, fol. 161v
from *Les Très Riches Heures du duc
de Berry*, c. 1412–16
Tempera on vellum, 30 × 21.5 cm
Musée Conde, Chantilly, Ms 65/1284

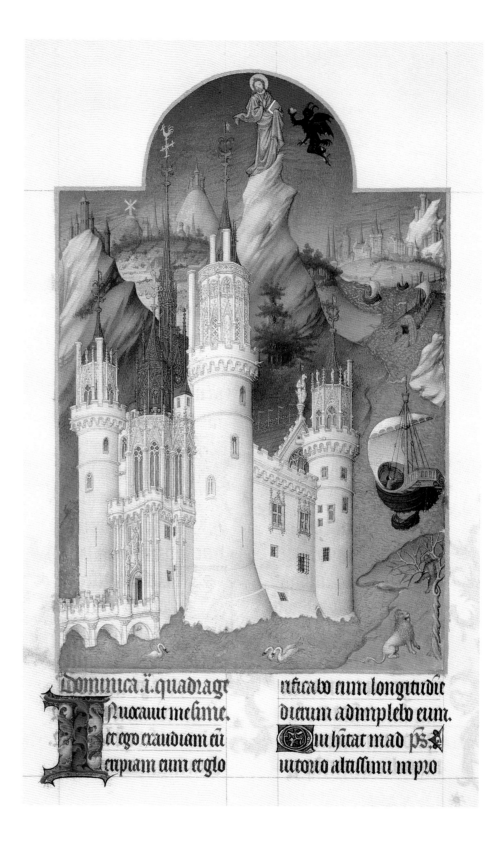

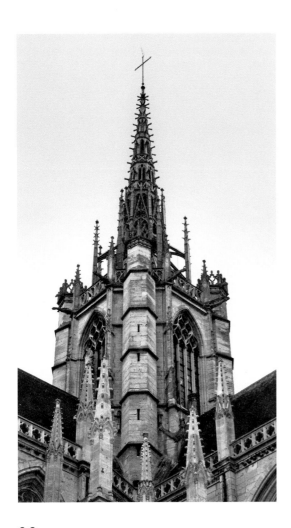

23
Évreux, Cathédrale Notre-Dame,
spire, c. 1475

At the same time, towers were expensive and dangerous projects. Only rarely were churches and cities sufficiently rich and politically unified to complete the construction of a great tower. Spires were often left incomplete, as at Cologne Cathedral in Germany, where a crane was abandoned on top of the unfinished south tower in 1437 and became one of the city's distinguishing landmarks until its removal in 1868.[31] Economic and static problems could also impose design changes on an existing construction, as at Rouen, where both the Cathedral's southern tower, known as the Tour de Beurre, and the crossing tower of the Abbey of Saint-Ouen showed signs of structural distress at the turn of the sixteenth century, and had to be completed with lighter stone 'crowns' rather than with spires. For the Tour de Beurre, the design change prompted a lively debate in which the chapter, the powerful archbishop Georges d'Amboise, the city councillors and various architectural experts all played a part: towers mattered to different urban constituencies, all of whom felt entitled to a say in design.[32]

'Crown' terminations were not very common, however: if a stone spire was too heavy or expensive, towers were usually topped with wooden structures covered in lead. While generally simple pyramids, these wooden spires could sometimes include decorative pinnacles, buttressing and gables, resembling great stone spires in their appearance. Easily damaged by wind or fire, decorated wooden spires rarely survive. A beautiful example erected at the Château of Mehun-sur-Yèvre was portrayed in the early fifteenth century by the Limbourg brothers in the famous illuminated manuscript *Les Très Riches Heures du duc de Berry* (fig. 22). Another French example of the type is the spire of Évreux Cathedral (fig. 23), reconstructed in stone in the eighteenth century as a copy of the wooden original.[33]

These soaring, gravity-defining towers were remarkably similar to much smaller objects when drawn on paper. A design on the back of the spire plan (fig. 3) in the Victoria and Albert Museum shows the base of a chalice, drawn according to the same conventions as contemporary architectural drawings, and deploying some of the same motifs (fig. 4). Such decoration is known as micro-architecture, namely the decorative use of miniaturized architectural elements – for example spires, domes, portals, buttresses and pinnacles – in the design of objects or structures. A prominent aspect of late medieval architectural invention, micro-architecture offered opportunities to display geometrical and ornamental creativity, but with small economic and structural constraints. As a result, their decoration could be more experimental and daring than in larger structures. Moreover, the construction of ambitious micro-architectural objects required a much shorter timespan than an entire building, turning them into an ideal showcase of their

24
Nuremberg, St. Lorenz Kirche,
Sacrament House, 1493–96
(photograph of c. 1890)

25
Nuremberg, St. Lorenz Kirche,
Sacrament House, detail, 1493–96

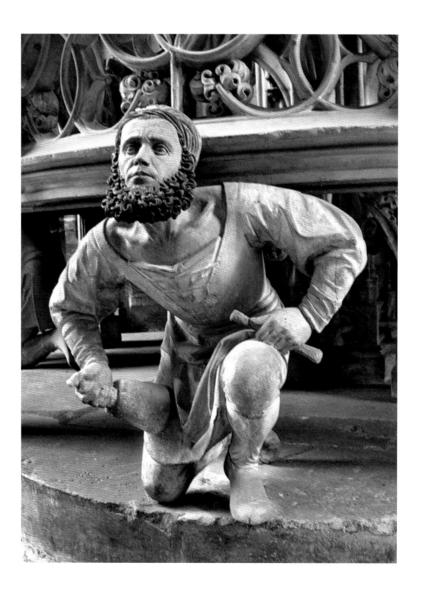

INTRODUCTION

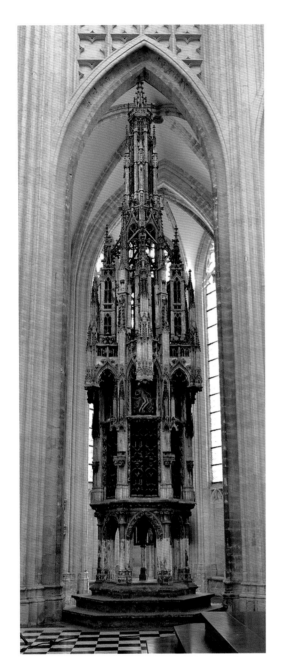

26
Leuven, Sint-Pieterskirk,
Sacrament House, 1430

designer's abilities. For example, the massive sacrament house
of the church of St Laurence in Nuremberg (1493–96) is balanced
on the shoulders of a sculpted self-portrait of its designer Adam Kraft
(active 1490–1509) – a powerful metaphor for his fundamental role
in its conception (figs. 24, 25).[34]

Among micro-architectural objects, sacrament houses were most
similar to towers in their conception and design. Conceived as
'hagioscopic devices' intended to attract and focus the congregation's
gaze on the host which they contained, these tabernacles were designed
to be seen, just like towers.[35] They were also *like* towers in their design:
despite their designation as 'micro'-architectural, they could span the
whole height of a church's nave, and push even further, as at Nuremberg
(fig. 24), where the top of the sacrament house's spire seems to curl
against the vault. Moreover, they required a solid, concave body to
protect and display the host, and a spire-like termination to underline
its importance and sanctity. Such similarities could be consciously
emphasized, as in the sacrament house at the church of Saint Peter at
Leuven (1450), which features miniaturized windows and a viewing
platform (fig. 26), and that of the church of St Kilian at Heilbronn
(1483–87), with shrunken staircases. Not only did such devices direct
the viewer's gaze upwards, they also offered fictional spaces for
"the beholder's miniaturized self", an effect perhaps mirrored in the
perspective of the Rouen tower drawing, which defines a precise point
of view for the observer. Although many micro-architectural structures
have disappeared across the centuries, the ambiguity between the
macro- and the micro- levels would have been real for a contemporary
observer.[36]

As is argued in the following chapters, ambiguity plays an important
role in the Rouen tower drawing, besides other forms of visual play
and decoration typical of the Late Gothic period. Concomitantly the
drawing calls into question the way we understand the transition from
Gothic to Renaissance, and sits uncomfortably within recent analyses
of Gothic drawing and Gothic design methods. But before these
complex issues can be addressed it is necessary to establish a context
for a drawing with no signature, date or clear connection with any
extant building. This can only be achieved by looking at it very closely.

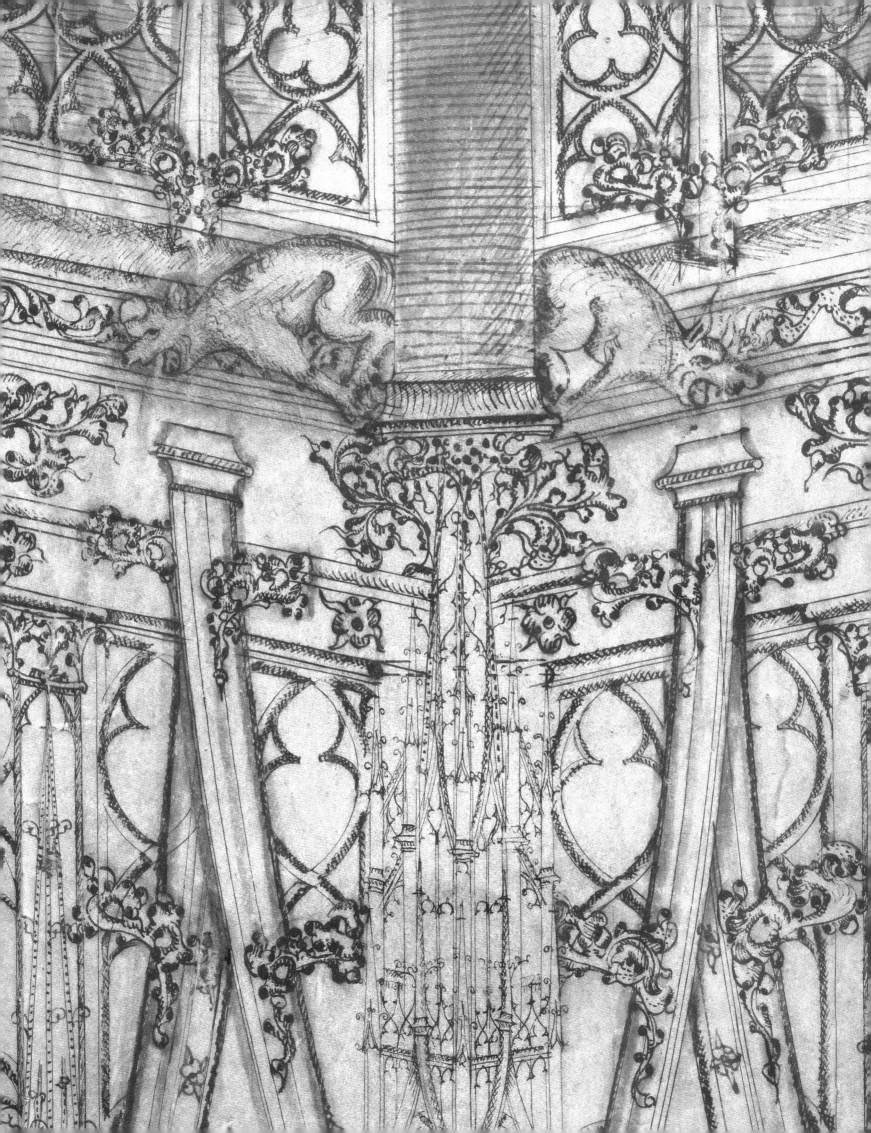

I. A Close Look at the Drawing

Materials and media

THE ROUEN TOWER DRAWING REPRESENTS A THREE-STORIED square Gothic tower set at 45° to the picture plane. Above is a polygonal spire, three of its sides visible – possibly a hexagon, more likely an octagon. Joining the tower and spire is an octagonal transitional fourth storey, angled to the picture plane so that four sides are visible. Stair turrets mark the sides of the body, whilst the spire is surrounded by pinnacles of different heights (figs. 27, 28). The ensemble is highly decorated with furling crockets, foliage, trefoils and fanciful gargoyles, as well as sculptures representing bishops, Apostles, Prophets and other saints. These decorative features are represented in minute detail thanks to the drawing's considerable scale: the tower represented in the drawing reaches 3.38 metres in height and a width of 0.63 metres at its base. As we will see, the decision to represent the tower at this size partly determined how the drawing was made, stored and displayed.

The drawing is realised on parchment, a material obtained from the treated skin of sheep, goats or, most commonly, calves. It was the standard writing support in Europe during the Middle Ages. The size of parchment sheets was limited by the size of the animal whose skin was used; as a result, the area of parchment leaves typically ranges between a third and half a square metre. Four sheets of average size were necessary to accommodate the Rouen tower drawing, and these were joined together with animal glue, as in several other Gothic architectural drawings. An additional parchment scrap was later attached to the top of the drawing, which measures 3.40 × 0.64 m at the bottom, tapering at the top to a width of 0.52 metres. The strength and elasticity of parchment – a material more resilient than leather – made it particularly well-suited to large-scale designs that would regularly be handled.[37]

The size of the Rouen tower drawing is impressive in comparison with most other Gothic drawings, not least because of its expense. It has been calculated that parchment could cost almost sixty times more than paper, even once paper had started to be widely produced in Western Europe in the late fifteenth century. For this reason, large parchment surfaces were commonly used more than once. Such was the fate of the Reims Palimpsest, a group of leaves that contains what are probably the oldest surviving Gothic architectural drawings. These leaves were cut into pieces, erased and reused to make a martyrology and obituary book less than fifty years after the architectural designs – still faintly visible under the text – were originally drawn. Such a fate, or worse, must have been met by many other medieval architectural drawings. In contrast, the great expense of parchment and the careful preservation of the Rouen tower drawing suggests that it was not intended as a temporary

27

Elevation of the tower depicted
in the Rouen tower drawing

28

Storey plans of the tower depicted
in the Rouen tower drawing

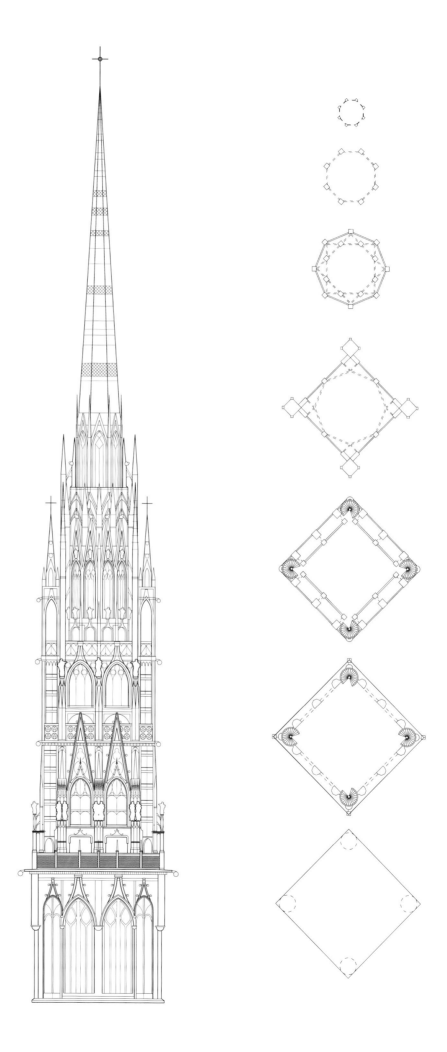

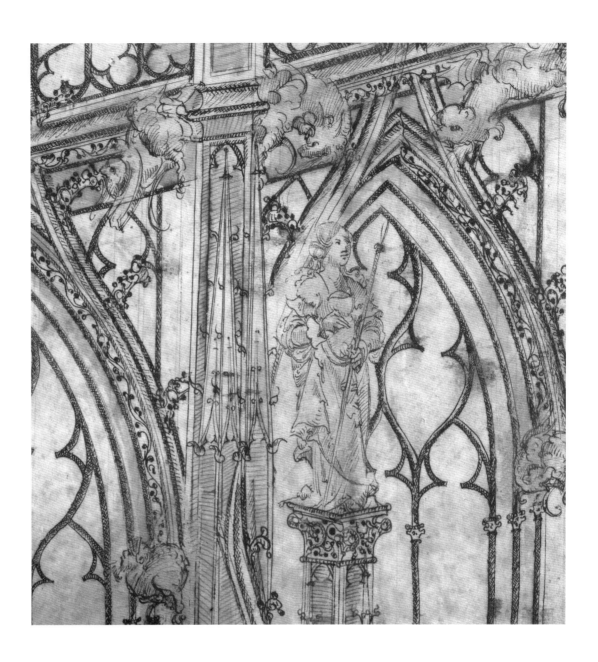

29
Detail of the Rouen tower drawing
showing preparatory lines

'blueprint' for builders, but rather as a highly finished presentation
piece, intended to win the approval of prospective patrons.[38]

The value of the project justified the great care lavished on minute
architectural details. From the outlining of the entire design to
the finishing of such small details, a full range of medieval drawing
techniques can be seen in the piece. The preparatory lines were first
traced in metalpoint, a fine metal stylus of silver or lead which left faint
traces on the priming, the base layer of chalk applied to the parchment
(fig. 29). Most metal-point traces were eventually covered with ink, but
some are still visible in areas with scarce decoration, or else register as
incised grooves when the drawing is viewed under oblique or raking
light (fig. 30).

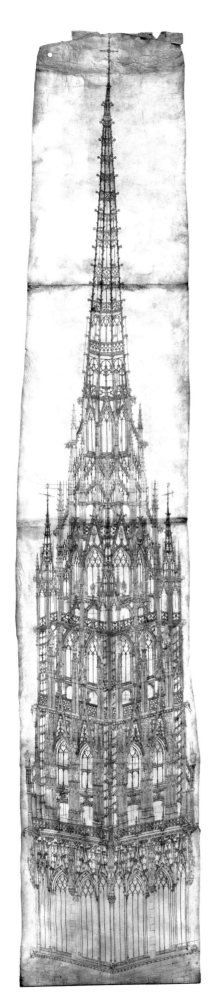

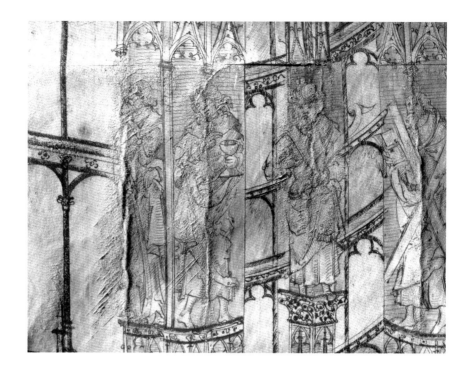

Ink lines would have been traced with different types of pen, depending on their function. A drawing pen that could retain a large quantity of ink must have been used together with a straight edge or ruler to trace the long, fine lines defining the architectural structure, whilst goose quill, which can produce lines of varying thicknesses and strengths, was probably used to draw decorative details free-hand. The quill was also used to suggest solidity and three-dimensionality through hatching, with a variety of effects: orderly lines suggest the form of buttresses and pinnacles in the lower part of the drawing, dense hatching was used for finer tracery and the spire (see fig. 32), and disorderly, broad lines fill the windows of the tower's second and third storeys, as if the artist had suddenly decided to turn open spaces into solid walls. In addition, a brush was used to apply grey wash to structural details, creating a painterly, three-dimensional effect.[39]

The variety in tools and techniques suggests that several artists collaborated in creating the drawing. This seems to be confirmed by the sculptural decoration: statues are often too large or small for the spaces designed for them, and for the consoles on which they stand. Moreover, looking at the drawing under raking light reveals several points where the parchment has been scraped with a knife to erase pre-existing lines and draw sculptural details according to a different design (fig. 31). It seems likely that a first artist or team drew the architectural structure, and then a second artist added the sculptural decoration, filling the

30
Construction lines visible in the Rouen
tower drawing under raking light

31
Detail of the Rouen tower drawing
under raking light

32
Detail of the Rouen tower drawing
showing different drawing techniques
and various types of hatching

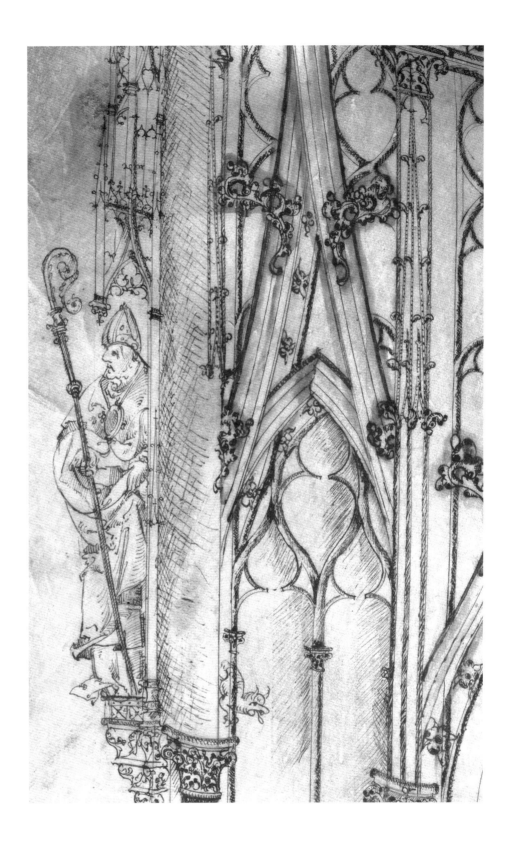

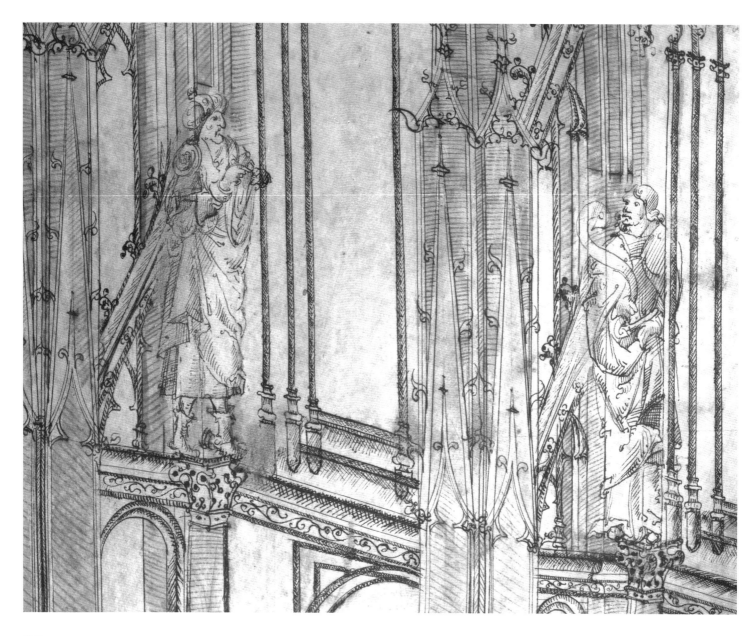

33
Detail of the Rouen tower drawing
showing statues inserted in
the architectural structure by a
different hand

A CLOSE LOOK AT THE DRAWING

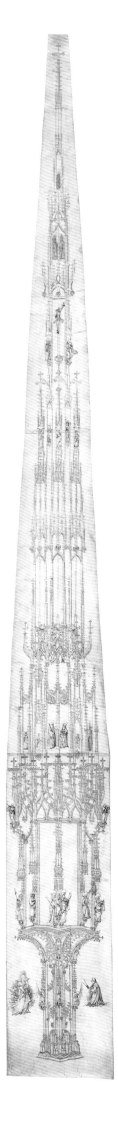

34

HANS NIEDERLÄNDER (ATTRIB.)
The Sickinger Bauriss (drawing of
a sacrament house), c. 1513
Brown and black tusche on
parchment, 259.3 × 27.4 cm
Munsterbauverein, Freiburg

spaces provided but also adding figures in areas where no decoration had been planned (see fig. 33). Such collaboration is not unique in medieval drawings: a particularly clear example is the so-called Sickinger Bauriss, a drawing of a sacrament house made for Freiburg Cathedral around 1513 (fig. 34). In this drawing, architecture and sculpture are clearly differentiated through the use of inks of different colours.[40]

Although the majority of late medieval drawings – especially those with a more directly practical function – do not feature sculptural decoration, some presentation drawings seem to have been created with the intention of showcasing a complete decorative programme that encompassed not only architecture but also sculpture, wall-painting, and even furniture. A notable example is the drawing of the choir screen erected in the late 1510s at the Cathedral of Le Mans (fig. 35), commissioned by Cardinal Archbishop Philip of Luxembourg together with his vicars-general and the Cathedral chapter. The drawing contains elements specifically targeted at each of these patrons, including heraldry representing the arms of the cardinal's family and sculptures of saints connected with the vicars-general.[41]

Like the Le Mans drawing, the Rouen tower drawing represents different materials: masonry blocks are clearly delineated at the bottom of the image, whilst the spire is formed of twig-like ribs and lopped branches, suggesting a wooden structure. Moreover, the serpentine curves they form when merging into the cross-shaped finial evoke an even more malleable material, such as metal. In the Le Mans drawing, colour clarifies the intended medium; in the Rouen tower drawing ambiguity remains: does it show a full-scale stone building, a lighter wooden construction, or perhaps a small-scale metalwork object? The ambiguity is exacerbated because, like the majority of medieval architectural drawings, it does not feature any indication of dimensions or scale.

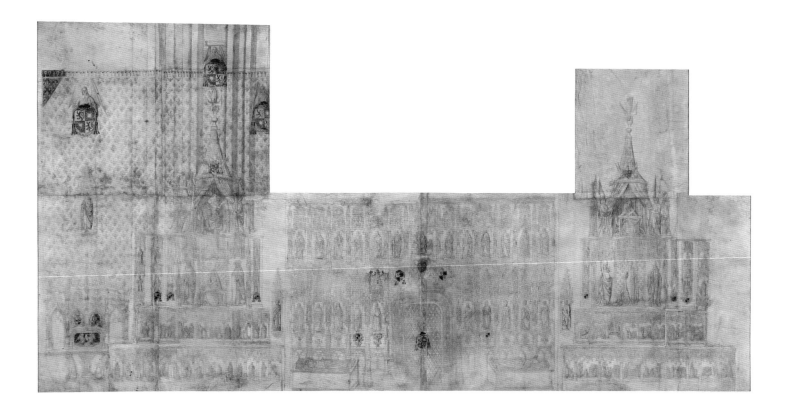

35

Drawing of the choir screen of
Le Mans Cathedral, c. 1519
Ink, gouache and gold leaf on
parchment, 107.5 × 210.5 cm
Musée de Tessé, Le Mans,
inv. no. 2004–01

Structure and geometry

Seen in the context of other surviving Gothic drawings, the most
striking feature of the Rouen tower drawing is not its size or technique,
but its remarkable three-dimensionality. The tower has not been
represented orthogonally, but in reverse perspective, with one of
its corners placed at the centre of the sheet, closest to the viewer.
Moreover, the tower and spire are seen from a raised viewpoint.

In this respect, the tower drawing differs from nearly every
other surviving Gothic drawing, in which buildings are represented
orthogonally with only very minor spatial clues, if any (for example,
figs. 3, 4, 35). As we have seen, such flat representations were derived
partly from the design methods of Gothic masters, who conceived
complex structures through the manipulation of two-dimensional
geometrical shapes. Traces of such geometrical construction are
often still visible in Gothic architectural drawings in the form of
compass pricks and preparatory metalpoint lines used to set out a basic
geometrical framework. For example, in a French drawing of a portal,
dated to 1450–1500 and now at the Cloisters Museum, diagonal lines
and a worn prickmark are prominent in the open space of a doorway
(fig. 36). They bear no relation to any element of the finished structure as
represented in the drawing, but were instead used to set out the portal's
overall form. The basic skeleton was then elaborated into a framework

36
Drawing of a portal, c. 1450–1500
Pen and brown ink over black chalk
on parchment, 44.6 × 29.8 cm
The Metropolitan Museum of Art,
New York, inv. no. 68.49

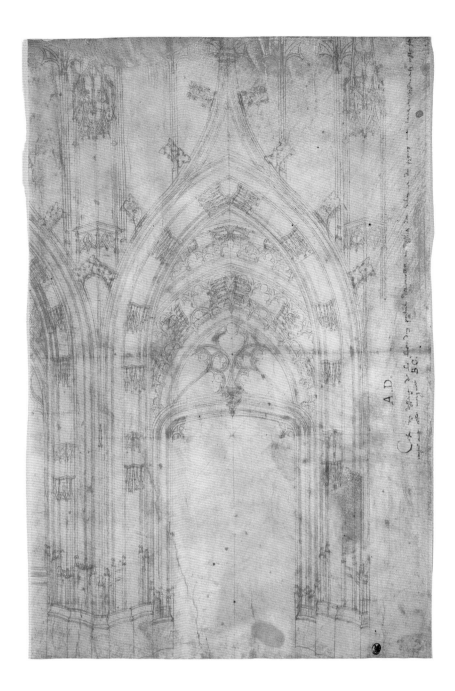

of double squares and octagons, whose key points established the
position of openings, arches and buttresses.

Study of the Rouen tower drawing under raking light reveals
construction lines of a wholly different type (fig. 30), suggesting tht
was created through a different design procedure. The verticals of the
windows to either side of the central corner of the tower's first storey
are heavily incised, as if retraced several times, and were probably
central in the development of the design. Nevertheless, construction
lines seem to have been employed more sparingly in this drawing than
in other Gothic examples. Moreover, they construct a relatively simple

geometrical framework of rectangular grids – presumably established with the help of a straight edge – around decorative features such as pinnacles and tracery. Meanwhile, compass pricks are clearly visible in the balustrade roundels of the second and third storeys and in the round arches of the third and fourth storeys (fig. 37). It is striking that these lines and compass pricks only relate to discrete design elements: the grids helped to position decorative details that were otherwise drawn in freehand, while compasses were used to establish the circles and semicircles of roundels and arches.

The role and importance of geometry and geometrical design were clearly quite different in the Cloisters and the Rouen tower drawing. In the former, geometrical relationships guided the artist's hand and directed his creativity. In the words of Robert Bork, in such cases geometry was a "quasi-random growth factor", and the dialogue between geometrical possibilities, artistic intention and craft knowledge explains the "organic quality of Gothic design".[42] In contrast, the rectangular preparatory grid in the Rouen tower drawing seems to have been used as a means of 'gridding up' the drawing surface, perhaps in the process of copying and adapting the composition of an earlier working drawing.[43]

This task of transforming a two-dimensional working drawing into a three-dimensional presentation piece was clearly not easy for the Rouen draughtsman. Although artists might have deliberately distorted architectural elements and played with perception, as in the 'skewed' door in the transept of Beauvais Cathedral (figs. 10 and 11), many mistakes in foreshortening are immediately evident in the drawing. Ambiguities and errors are concentrated on the second, third and fourth levels of the tower, which have the most complex architectural organization and decoration. On level two, three sides of the buttresses are represented, with three niches visible further up the buttresses. Nonetheless, the three niches are only ever filled with two sculptures, creating considerable spatial confusion. In the two next levels, round arches were drawn with a compass as semicircles, rather than in perspective. Moreover, the balustrades of the stair turrets flanking the main body of the tower were represented in exactly the same way on the right and left of the drawing, although they should actually recede in opposite directions. Finally, the central edge of the tower, theoretically the point nearest to the viewer, seems to recede rather than protrude on the second and third stories, creating an unsettling effect of spatial ambiguity.

These ambiguities become particularly evident when any attempt is made to reconstruct the plan of the tower at different levels, as in fig. 28. To be sure, late medieval master masons would have had considerable

Detail of the Rouen tower drawing
seen with transmitted light showing
the pricks of compass points

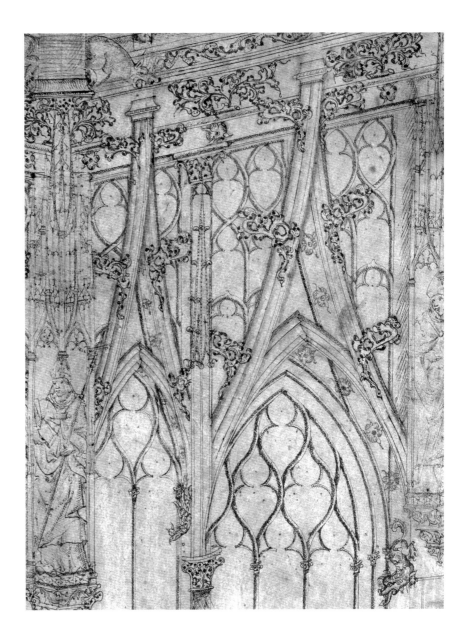

experience in dealing with the complexities of pinnacles and buttresses,
but even so there is no way that the Rouen tower drawing could have
been used to guide construction directly. Nor do its ambiguities and
lack of annotations make it likely that it formed part of a contractual
agreement between patron and architect. Instead, the decision to
represent the tower in perspective suggests that clarity was sacrificed
for the sake of surprising potential patrons, who would have been
accustomed to orthogonal architectural drawings, if at all used to
seeing and evaluating architectural projects. This conclusion is partly
confirmed by two other designs that feature perspective organization,
two of only five such examples in the entire corpus of six hundred
surviving Gothic drawings.

38

VINCENT CORROYER (ATTRIB.)
Drawing of the ramparts of
Méaulens, c. 1509–10
Ink on parchment, 39.1 × 27.5 cm
Archives départementales du Pas-
de-Calais, Dainville, inv. no. 3 Fi 635

A three-dimensional representation of the ramparts of Méaulens,
in the northern French city of Arras, was rediscovered in 1999 and has
been dated to 1509–10 (fig. 38). As might be surmised by its somewhat
crude execution, there is no evidence that its designer made use of
a compass or straight edge, and it is not drawn to scale. The task of
recording the rampart's intended size and other technical information
was left to the textual *devise* accompanying the drawing rather than to
the image itself. Indeed, the image was not realised by an architect at all:
archival records show that the local painter Vincent Corroyer was paid
to transform the *devise* (established by a team of master architects and
carpenters) into visual form, capable of convincing its citizens of the
importance of rebuilding the city's fortifications.[44]

A CLOSE LOOK AT THE DRAWING

39

JUAN GUAS (ATTRIB.)
Drawing of the interior of San
Juan de los Reyes, c. 1485–90
Ink on parchment, 190 × 90 cm
Museo del Prado, Madrid,
inv. no. D5526

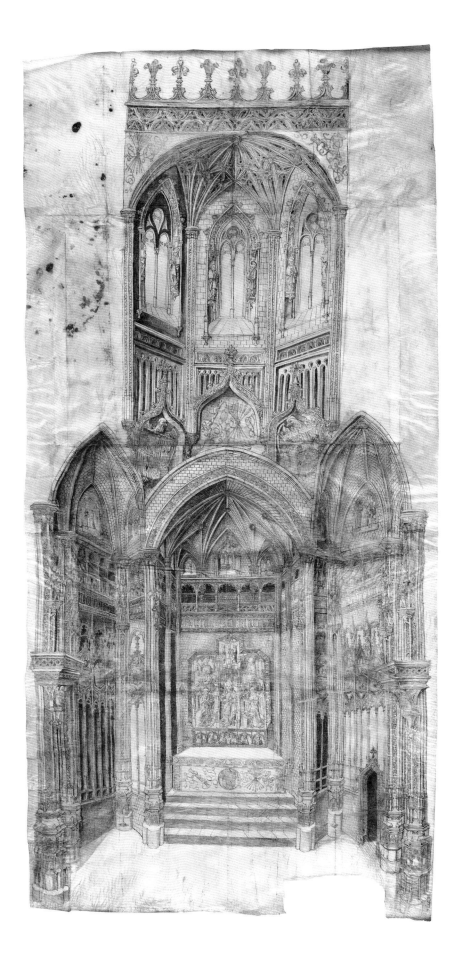

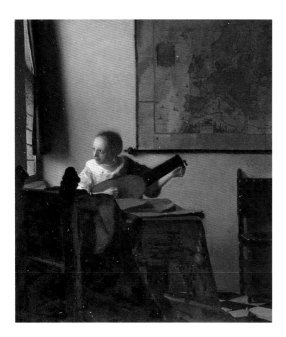

40

Whilst the Arras drawing is a lively sketch intended to provide a general impression rather than technical information, a drawing of the interior of the church of San Juan de los Reyes in Toledo is as conceptually complex as it is detailed (fig. 39). Probably realised around 1479 or 1480 by the architect Juan Guas and his collaborators, the drawing subtly distorts the interior of a church in order to show both its apse and the terminal walls of its transepts. Although the spatiality of the church's interior suggests immediacy, the perspective view of this drawing is actually highly artificial and intended to display the church's rich decoration of sculptures, heraldry and textiles to the greatest possible extent. Measuring 1.9 × 0.9 metres, this was a presentation drawing made for Ferdinand II and Isabella of Castile, who briefly planned burial in the church's crossing.[45] The precise representation of the church's decorative features took priority over the creation of a convincing perspective: every sector of the drawing is represented with equal meticulousness, irrespective of height or depth. Whereas the Arras drawing drew on well-established conventions of representing cities in maps, the Spanish drawing borrowed a radically new technology to give Ferdinand and Isabella the impression of standing in real space.

The Rouen tower drawing falls into a category somewhere between these two other perspectival representations. On the one hand, it is impressive for the painterly effect of its grey wash, and for the liveliness of its sculptures and gargoyles, improvised and corrected several times rather than carefully planned out in advance. On the other, as in the San Juan de los Reyes drawing, every architectural detail is represented with the same amount of precision, regardless of its position. Together with the mistakes in the representation of perspective, the effect of this uniform focus is partially to deny the sense of standing before a real and solid tower. The tension between three-dimensional effect and detailed representation in the Rouen tower drawing might reflect the way the piece was displayed and intended to be seen.

The drawing in use

Today, the drawing is stored rolled on a wooden spool, which is attached to the drawing's lower edge (fig. 41). The spool seems to be a nineteenth-century addition, and in fitting it the drawing was cut on its sides. This is noticeable at the bottom right, where a gargoyle lost part of its head. The lower edge of the drawing may have been trimmed at the same time, although the lack of complex decoration in the area suggests it was always peripheral to the main representation. This cropping is the only visible damage incurred by the drawing during its history, as it is in excellent condition. However, cropping may have

eliminated some evidence of the drawing's initial display. A series of triangular, regularly spaced holes on the edges of an early sixteenth-century drawing for the portal of a hospital in Amiens suggests that this drawing was fixed to a wooden board with nails. If this had been the case with the Rouen tower drawing, every trace of such fixing would have been lost when the drawing was trimmed. However, the sheer size of the piece argues against this kind of display. Just sixty centimetres wide, the Amiens drawing could be easily handled when fixed to a board, whereas the Rouen tower drawing would have been extremely heavy and cumbersome if mounted in the same way.[46]

It seems much more likely that such a long and thin object was always stored rolled up, and this is corroborated by the absence of crease marks in the parchment. In this way, the drawing could have been easily moved and unrolled on a table or wall of suitable dimensions. When placed on a table, it would have been very close to the observer; in these conditions, it could have been unrolled partially, helping the viewer to focus on its rich details. Hung on a wall, the drawing would have been visible in its entirety, and perhaps from a distance. Seventeenth-century Netherlandish paintings often portray artworks displayed in this way, especially large-scale printed maps, as in Johannes Vermeer's *Woman with a lute* (fig. 40). Although finding a room high enough to display the Rouen tower drawing might seem quite a challenge today, the neat hole in the drawing's top right corner offers indirect evidence of such a practice. Similar holes are found at the top of another large-scale drawing, preserved in the treasury of Rouen Cathedral (fig. 68), which will be discussed further below. Moreover, the drawing's upper part was reinforced with an additional strip of parchment, perhaps because it was hung from here. Indeed, this apparently unremarkable scrap holds the key to understanding where and when the drawing was made, as will become clear in the next chapter.

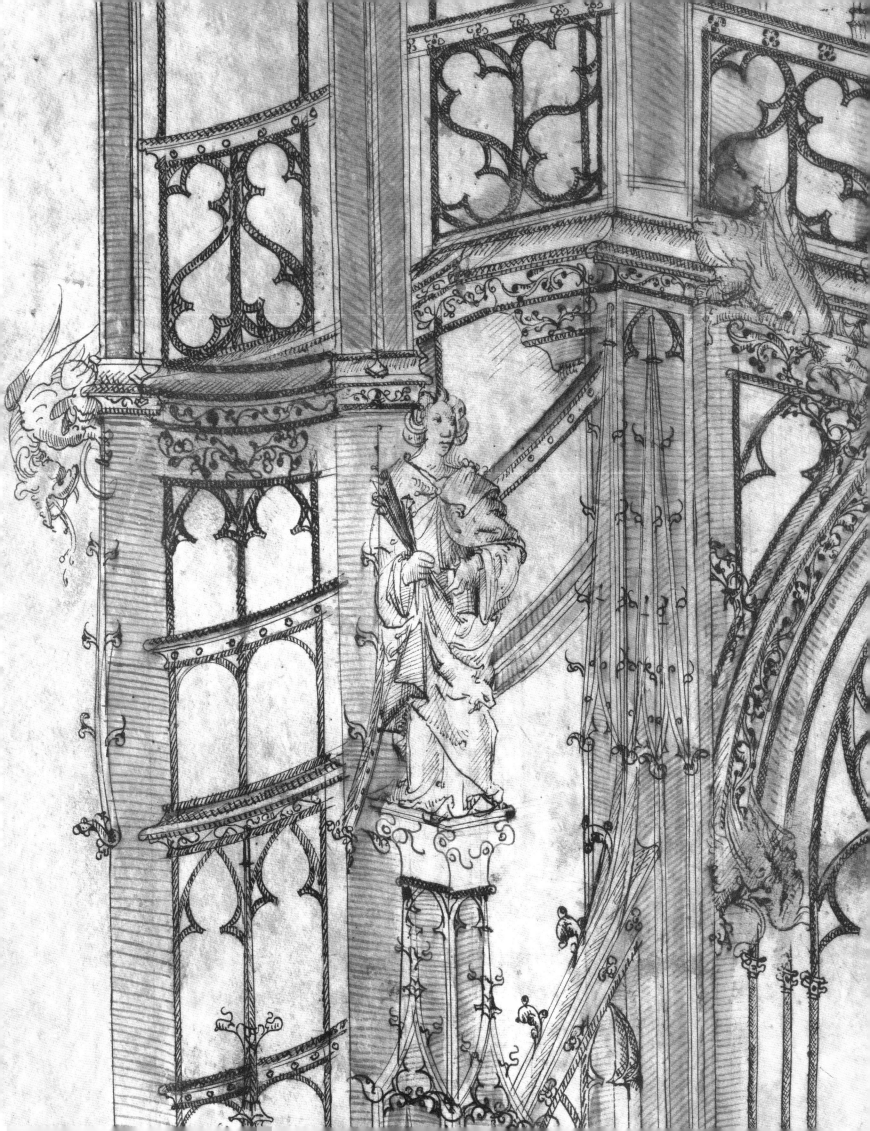

II. Solving the Puzzle

THE STRIP OF PARCHMENT ATTACHED TO THE BACK OF THE TOWER drawing contains key evidence of its origin and provenance (fig. 42). Four lines in thick brown ink in an eighteenth-century hand read:

Le Boucher Prestre au
Dessous de Mr Le President
De Louraille en l'année
1726.

The letters are partially faded, yet the words are mostly easy to read. The only difficulty is the first word of the second line, of which the last three letters are blurry, apparently scraped and retraced. It translates as 'The priest Le Boucher, under(?) Monsieur the President of Louraille during the year 1726'.

This inscription, probably added to the object when it changed hands, represents the only evidence of provenance prior to its acquisition from a French family of architects in 2014. The implication of French provenance is confirmed by the fact that, during the Ancien Régime, Louraille was the name of an estate in the vicinity of Rouen in Normandy, which had been held by the noble du Mouchel family since at least the early fifteenth century. In the early eighteenth century, the lord of Louraille was Jacques-Alexandre du Mouchel (1693/94–1767), who, like his father and grandfather, was a councillor of the Parlement of Rouen, a permanent regional court established in 1515 and derived from an older regional exchequer. In 1718, he became the first of his family to obtain the title of president of the Parlement, which he held until 1742. Without doubt, he is "*Mr Le President*" mentioned in the inscription.[47]

Jacques-Alexandre was a humanist and a prize-winning poet, and his daughter Constance married Joseph Bonnier de la Mosson, a French aristocrat who collected natural marvels and works of art in his private museum in Paris.[48] This collection was sold at auction by Constance and her father after Joseph Bonnier's death in 1744; a surviving catalogue of the sale reveals that the collection comprised a small number of architectural paintings and late medieval artefacts, such as a cross decorated with several scenes from the life of Christ, "very ancient and sculpted in a Gothic taste".[49] Gothic architecture was hardly fashionable in France in the early eighteenth century, but this suggests that Jacques-Alexandre du Mouchel moved in circles where a Gothic drawing might have been appreciated.

Unfortunately it is impossible to identify Le Boucher, the other figure named in the inscription. As far as we know, no priest with this name

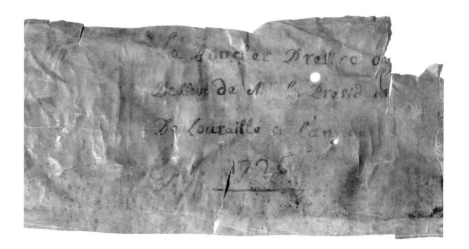

had any kind of close relationship with Jacques-Alexandre du Mouchel, and the surname was extremely common in eighteenth-century Normandy: for example, it was the name of Rouen's most important dynasty of printers and publishers. The inscription nonetheless helps to establish a strong and convincing link between the drawing and early modern Normandy. Such a connection is confirmed by analysis of the architectural details of the drawing itself.

Flamboyant architecture in Rouen

'Gothic' architecture is now almost immediately synonymous with medieval France. The emergence of Gothic architecture is commonly connected to the twelfth-century abbey church of St-Denis, near Paris, and the 'High Gothic' cathedrals completed in the thirteenth century at Chartres, Bourges, Reims and Amiens have long been considered masterpieces of the style. French Gothic architecture did not lose its vitality after these tremendous achievements. In the 1230s and subsequent decades, patrons and builders in and around Paris established a vogue for churches with diaphanous wall surfaces covered by skeletal tracery forms, their interiors lit by generous windows and their exteriors punctured by spiky gables and pinnacles. Variants of this so-called Rayonnant Gothic style continued to be chosen for France's most prestigious building projects until well into the fifteenth century. Later that century, and especially after the end of the Hundred Years' War in the 1450s, tastes changed dramatically, and new projects featured decorative explosions of Flamboyant (*flamboyant*, literally 'flame-like') motifs, whose popularity did not fade until at least the middle of the sixteenth century.[50]

A typical and well-known example of the Flamboyant style is the church of the Trinity in Vendôme (Loir-et-Cher), built around 1500

43
Vendôme, Abbaye de la Trinité,
western façade, c. 1500

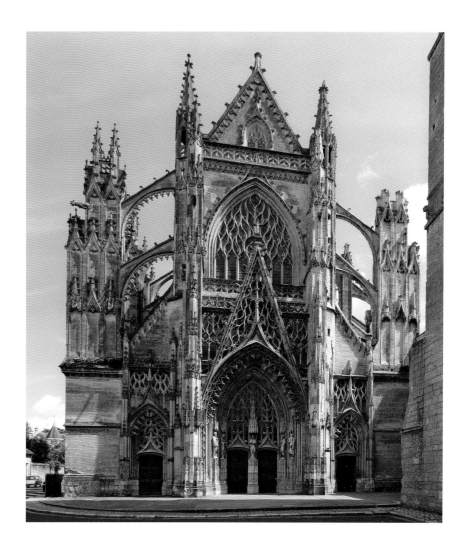

(fig. 43). Characteristic of the style are the decoration of solid wall surfaces with screens of blind tracery and its dissolution into a succession of openwork screens, as is prominent in the portals. Highly decorated balustrades, such as those below the main window and gable, are also used to decorate and dissolve masonry surfaces. Decorative detail is characterized by the use of the double-curved, sinuous tracery which gave the style its name, pinnacles and baldachins with miniature sculptural decoration, and lush vegetal flourishes. All these features can be found in the Rouen tower drawing, for example in the blind tracery on the first storey, in the tracery of the prominent fourth-storey balustrade, and in the forms of pinnacles and crockets. Other similarities can be drawn between the overall shape of the tower and tower projects built in the Flamboyant style. The earliest example is the Tour Pey Berland in Bordeaux (fig. 44). Begun in 1436, it already shares some similarities with the drawing, especially in the clear differentiation between square body and octagonal spire, in the use of curved buttresses to mediate between the two, and in the presence of stair

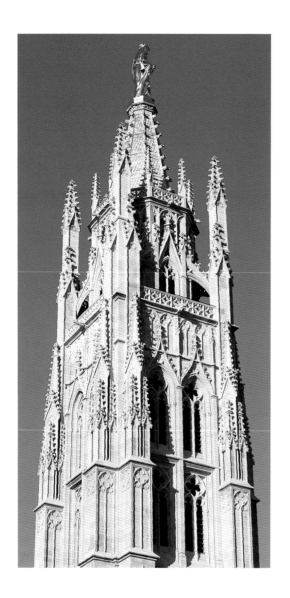

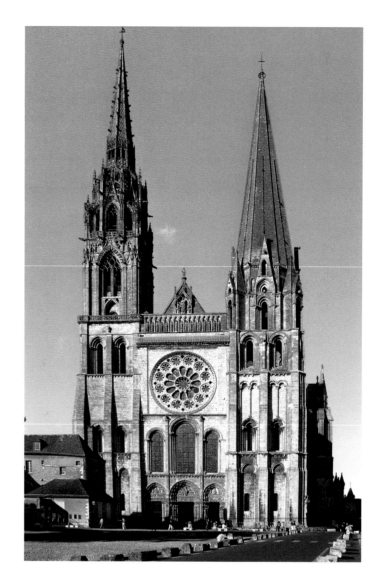

44
Bordeaux, Tour Pey Berland,
begun 1436

45
Chartres, Cathédrale Notre-Dame,
western façade

turrets at its corners. The Rouen tower drawing resembles later designs even more closely. It has the same proportions as the crossing tower of the Cathedral of Évreux (Normandy), begun in 1465 as a solid square structure with four octagonal spire turrets and completed in 1475 with a wooden spire that soars to about the same height as the masonry body (fig. 23). The Rouen drawing tower also shares its plan with the somewhat less ambitious termination added to the thirteenth-century north tower of Chartres Cathedral from 1506 (fig. 45).[51]

Similarities are closest when, following the clues offered by the inscription, the drawing is compared with architectural projects in Late Gothic Rouen. Occupied by the English during the Hundred Years' War, the Norman capital flourished after its reconquest for France in 1449, when it became home to one of Europe's foremost markets thanks to its advantageous position close to the Atlantic and on the navigable

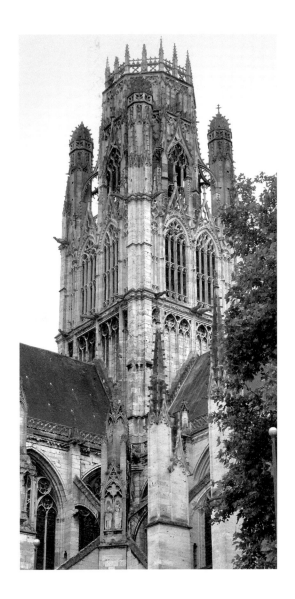

46
Rouen, Abbaye de St-Ouen,
crossing tower, 1440–80 (lower storeys),
1490–1510 (crown)

47
Rouen, Cathédrale Notre-Dame, western
façade, mostly late 14th–15th century,
significantly altered 1509 to 1520s

Seine river which flows up to Paris and Dijon. This period of economic prosperity was also one of great building, thanks largely to two great patrons, the Archbishop of Rouen Georges I d'Amboise (1493–1510), cardinal and minister of Louis XII, and the Abbot Bohier (1492–1515), head of Saint-Ouen, then one of the foremost Benedictine abbeys in France. They instigated significant transformations to the Cathedral and abbey. At the abbey, the fourteenth-century nave was partially reconstructed and almost completely finished in this period, the crossing tower was repaired and completed with an openwork crown (fig. 46), and a new abbot's palace was added to the monastery. In roughly the same period, the twelfth-century Tour St-Romain on the north side of the Cathedral façade was completed (1468–78), the Cathedral library enlarged (1479–84), and the Tour de Beurre built on the south side of the façade (1485–1506; fig. 47). The name of the last derives from the

48
Rouen, Palais Royal, courtyard, 1499–1526

49
Rouen, Palais Royal, detail of balustrade

50
Detail of Rouen tower drawing showing decoration of the third-storey balustrade

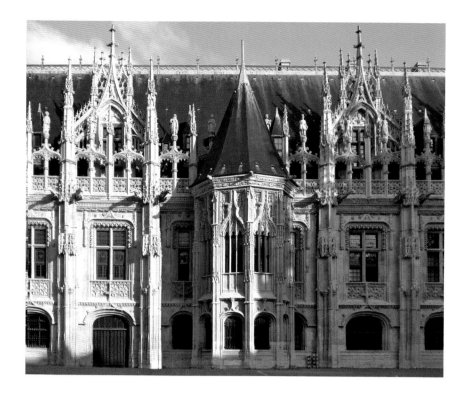

fact that it was partly financed by donations from those who paid for the privilege of not renouncing butter during Lent. Its construction caused major structural damage to the Cathedral's late fourteenth-century façade, which had to be entirely reconstructed after its near collapse in 1508. Its re-decoration was not completely finished when the crossing tower fell in a disastrous fire in 1514, and reconstruction dragged on until 1544. Although Georges d'Amboise played a key role in promoting much of this building activity, its day-to-day running was managed by the Cathedral chapter, leaving the archbishop free to engage with more personal projects such as the transformation of Rouen's archiepiscopal palace into a sumptuous residence (1494–1507) and the creation of one of France's first Renaissance buildings at the château of Gaillon, described by contemporaries as the most beautiful and superb building in all France.[52]

This list of building projects is long, but not exhaustive: the whole of late medieval Rouen must have been a building site. Almost all its parish churches were completely rebuilt in the Late Gothic period, starting with the church of St-Maclou in the mid fifteenth century and continuing with St-Godard and St-Laurent (fig. 53). Civic institutions were also changing their appearance, with the construction of a new Flamboyant palace shared between Rouen's municipal authorities (occupying the wing known as the Palais du Vieux Marché) and the city's juridical court, the Norman Parlement (in the so-called Palais Royal) (1499–1526; fig. 48). A new Renaissance *hôtel*, the Bureau des

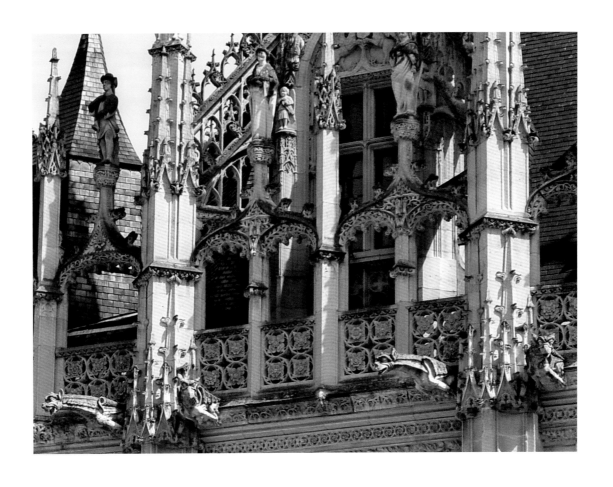

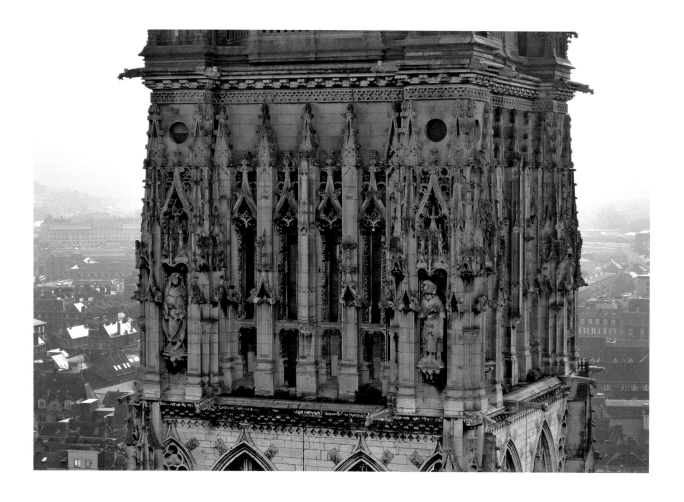

51
Rouen, Cathédrale Notre-Dame, second
storey of the crossing tower, c. 1516–17

Finances, was likewise built on the cathedral square for the city's
financial authority (1508–42). Change extended to private palaces, such
as those of the Bourghteroulde and Romé families, and also to everyday
features of the urban landscape, such as the improvement of a now-lost
system of water fountains.[53]

This dazzling variety of projects makes it difficult to characterize
Late Gothic architecture in Rouen. As is apparent from the coexistence
of Gothic and Renaissance buildings – erected for the same patrons
and by the same local architects – stylistic diversity was appreciated.
Nevertheless, Rouennais Gothic buildings are distinctive in the fact
that sculptural decoration remained a key feature. Whilst at Vendôme
(fig. 43) and other canonical Late Gothic structures, such as the west
front of Toul or the south transept façade of Beauvais, sculptural
programmes were mostly replaced with architectural detailing and
tracery, statues remained visually prominent and organized in complex
iconographic programmes at prominent Rouennais constructions
such as the Cathedral (fig. 47) and the Palais Royal (fig. 48). As we have
seen, statues are similarly important in the Rouen tower drawing. In

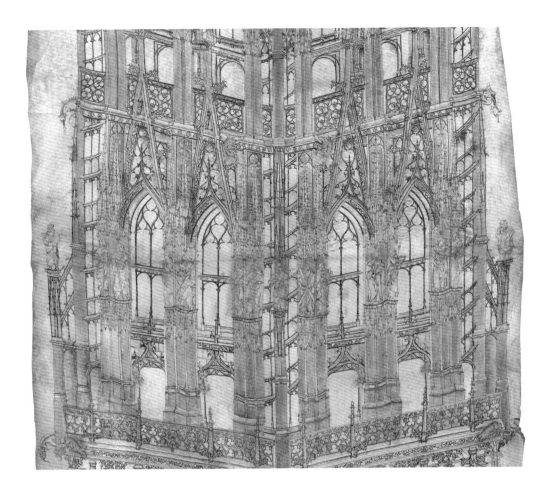

52
Detail of Rouen tower drawing
showing second storey

both Rouen's Palais Royal and in the drawing, for instance, tracery is not used as a substitute for sculpture, but becomes almost figurative, carved so as to resemble different types of flowers (figs. 49, 50). Another distinguishing feature of Rouennais architecture is the preference for two-tiered windows, formed by a low, squat light placed below a taller one and connected to it by a decorated arch, as visible in the crown of St-Ouen (fig. 46), in the upper storey of the tower of St-Laurent (fig. 53) and in the second storey of the Cathedral's crossing tower (fig. 51).

Which tower? Three candidates

Despite similarities with a number of surviving examples, the tower represented in the Rouen drawing does not correspond, even loosely, to any of the late Gothic towers still extant in Rouen. To find a match for the structure, it is necessary therefore to investigate documentary records to discover what structures were planned but never realised or erected but later destroyed. Three candidates emerge. The first is a now-lost metalwork sacrament house commissioned for the church of

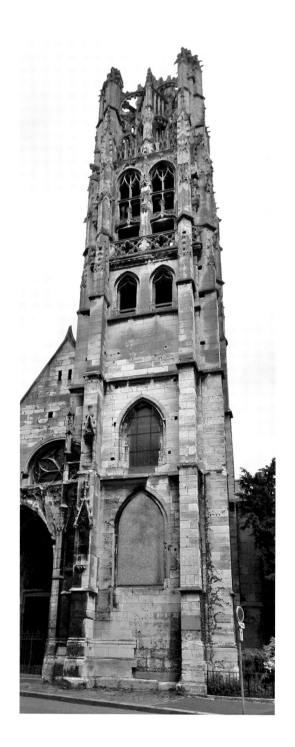

53
Rouen, Église St-Laurent, tower,
1490–1501

St-Laurent before 1519. The second is one of the towers of the façade of St-Ouen, destroyed in 1845. The last is an unexecuted Gothic design for the reconstruction of the crossing tower of Rouen Cathedral, which had been destroyed by a fire in 1514 and was eventually rebuilt in the 1540s to a Renaissance design.

A micro-architectural structure like a sacrament house might seem an unlikely match for the Rouen tower drawing, given its sizeable dimensions. Yet it has already been noted that the drawing contains no clear indications as to the materials and size of the structure it represents; measuring 2.59 × 0.27 metres, the Sickinger Bauriss discussed earlier (fig. 34) offers an example of a large-scale drawing for a micro-architectural object. Moreover, 'micro-architectural' structures such as Late Gothic sacrament houses could be monumental, reaching heights of more than twenty metres. The match seems all the more possible given that the treasurers of St-Laurent in Rouen commissioned a golden sacrament house in imitation of their church's own tower (see fig. 53).[54] According to this scenario, the large windows represented on the first storey of the tower drawing would enclose the host and ensure its visibility. Nor is this incompatible with the representation of stair turrets and gargoyles spouting water, for such details were commonly included on German sacrament towers, as discussed in the Introduction.

No monumental sacrament towers of the type common in Germany and the Netherlands survive in Rouen, though a comparable example can be found in the church of St-Gertrude (before 1484), in a village thirty kilometres north-east of the city. Smaller crystal monstrances seem to have been more frequent. A surviving fifteenth-century example in the reserves of Rouen Cathedral probably gives a good sense of the piece commissioned for St-Laurent: just sixty-five centimetres tall, this gilded copper monstrance features windows, gargoyles, crenellations, imitation roof slates and a cockerell weathervane. Yet its overall shape is very different from that of the tower represented in the tower drawing, and it is impossible to imagine that such a large drawing could have been made for such a small object.[55]

The second hypothesis, that the drawing might have been realised for the abbey of St-Ouen, is substantiated by evidence of the original arrangement of St-Ouen's façade. Whilst the present-day arrangement is a neo-Gothic fantasy of 1845–51, antiquarian prints record the façade's original design, which was never completed. In particular, an engraving by Jean Boisseau, published in Claude Chastillon's *Topographie française* of 1655, purports to represent the tower as planned (fig. 54). Boisseau's engraving shows a façade with side portals placed at a 45° angle to the main structure, whereas other antiquarian evidence suggests that only

54

Jean Boisseau

Portal of the church of Saint-Ouen in Rouen, as it should have been completed

Engraving from Claude Chastillon, *Topographie française* (Paris, 1655)

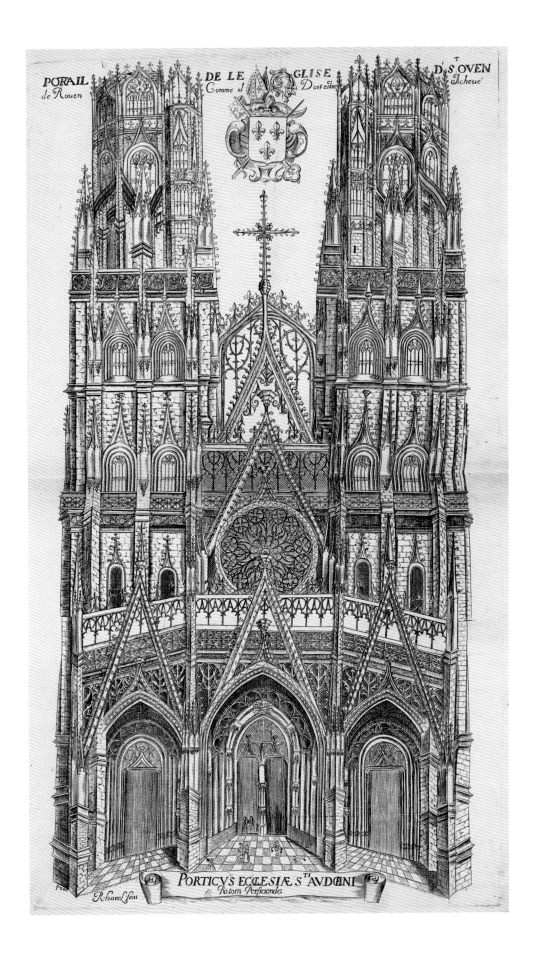

the side towers stood at an angle to the façade. Since the abbey's records are missing for the crucial years 1492–1576, it is impossible to know how far the engraving is accurate or whether, alternatively, different solutions were being debated, as has been variously suggested by scholars.[56]

In any case, the possibility that St-Ouen's towers might have been placed at a 45° angle is striking, given the Rouen tower drawing's 45° viewpoint. Indeed, there are other similarities between the engraving (fig. 54) and the tower drawing, for example in the transition between a square and an octagonal plan towards the top of the towers. St-Ouen also makes sense in relation to the tower drawing's iconography. In the late medieval period, the abbey was more attached than any other church to the legacy of the city's archiepiscopal saints, and a papal privilege of 1256 had granted the use of episcopal dress to St-Ouen's abbots.[57] Nevertheless, the drawing from Ingolstadt already mentioned (fig. 6) demonstrates that 45° towers were not necessarily represented in perspective. Moreover, the towers represented in the engraving are topped by crowns, not spires, and contain side portals rather than flanking them.

The visual evidence connecting the tower drawing to Rouen Cathedral is much stronger. In the early sixteenth century, the master mason in charge of the site was Roulland le Roux, a well-respected and popular designer who was also commissioned to work for the archbishop and the city. He was associated with the foremost projects of the time, including the Palais Royal and the reconstruction of the Cathedral's façade, and his personal style left a strong mark on late medieval Rouennais designs. A recurring feature in his buildings is the openwork gable crossed by a horizontal course of masonry, especially visible on the Cathedral's façade. This motif was not unique to Roulland: it had already been used, for example, in the porch of St-Maclou in Rouen (c. 1470–90) and further afield at Toul (1480/85–1500) and Beauvais (south transept, begun 1500). Nevertheless, Roulland returned to it with particular frequency, introducing it at different scales and with different decorative variations. A case in point is the elevation of the Palais Royal (figs. 48, 49), dominated by the motif of segmental ogee arches on the first storey, their finials crossed by a horizontal course of masonry before terminating in front of the second-storey balustrade. The motif is repeated with ornamental variations on every storey of the Rouen tower drawing. Other precise comparisons can be made between the drawing and the decoration of the Palais Royal: the frond-shaped crockets and garlands on the windows of the palace are very close to those on the drawing's first and second storeys, while the two-tier buttresses connecting the tower with its surrounding pinnacles in the drawing correspond to those abutting the palace's roof. The

SOLVING THE PUZZLE

55
Louviers, Église Notre-Dame,
porch on the southern side, c. 1506

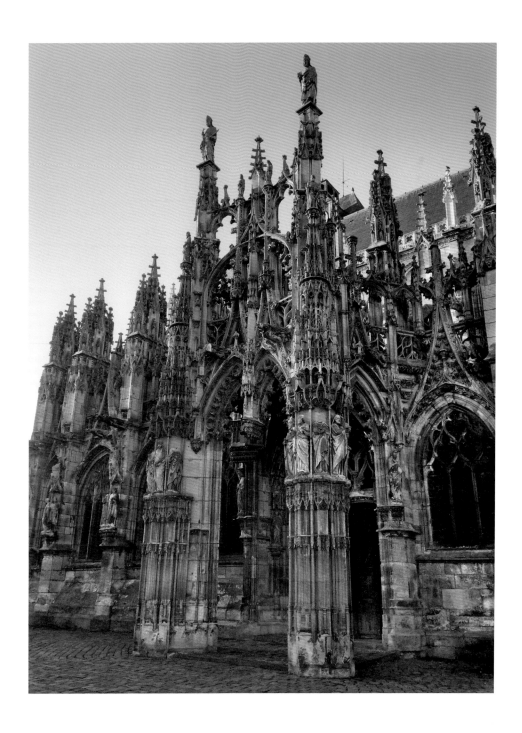

drawing is also closely similar to Roulland's designs outside Rouen. For
example, the three-lobed decoration of the drawing's thinner buttresses
is repeated on the exterior of the south aisle of Notre-Dame in Louviers
(c. 1506), also attributed to Roulland (fig. 55). Tracery on the window
to the right of the church's southern entrance closely resembles tracery
in the drawing, as does the decoration of the balustrade above the
entrance. Other balustrades in the drawing are decorated with roses,
as in the Palais Royal, albeit with a slightly different design.[58]

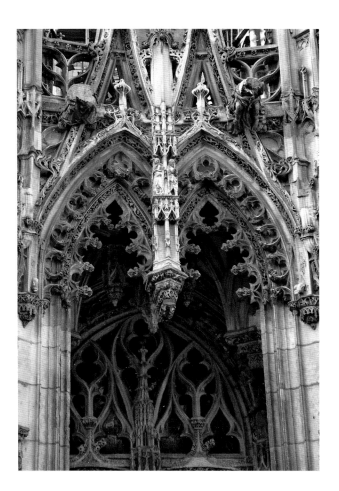

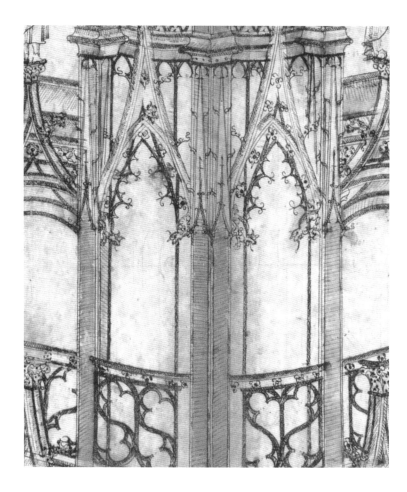

56
Louviers, Église Notre-Dame,
detail of the porch in front of the church's
south entrance

57
Detail of Rouen tower drawing showing
top of the stair turret on the fourth storey

If these visual comparisons link the Rouen tower drawing with
Roulland's authorship, rather than directly with the Cathedral crossing
tower, a closer look at the first storey of the Cathedral tower reveals
clear connections between the drawing and this unrealised project
(figs. 58, 59). Together with its base, this storey is the only part of the
Cathedral's original fourteenth-century tower to have survived the
fire of 1514, after which it was repaired and decorated with up-to-date
architectural motifs. In this process, narrow blind windows were added
on either side of the surviving structure, and foliate decoration added
to the whole storey, so that it resembles a simpler version of the lowest
storey of the tower drawing. An even closer similarity links the statues
represented in the Rouen tower drawing with the "extraordinary figures
of Prophets in theatrical costumes, wearing large hoods" on the crossing
tower's side buttresses and second storey, partly built by Roulland le
Roux in 1516 (fig. 51).[59] The statues are attributed to the workshop
of Pierre des Aubeaux (active 1511–23), and it seems feasible that he
may have collaborated on the Rouen tower drawing. On the crossing
tower Pierre des Aubeaux's sculptures are disposed in niches, but in the

SOLVING THE PUZZLE

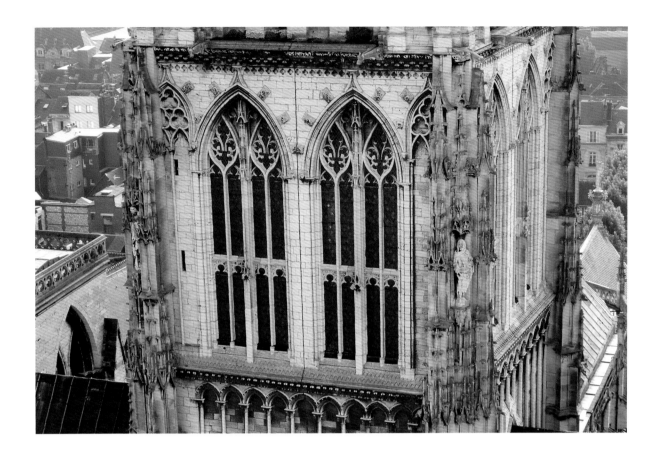

58
Rouen, Cathédrale Notre-Dame,
first storey of the crossing tower,
13th century, significantly altered 1514–16

59
Detail of Rouen tower drawing
showing first storey

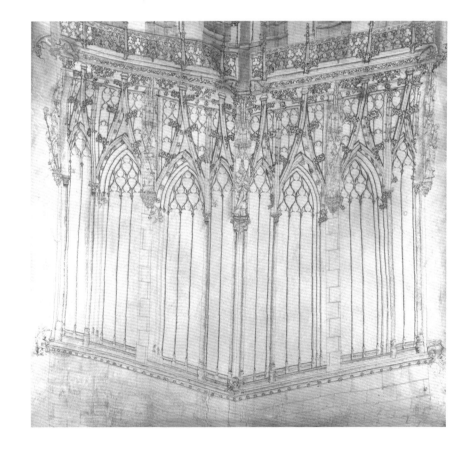

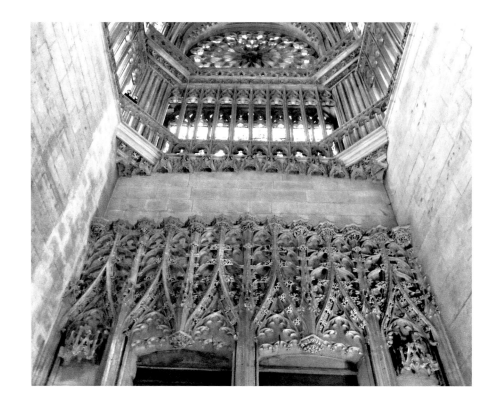

drawing they are mostly balanced on top of ogee arches. This provides
further proof of Roulland le Roux's involvement, as this is a feature of
the Palais de Justice and the bell tower of the church of Mary Magdalene
at Verneuil (1500–26) – the latter funded by Artus Fillon, Georges I
d'Amboise's vicar-general, who expressly emulated the archbishop's
patronage of the Le Roux family of masons. At the same time, analysis
of the drawing's spire suggests that Pierre des Aubeaux's involvement
went beyond the addition of sculptural figures. He was responsible for
the choir screen and Death of the Virgin group commissioned by Robert
Chardon, prior of the Abbey of Fécamp, who at the same time (c. 1500–
10) commissioned an Easter Sepulchre for the Abbey – its authorship
undocumented, but often associated with Pierre.[60] The only surviving
element of this Sepulchre is the thistle decoration, already mentioned
in the Introduction (fig. 17), similar in conception to the organic forms
of the spire in the Rouen tower drawing. To be sure, other examples
of Norman foliage decoration and *Astwerk* survive, including the lush
foliage on the interior of the transept of Évreux, realised by Jean Cossart
before his death in 1517 (fig. 60), and on the exterior of the churches
at Ménilles (completed 1514) and Pont-de-L'Arche (1513–29), but the
effortless transition between architecture and vegetation in the Easter
Sepulchre comes closest to achieving the life-like detail visible on the
spire in the Rouen tower drawing.

The similarity between the sculptures in the drawing and those carved by Pierre des Aubeaux for Rouen Cathedral's crossing tower and façade helps to recreate the drawing's probable scale. Pierre des Aubeaux's sculpted figures vary in height between 1.65 and 2 metres; if those in the drawing were carved at the same size, the approximate measure of the tower and spire can be calculated as between 68 and 82 m, similar to the 82 m of the Cathedral's northern tower, the Tour St-Romain.[61]

Such close visual comparisons suggest a strong link between the drawing, Roulland le Roux, and the crossing tower of Rouen Cathedral. Nevertheless, the skilled architect was never nominated to direct new construction on the site: apart from the tower drawing, there are no visual documents of his practical involvement with this particular building project. To understand why Roulland le Roux was never allowed to build the tower shown in this drawing it is necessary to turn to a closer examination of events following the fire of 1514.

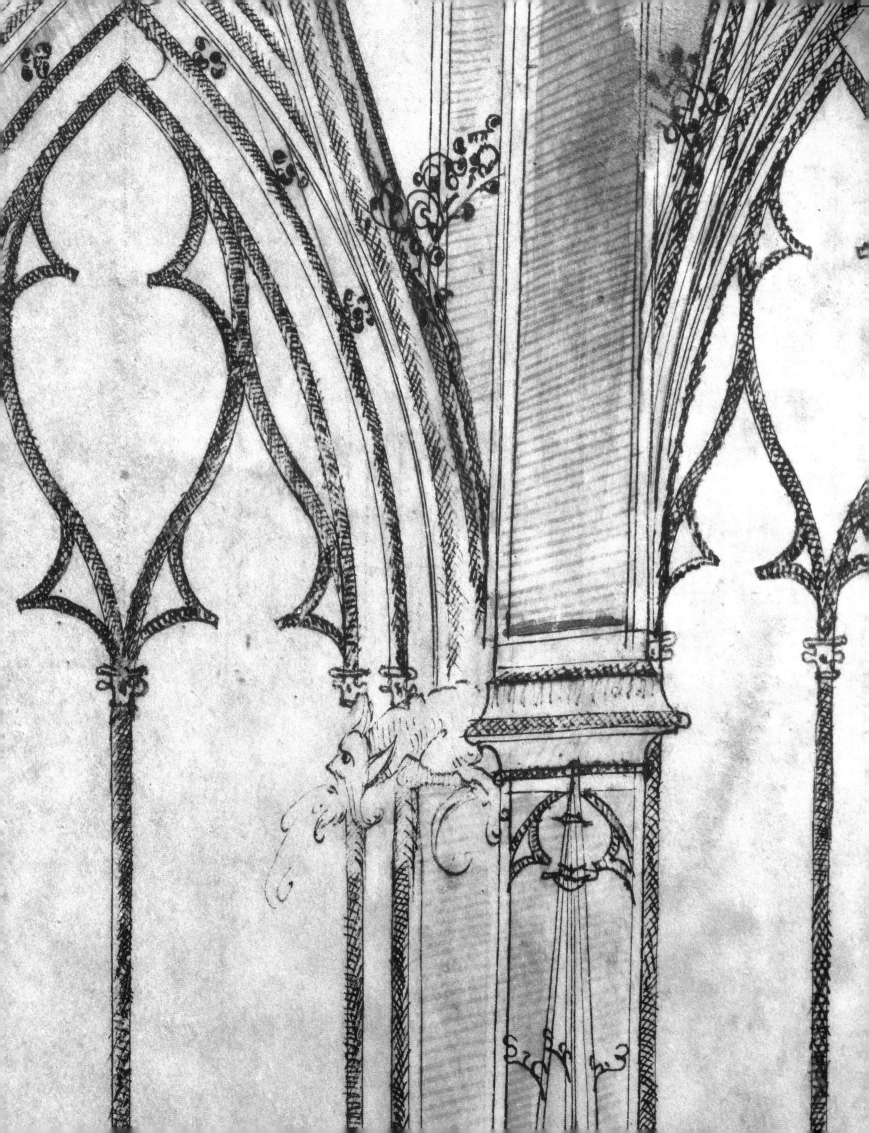

III. Building a Crossing Tower

The chapter accounts

THE FATE OF THE CATHEDRAL'S CROSSING TOWER DURING the fire of 1514 and in the years that followed can be reconstructed in unusual detail thanks to the survival of minutes of the chapter assemblies held by the canons of Rouen Cathedral. In the Appendix to this book the relevant entries are reproduced in full for the first time. The chapter was a community of canons who resided (at least in theory) in the cathedral's precinct and were in charge of celebrating the canonical hours in its choir and of managing its possessions, so for the most part its minutes concern religious and organizational matters such as masses, indulgences and the relationship between the chapter and other bodies and institutions. But as the chapter was responsible for managing the cathedral's revenues and physical structure its discussions could also embrace questions of architectural design and financing, and thus its minutes have captured the kinds of conversations around architecture that are rarely recorded in other medieval contexts.[62]

In the early Middle Ages the bishop led a communal life with the canons who made up the chapter, and was joined in a 'spiritual marriage' with the cathedral. By the end of the Middle Ages, however, the chapter had developed into a legally and financially independent association, and the bishop was little more than a guest in his own cathedral. For example, the bishop of Toul in north-eastern France did not have a key to the Cathedral building, but depended on his chapter to open and close it for him. The situation was less extreme in Rouen, where the archbishop was nominally a member of the chapter, and would sometimes take part in the chapter's liturgy wearing the black cape of ordinary canons rather than his archiepiscopal dress. Yet relations were not always easy: although eminent archbishops such as Georges I d'Amboise had the political clout to direct the election of new canons, their actions did not always go uncontested. In 1501, the Archbishop's nephew, Georges II d'Amboise, arrived at the chapter with a letter from his uncle requesting his election as Treasurer, an important and well-appointed title within the chapter. The canons received him, yet could not decide if he should be allowed to sit in the Treasurer's high chair in the choir, as he was not ordained. The chapter consequently split into two separate factions, for and against the Archbishop, revealing the underlying tension between the relatively cosmopolitan personalities of the archbishop's court and locally born canons with very different loyalties.[63]

Tensions were also be reflected in the management of building works. In the later Middle Ages, the management of the cathedral as a physical entity fell under the remit of the chapter, but the archbishop would

generally lend it financial support. For example, in 1500 the Archbishop of Rouen donated 4000 *livres tournois* to make a bell for the Cathedral's south tower, the Tour de Beurre. The bell was thus known as the 'Georges d'Amboise'. Yet it was left to the chapter to buy the materials to make the bell, and it was the chapter who decided that it should be the largest in France. The situation was equally complex when it came to the construction of the Tour de Beurre itself. Begun around 1483, work on the tower slowed down in 1499 after the second storey was completed, and a fierce debate emerged as to whether the tower should be topped with a spire or a crown. In February 1501, Georges I wrote to the chapter proposing a crown termination, but the canons were not convinced and asked for the opinion of various experts. The following year, when the Cathedral's central portal was close to collapse and had to be propped up with scaffolding, the canons did not immediately initiate its repair but focused instead on the possibility of building a daring and expensive spire termination for the Tour de Beurre, on which they finally agreed in 1505. This decision was harshly reprimanded by Georges I, who sent two master masons employed in the construction of his own palace at Gaillon, Guillaume Senault and Nicolas Biart, to inspect the portal and the tower. The costs of the portal's repair were then divided in three: one third was paid by Georges I; another third by the chapter, redirecting money from their prebends and other revenues; the other third by the *fabrica*.[64]

The *fabrica*, first attested in the thirteenth century in northern France, was an administrative body in charge of financing and directing new building works, as well as activities relating to the church's day-to-day upkeep, such as buying candles or winding up the church's clocks. Such duties had earlier been entrusted to a single chapter official, the treasurer or *custos*, who collected and redistributed the substantial amounts of money earmarked for the church's upkeep. The treasurer remained extremely important in Rouen until 1470, when a papal bull reassigned to the *fabrica* the duties of looking after the Cathedral's relics and lighting, financed by its own revenue streams and from half the *débite*, the tax paid to the Cathedral by each parish in the diocese. The *fabrica* was a corporate institution, managed in Rouen by three canons, nominated every year by the chapter – two *maîtres d'œuvre* or superintendents, distinguished canons with a prestigious supervisory role, and a *procureur* or procurator, usually one of the lesser members of the chapter, with a more modest and bureaucratic role that required him to collect revenues, buy necessary equipment, pay fees, and keep the *fabrica*'s account books. This last meant keeping accurate weekly records of income and expenses, and compiling them yearly in two itemized accounts. The names and stipends of architects, carpenters

and even unskilled labourers were listed in these accounts. Although closely connected to the chapter, the *fabrica* was a separate body able to deal with everyday necessities and problems by itself. Unfortunately, Rouen Cathedral's *fabrica* accounts are lost for the years between 1513 and 1521, but the destruction of the Cathedral tower in 1514 and the economic and architectural problems encountered during its reconstruction represented such a dramatic crisis that they were discussed within the chapter rather than resolved independently by the *fabrica*. Thus it is only the institutional consequences of the fire that make it possible to reconstruct the history of the Cathedral's crossing tower in detail.[65]

While the *fabrica* records are largely economic in content, the chapter acts record the discussions and the decisions taken by the chapter during their assemblies, which took place almost daily. Not all the canons were regular attendees: although some privileges and revenues were granted only to those resident in the Cathedral, canons might also be nobles living in their own estates or at court, and many of them acted as parish priests in other villages or towns. Nevertheless, the accounts always present the actions of a community: individual opinions and individual opposition to general decisions are only rarely noted, perhaps only when disagreements were particularly strong. Judging from the language of contemporary *fabrica* and chapter accounts from other cathedrals, it is likely that the Rouen chapter discussed in French, yet its meetings were summarized and transcribed in Latin by a specially appointed clerk, or *tabellarius*. As we know from his own introduction to the accounts, the *tabellarius* in Rouen in the years around 1514 was Jacques Lemoine. Nothing more is known about this figure, whose authorial voice only intervenes once, to express despair at the ravage caused by the 1514 fire (see the Appendix, no. 1). His mixture of Latin and French terms to describe the church's architectural features (for example, Appendix no. 31) suggests a lack of familiarity with building works, but it is impossible to evaluate his accuracy in transcribing the chapter's discussions, or his opinions on the architectural decisions taken by the chapter.[66]

The fire and its aftermath

On the morning of 4 November 1514, a team of lead-workers was repairing Rouen Cathedral's crossing tower, known, because of its narrow wooden spire, as the *tour grêle*, 'the spindly tower'. A spark from the fire used to melt the lead caught on the tower and soon the entire structure was ablaze. Fire melted the base of the cross mounted on the spire, which fell down on to the choir, destroying its roof and starting a second fire; the entire spire collapsed soon after. At the same time,

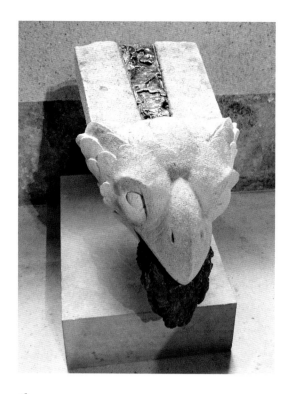

61
Gargoyles from Reims Cathedral,
choked with lead after the fire of 1914
Musée de Tau, Reims

sparks were blown around by the wind, and molten lead poured through the gutters "like rain" (Appendix, no. 1). Elements of this memorable description recall other accounts of church fires, such as that of Christ Church, Canterbury, penned by the monk Gervase in the late twelfth century. However, the *tabellarius*'s narrative is not polished or literary. It is clear, rather, that he struggled to find words to describe the terrifying and apocalyptic scene of the fire, an event whose trauma is partially captured for us by the gargoyles of Reims Cathedral (fig. 61), choked with lead that melted off the Cathedral roof after a German shelling in 1914.[67]

As at Canterbury, human efforts to limit the Rouen fire were useless, and it died down only when the wind suddenly dropped, leaving a scene of desolation. The tower was entirely destroyed except for its masonry base, which rose about four and a half metres above the apex of the roof, and part of its first storey (fig. 58). Fortunately, the stone vaults over the choir ensured that the roof fire did not spread to the interior, which was nonetheless badly damaged by the water used to quell the fire. Meeting later that day in the Archbishop's Palace, the chapter asked the superintendents of the *fabrica* to try and save as much of the old building as could be reused, but the damage was clearly too great for the *fabrica*'s immediate resources. Collecting extra money was a priority in the days that followed: some was donated by the canons themselves, the rest was collected from the inhabitants of the city (7 October), or requested from the abbots and abbesses of nearby monasteries (6 October), the Archbishop (12 October), and the King (17 October).[68] In November, the chapter also considered procuring an indulgence from the Pope as an additional way to finance the tower's reconstruction (Appendix, nos. 6 and 7).

Deciding how to proceed with the reconstruction was much more than an economic problem, however. On 27 October, the chapter received several proposals for the tower's reconstruction, submitted by different Rouen artisans (Appendix, no. 2). As the chapter was unwilling to take such an important decision alone, the project drawings were shown to the city councillors who administered civic matters in the Palais du Neuf Marché, a group formed by officials of the king and clergy and representatives of the local nobility and burghers (Appendix, nos. 3 and 5). The chapter also received Rouen's artisans in person on 20 November 1514 (Appendix, no. 4), asking them a question to which they would later obsessively return: should the crossing tower's spire be rebuilt in wood, as before, or should a more ambitious stone structure be erected in its place? Opinion was divided, and the chapter delayed its decision. On the following day, one of the canons went to the civic hall to pose the question not only to officials but also to the inhabitants of

BUILDING A CROSSING TOWER

the city more widely. Clearly, the tower's repair had become a significant issue, of concern to the municipality as a whole rather than just the chapter or clergy. On 29 November, the officials gave their answer, recommending that the tower be reconstructed "entirely of stones and masonry". The hopeful canons then met on 6 December to decide "once and for all" how to build the tower. Ignoring the decision of the civic officials, they agreed that the tower's pre-existing masonry should be repaired, extended by about one or two metres (four, five or six *pieds)*, but then topped with a wooden spire, as sumptuous as possible (Appendix, nos. 10 and 11). They ordered the procurator to set aside the *fabrica*'s regular income for this new construction, and nominated another lesser canon to collect the regular donations left by the faithful in the Cathedral's moneyboxes for the same purpose. Together with the consultation of civic officials and citizens, the existence of such boxes and the implied size of their revenues suggests that there was general lay interest in the reconstruction campaign.

The question of how to rebuild the tower was still far from decided. On 23 January, the woodworkers Nicholas Castille, Richard du Bosc and Johan Derbe were paid for a single drawing, presumably the result of their collaboration, representing a new project for the spire (Appendix, no. 14). In response, the canons asked more experienced masters – the carpenter Jean du Mouchel, who had appraised archiepiscopal buildings in several nearby towns since the 1480s, and the Cathedral's own master mason Roulland le Roux – to examine the drawing and advise whether the tower should be constructed according to this new proposal (Appendix, no. 15). Approving the drawing, the two experts emphasized that the tower should be built by carpenters ("*carpentatores*"): this recommendation probably makes a distinction between *huchiers* (woodworkers), who made furnishings such as choir stalls, and the carpenters in charge of building architectural scaffolding and large-scale wooden structures. What we know of the three masters' activities suggests that they were *huchiers*; nevertheless, the minutes describe them as "*architectores*", which may sound like the modern 'architect', but was in fact a term used to describe roofers, on the basis of a widespread etymological confusion between the Latin *tectus*, roof, and the Greek *tekton*, builder.[69]

The decision to build in wood led to the appointment of the carpenter Martin Desperrois as head of the works, and of Jean du Mouchel as his advisor (Appendix, no. 19). The chapter also acquired wood from the Parisian merchant Simon Aguiton, who specialized in material for large-scale works and was involved in the most significant Flamboyant worksites of the capital (Appendix, no. 20).[70] Nevertheless, the chapter deliberation confirming the conclusion of the sale also

discusses the renting of a cart for trasporting stone: although wood might have been envisaged as the main building material, it was never expected to be the only one.

In fact, repair of the pre-existing masonry – agreed on 6 December 1515 – continued throughout the following year. Slowly, the shadow of the tower regained its dominant position in the cityscape – all too dominant, as the canons discovered on 3 January 1516, when a group visiting the worksite realised that the repairs had extended far beyond what had been agreed the previous year, with the construction of almost three metres (nine *pieds*) of new masonry (Appendix, no. 22). The Cathedral's master mason, Roulland le Roux, was held responsible for this furtive construction, continued in outright disregard of the chapter's instructions. He was summoned before the chapter on the following day, but defended himself robustly, arguing that he had worked in agreement with Martin Desperrois, and for the good of the church (Appendix, no. 23). Rather than downplay his actions, Roulland stated boldly that a further seven and a half *toises* (14.58 metres) were necessary to make the tower truly sumptuous, or another fifteen *pieds* (4.86 metres) at the very minimum. The canons were not convinced, and it may be significant that in the deliberation of 18 January 1516 Roulland no longer appears as "master Roulland le Roux, mason" but just as "mason" (Appendix, no. 25). Nevertheless, in later deliberations Roulland resumes the usual title, suggesting that he retained his association with the Cathedral, and in fact he was requested to produce drawings (Appendix, nos. 31 and 32).

The unexpected discovery of Roulland's illicit building reopened the debate as to how the Cathedral's crossing tower should be constructed. On the one hand, Roulland's self-defence underlines the fact that great height was a desirable and even essential feature of any ambitious building in this period. As representatives of the Cathedral of the kingdom's most successful merchant city, the canons could hardly settle for a modest design. On the other hand, building tall towers was an expensive and dangerous enterprise. The canons must have wondered if the existing foundations, including the reinforced buttresses which Roulland had started to build at the four corners of the Cathedral, could sustain a stone construction that was already over fifty metres above ground. With no structural theory with which to assess this risk, extreme caution was necessary. Towers collapsed frequently, including the south tower at Sens in 1268, the crossing tower at Troyes in 1365, and the north tower at Bourges on 31 December 1506. Even if the news of this most recent collapse had not reached Rouen by 1514, the canons were surely aware of static problems at the nearby Abbey of St-Ouen and especially on the portal of the Cathedral itself.[71]

Questioning as many expert builders as possible was the key to good decisions, but, as the chapter had learnt with Roulland, experts could not always be trusted. The chapter therefore asked them to swear their opinions on the Gospels (Appendix, no. 26), and eventually decided to seek advice from experts in other cities, fearing connivance among the local ones. Their fears were well founded, given that builders generally worked as associates, as in the cases of Nicolas Castille, Richard Du Bosc and Jean Derbe (Appendix, no. 13), Jean du Bosc and Roulland le Roux (Appendix, no. 14) and perhaps Le Roux and Martin Desperrois (Appendix, no. 23).

The chapter's continuous indecision and the recourse to several external experts evoke the debates held at the Cathedral of Milan, founded in 1386 with the support of the first Duke of Milan, Gian Galeazzo Visconti. As part of the Duke's ambitious political strategy, the Cathedral was begun in an ambitious Gothic style rather than in the traditional Lombard idiom. Problems in the design established by a council of local masters became apparent as soon as construction began, leading the Milanese to seek help from beyond the Alps. Seven French and German masons were employed to advise on construction and then rapidly dismissed over the next fifteen years, and the Cathedral was eventually erected to a design mostly established by local masons. Conflicts were very evident during expertises, such as that of 1 May 1392, when Heinrich Parler von Gmünd, an expert from Swabia, was asked to comment on a series of questions, presented as alternatives or *dubia* (the same terminology as later used at Rouen, see Appendix, no. 29): Heinrich's opinions were always the opposite of the local masons'.[72]

The Milanese expertises highlighted radical differences between northern Italian and northern European masons: whilst the former strove to connect the Cathedral's plan and elevation in a geometrical relationship, the latter relied on good craftsmanship to ensure the stability of a building where geometry was not the only governing principle.[73] Nevertheless, comparison with Rouen confirms that strict geometrical interrelation between plan and elevation was not always a requirement, and that construction could proceed on an ad hoc basis: the tower's square plan was effectively established by the Cathedral's crossing, but its elevation was up for debate. The expertises at both Milan and Rouen also demonstrate that different building principles and rules of thumb could coexist in the absence of any shared engineering theory that might enable masons and patrons to evaluate static considerations.

Calling expertise after expertise rather than following Roulland le Roux's daring project, the Rouen canons proved themselves to be

62

A view of Rouen in 1525,
65 × 137 cm, from Jacques Le
Lieur's *Le Livre des fontaines*, 1526
Bibliothèque Municipale, Rouen,
Ms g 3–5

cautious architectural patrons. Yet their choice of external advisors reveals both knowledge and ambition: master masons were drawn from Chartres and Harfleur, where bell towers were being erected or completed with significant stone spires, and from Beauvais Cathedral. Here the famous Martin Chambiges had recently reopened a famously dangerous building site, at which work had ground to a halt in the 1340s. At Beauvais, Chambiges was dealing with the instability of the highest Gothic choir ever built, not yet braced by transepts. Thus, he had already encountered several issues also faced at Rouen, including problems of buttressing extant structures and of analysing old foundations without being able to excavate them completely. Nevertheless, Chambiges and Roulland were fundamentally equals: less than one year before the expertise in Rouen, the situation had been reversed and Roulland had been called by the canons of Beauvais to critique Chambiges's plans for the new construction (Appendix, no. 21). And the Rouen expertise was a complete success for Roulland, for the experts confirmed the strength of the Cathedral's foundations and recommended that a stone structure be erected (Appendix, no. 30).[74]

A month after this positive expertise, Roulland submitted a new drawing to the chapter, "*cum pictura*" or 'painted' (Appendix, no. 30). The canons approved this drawing, and asked the mason to proceed with building on that basis. Nevertheless, their decision was never fulfilled: hostility to the completion of a stone tower had been growing among the chapter, with canons Le Lieur, Challenge and Voysin

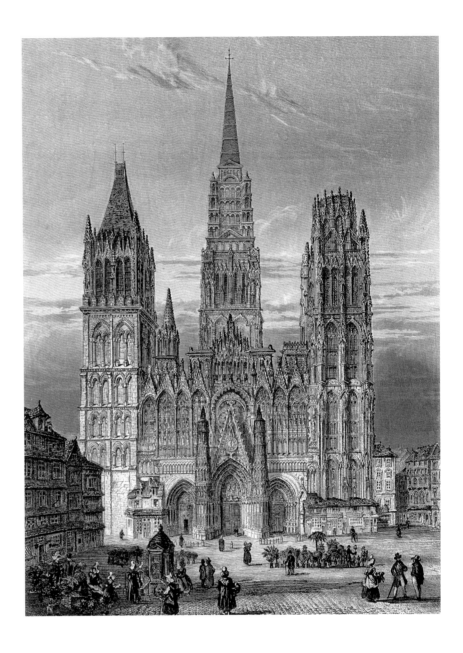

63
Rouen Cathedral in the
early 19th century
Coloured engraving
Bibliothèque des Arts
Decoratifs, Paris

particularly forthright in their opposition. Works were eventually halted
on 23 February 1517, when the decision was taken to finish the masonry
already underway and then close the works, expressing only a vague
intention to wait for Roulland to propose a new project (Appendix,
no. 32). Such a project never materialised, and the construction of the
tower was not mentioned again in the chapter accounts for several years.
The view of the city commissioned in 1525 for *Le Livre des fontaines*, a
survey of the city's water sources, depicts a temporary wooden belfry
on top of the unfinished crossing tower (fig. 62). Roulland retired one
year later, and the completion of the crossing tower was completely
abandoned until 1542, when a new master, Robert Becquet, designed a
classicizing wooden spire (fig. 63), which in turn was destroyed by fire

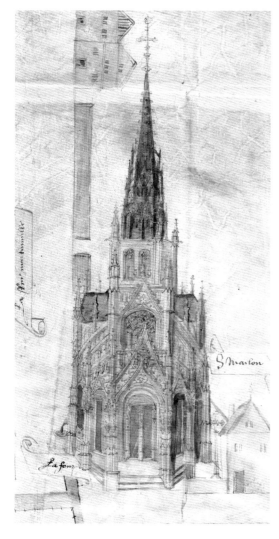

64

Detail of St-Maclou, from Jacques
Le Lieur's *Le Livre des fontaines*, 1526
Bibliothèque Municipale,
Rouen, Ms g 3-5

65

Model of the church
of St-Maclou, Rouen, before 1562
Papier maché, 95 × 44 × 71 cm
Musée des Beaux Arts, Rouen

in 1822.[75] Irreconcilable differences had thus paralysed one of the most ambitious building projects of the Renaissance Gothic.

The Rouen tower drawing and the Cathedral accounts

As we have seen, similarities between the decoration of the lowest levels of Rouen Cathedral's crossing tower and the Rouen tower drawing strongly suggest that the two may belong together. Thanks to the detailed nature of the chapter documents just explored, it is possible to go further and suggest an even more precise link between the construction history of the crossing tower and the drawing. Among the many drawings mentioned in the documents, the "painted portrait" of 9 March 1516 (Appendix, no. 30) is the most suggestive: as a drawing realised by Roulland le Roux, this piece fits well what has been suggested about the authorship of the Rouen tower drawing. Moreover, the description of this drawing as *"cum pictura"* evokes the use of grey wash in the tower drawing, a feature which is relatively rare among Gothic technical drawings. In addition to these similarities, the drawing fits very convincingly with the events outlined above.

Key evidence is provided by Roulland Le Roux's statement of 4 January 1516. When the chapter realised that the mason had built nine *pieds* of masonry rather than six, he defended himself by claiming to have worked with Martin Desperrois's advice. As the chapter had just agreed on the construction of a wooden structure over a low stone base, it is likely that Le Roux and Desperrois had been asked to collaborate on the design of a stone tower with a carpentry spire.

Although stones are clearly represented at the bottom of the drawing, the tree knots and flowers represented at the top are ambiguous. As we have seen, *Astwerk* was a popular technique in the Late Gothic period, and examples can be found in the environs of Rouen, yet the vegetal decoration of the spire in the Rouen tower drawing is especially compelling, and may indicate that it was to be built of wood. The idea is substantiated by evidence from the parish church of St-Maclou in Rouen, which suggests that the top of the drawing might actually show a carpentry construction, and give credence to Roulland's claims to collaboration. Begun around 1432, St-Maclou was completed in 1514 with the construction of a decorated wooden spire designed by Martin Desperrois. The success of this spire probably played a part in Desperrois's nomination as supervisor of the Cathedral's crossing tower. Although the original was destroyed in storms in the eighteenth century, its appearance is recorded in the above-mentioned *Livre des fontaines* (fig. 64) and in a remarkable papier-maché model of the church now conserved in Rouen's Musée des Beaux Arts (figs. 65

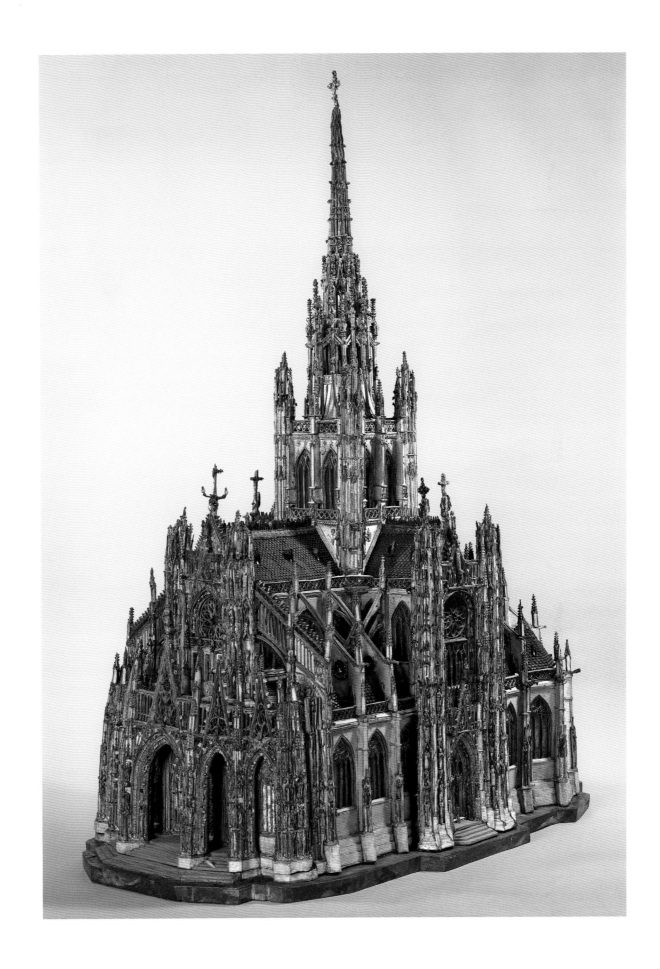

66

Detail of the Rouen tower drawing
showing the base of the spire

67

Detail of the model of the church
of St-Maclou, Rouen, before 1562
Papier maché
Musée des Beaux Arts, Rouen

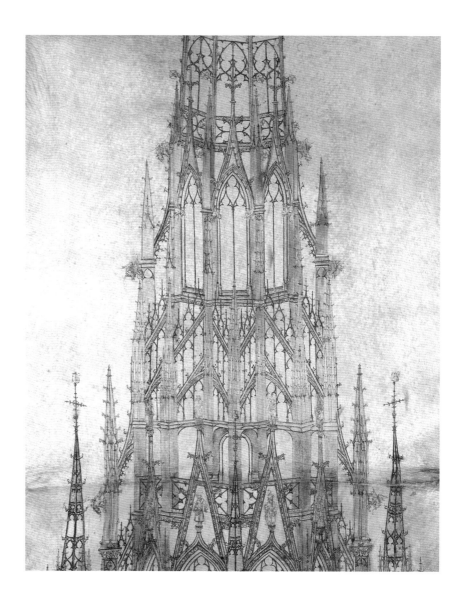

and 67), difficult to date with precision but certainly made before 1562.
Comparing the model with the Rouen tower drawing (fig. 66) reveals
many similarities, for example in the transition between octagonal
storeys of different orientation, in the openwork decoration of the
spire, and in minute details such as the connection between the spire's
structure and the cross which crowns it. Although the spire in the
Rouen tower drawing is far more ambitious than the one in the model,
the link between the two is undeniable.[76]

Despite collaboration between Le Roux and Desperrois, the relative
proportion of stone and wood envisaged by the master mason was very
different from what the chapter had approved. In ordering the master
mason to add four, five or six *pieds* to the tower's surviving first storey
(Appendix, no. 11), the canons probably wanted him to make nothing
more than a base for a wooden structure, similar to the *gradus* (step)

BUILDING A CROSSING TOWER

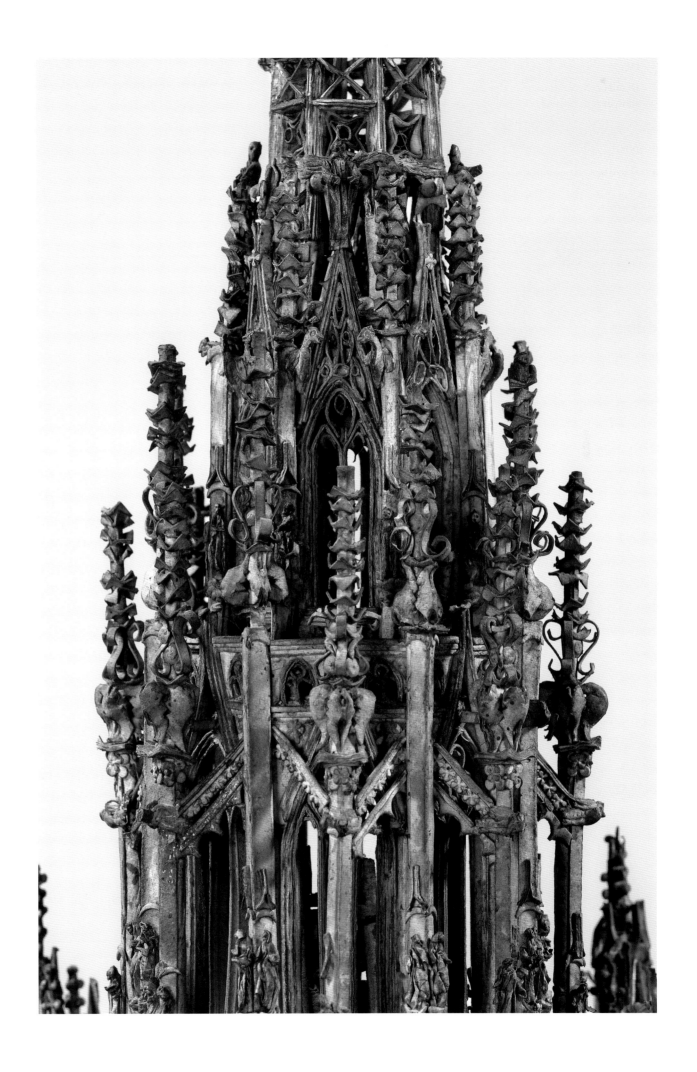

which was finally built before the closure of the construction site in February 1517. Building nine *pieds*, Roulland had in fact started a new storey on top of the one which had survived the fire. In other words, he had completed the six *pieds* required by the chapter for the repair and conclusion of the older storey, which thus stood roughly 12.5 m high, and started building the first courses of an entirely new storey. Once begun, construction on this new storey could not be interrupted without jeopardizing the magnificence of the tower, as the canons angrily remarked having finally caught him out in January 1516. Indeed, Roulland himself recognised that it was necessary to add at least fifteen *pieds* to the construction before building could stop. These fifteen *pieds* plus the three extra *pieds* which Roulland had already built equal 5.83 m. This is about half the height of the extant tower's second storey, and probably corresponds to what is shown in the view of Rouen in *Le Livre des fontaines* (fig. 62). Here a very narrow second storey is shown on top of the Cathedral's crossing tower, perhaps as high as the squat lower windows in the Rouen tower drawing. However, Roulland's preference was to continue building a further 7.5 *toises* over the three *pieds* which he had already realised against the chapter's orders, thus adding 16 metres above the first storey, which itself rose about 12.5 m (Appendix, no. 23). He presumably envisaged two new storeys, lower than the first storey, and proportionate with the tapering of the tower. This is precisely reflected in the drawing, where three square lower storeys diminish in size to form the basis for the octagonal spire (fig. 28).

It is more difficult to relate the drawing to the expertise of February 1516. This is because the records fail to specify whether the summoned experts recommended an entirely stone construction or, the preference for a wooden spire remaining unchanged since the decision of 6 December 1514 (Appendix no. 11), the debate now centred on the relative proportions of stone and wood. The "painted" drawing presented by Roulland in March 1516 showed a "new termination" for the tower: was this a new stone spire, rather than a wooden one? This is possible, but it is perhaps more likely that Roulland had simply re-worked the transition between wood and stone. In contemporary buildings such as the crossing tower of Évreux Cathedral (fig. 23) or the crossing tower at St-Maclou (as recorded in its model, fig. 65), an octagonal wooden spire is placed over a square stone tower with a rather abrupt transition between shapes and materials. In contrast, no strong divisions are visible in the Rouen tower drawing, while the absence of tree knots and flowers on the first octagonal storey suggests that this part of the structure was to be built in stone and to function as a base for the wooden spire above.

In conclusion, even if the documents are not clear about every detail of the project, there are nonetheless several connections between the Rouen tower drawing and the crossing tower project as presented by Roulland to the chapter on 8 March 1516. First, decorative details in the drawing are closely comparable to other buildings designed by this architect. In particular, the blind arches and foliate decoration which Roulland added to the crossing's first storey after the fire of 1514 gave it an overall arrangement very similar to that of the Rouen tower drawing. Similarly, sculptures represented in the drawing are very close to those carved by Pierre des Aubeaux for the second storey of the crossing tower. Secondly, the connection between the Rouen tower drawing and Roulland's crossing tower project is confirmed by Roulland's claims of 4 January 1516 that he had collaborated with Martin Desperrois, and supported by similarities between the model of St-Maclou's original wooden spire and the drawing. Moreover, Roulland's intention to build an extra seven and a half *toises* of masonry on top of the three *pieds* he had already built, and in addition to the six *pieds* necessary to repair the tower's lowest storey, corresponds very closely to the three-storey design seen in the square body of the Rouen tower drawing. Thirdly, Norman Late Gothic towers such as those at St-Maclou and Évreux were formed by a boxy stone base, topped with a clearly defined octagonal wooden spire; in the Rouen tower drawing there is instead a smooth transition between different shapes and materials. If the chapter's decision to top the spire with carpentry, taken "once and for all" in December 1514 (Appendix, nos. 10–11) still held good, then the "completely new termination" proposed by Roulland in March 1516 (Appendix, no. 31) must have shown a stone tower with a carpentry spire, as in the Rouen tower drawing. Lastly, the use of wash in the Rouen drawing confirms that this is the drawing "with painting", as specified in the chapter minutes and discussed in greater detail below.

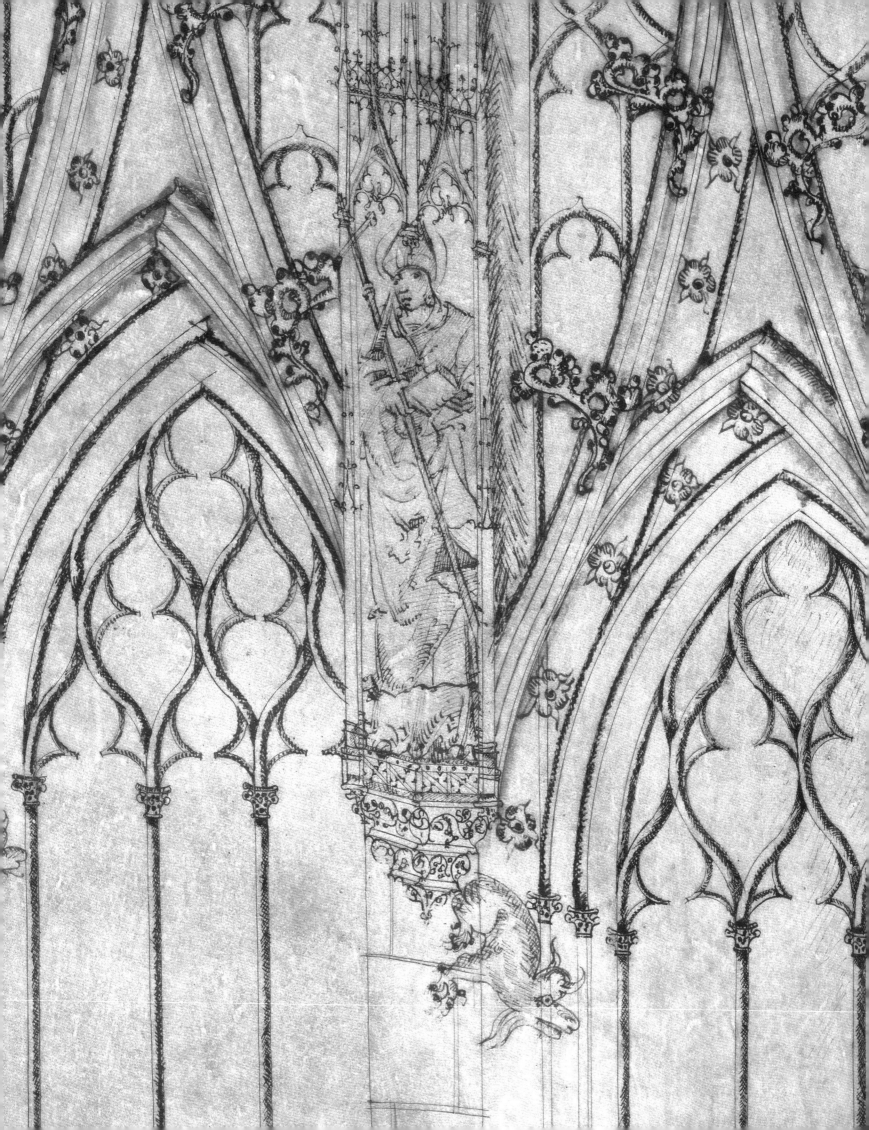

IV. Using and Describing Drawings

Drawing in Rouen

CONNECTING THE ROUEN TOWER DRAWING AND THE "PAINTED" piece of March 1516 answers many questions regarding the creation of the drawing, but perhaps not the most important: why was this project represented in such an uncommon way, almost unprecedented among surviving Gothic architectural drawings? To understand the drawing's function, it is necessary to look again at its context. From the documents discussed above it is clear that the practice of building in early sixteenth-century Rouen depended heavily on drawings, which were commissioned at different times in the process of building and for different reasons. But drawings are not only mentioned continually in the accounts, they also survive in uncommon numbers: while barely fifteen architectural drawings survive from all Gothic France (excluding Strasbourg, historically German-speaking and long claimed for the Holy Roman Empire), two examples survive from late medieval Rouen alone, with another drawing mentioned in the nineteenth century but since lost, and two further examples surviving from the nearby palace of Gaillon.[77]

Surviving drawings or documentary references to their use help nuance the distinctions commonly made between 'working' and 'presentation' drawings. As might be expected, presentation drawings are the type most commonly mentioned in documents, and also those most likely to survive over time. Nevertheless, Rouen offers clear examples of the use of working drawings, as at the parish church of Saint-Maclou, built on the basis of "a parchment where the church is represented completely" ("*un parchemin or leglise est gestee toute complecte*"), drawn by the Parisian master Pierre Robin in 1437, during a short visit to the city. Rather than a single drawing, this document must have contained all the plans and elevations necessary to construct the church in its entirety, enabling several different masons to build to Robin's specifications for more than fifty years without his return.[78] A comparable piece is the Cloisters drawing, already discussed as an example of geometrical design methods (fig. 36): attributed to a Rouen master, the drawing could have been used as a practical guide to construction thanks to the legibility of its underlying geometrical system.[79]

Examples from the 'presentation drawings' category are even more varied and numerous. Most frequently, such drawings were used to inform patrons of the intentions of an architect who had already been commissioned to undertake a certain work. An impressive example is the large-scale (1.87 × 0.57 m) drawing for Rouen Cathedral's wooden *cathedra* or archiepiscopal throne, commissioned from the woodworker Laurent Adam in January 1466 (fig. 68). Adam moved from Auxerre in Burgundy to undertake this commission, and was paid for the *cathedra*

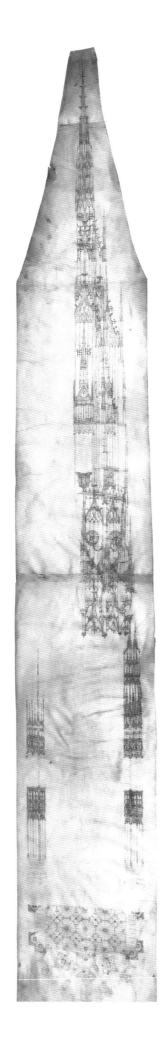

drawing and for the templates required by his workshop at the same time: clearly, he and the Cathedral chapter had already agreed on several details before the realisation of the drawing, which simply summarized them.[80] Consequently, it did not need to offer easily legible information, but rather provided technical information in a complete but condensed way, albeit with a suggestion of perspective. Thus the drawing features a plan of the *cathedra*'s baldachin at the bottom of the page (fig. 69), seemingly in connection with the elevation, but represents only half of the chair's symmetrical design (fig. 70). Another example of this use of drawings to confirm and communicate a pre-established design can be detected in chapter deliberations regarding the reconstruction of Rouen Cathedral's main portal, for on 6 March 1513 the chapter requested its master mason to send drawings to the archbishop in relation to an accepted design.[81]

Drawings were not only exchanged between the chapter and its masters: as in the case of Rouen's crossing tower, they could also be shared among the wider community. They enabled masters to evaluate one another's work, as when Roulland and Jean du Mouchel examined the proposal for the crossing tower by Castille, Du Bosc and Derbe (Appendix, no. 14). Like written documents, such drawings were easily transportable, and ensured that patrons did not have to depend entirely on the good references and verbal descriptions of experts with technical expertise. For example, drawings executed in connection with the Cathedral crossing tower were exchanged between the Cathedral chapter and civic officials (Appendix, no. 3).

USING AND DESCRIBING DRAWINGS

68–70

Drawing of a *cathedra* for Rouen
Cathedral (far left, with details
below and right), 1466
Ink on parchment, 187 × 57 cm
Réserves de la Cathédrale
de Rouen

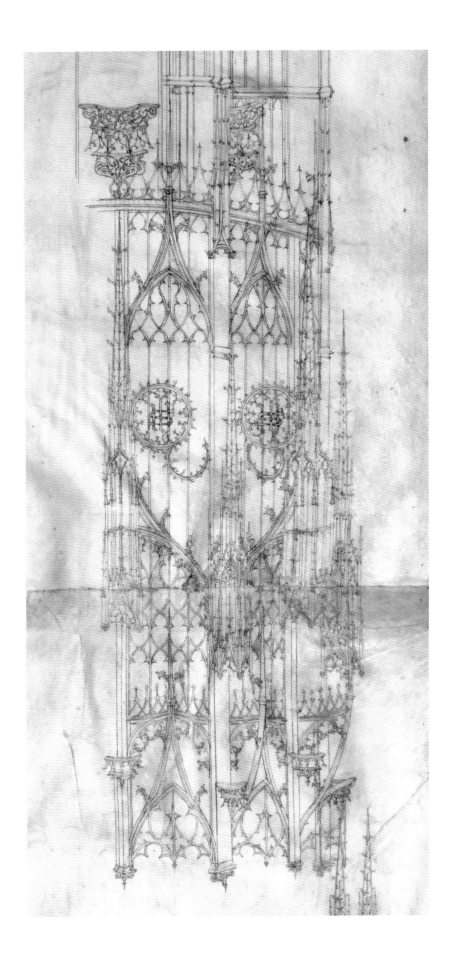

One of the most striking features of the records referring to Rouen's crossing tower is their revelation that drawings were used to help resolve disagreements. Drawings had already been used in this way during debates on the completion of the Tour de Beurre: around 31 March 1501, Roulland Le Roux's father and predecessor as the Cathedral's master mason, Jacques le Roux, was asked to design two projects, one with a spire and the other with a terrace.[82] Drawings executed in connection with the Cathedral crossing tower similarly functioned as the basis for discussion within the chapter. In particular, on 4 January 1416 Roulland was explicitly asked to draw up the design for the building which he had furtively started to construct "*ut deliberetur*", so that the chapter could discuss it (Appendix, no. 23).

Yet, as the circumstances clearly suggest, this last drawing (probably the Rouen tower drawing) was also intended as a tool for controlling the mason's work – more secure than an oral agreement, more succinct and readable than a long written contract. As the chapter's employee, Roulland ultimately had to yield to its decisions. Using perspective and ink washes, he could, however, try to make the drawing more appealing to patrons without architectural experience, striving to persuade them to approve his design, and ultimately to save his job. Yet at the same time, Roulland clearly had his own vision of how the tower should be built, and did not hesitate to follow his own scheme against the chapter's explicit intentions when working high up on the crossing, largely hidden by the dense scaffolding which must have surrounded the tower. Thus the drawing records Le Roux's creative self-assurance, which is to some extent symptomatic of the growing status of Late Gothic architects, as explored in the Introduction. Like the complex geometry of vault designs in pattern books, perspectival representation was a sophisticated design skill that could only be appreciated on paper (or in this case, parchment), not in relation to real buildings.

Describing drawings

Rouen Cathedral's chapter accounts also reveal how drawings were defined, described and conceived. Generally speaking, terms relating to moulds and templates used by workers are frequent in surviving records from the *fabrica* (as with Laurent Adam, mentioned above), but absent from the chapter minutes. Indeed, the documents that refer to the rebuilding of the crossing tower employ just two terms to describe drawings, *patronus* and *protractus*, and reveal no knowledge of comparable terms used in contemporary documents, such as *descriptio*, *liniamenta*, *devis* or *plana forma*. None of these terms had a completely

fixed meaning: *devis*, for example, could refer to a plan, an elevation or even just a written description.[83]

Of the terms found in Rouen's chapter minutes, *patronus* is the vaguer, and is presumably a Latin rendering of the French *patron* probably employed by the canons in their discussions. Connected to the Latin for father, it indicated a defender, founder or patron as well as an archetype or exemplar. In the latter sense the word could refer to two- or three-dimensional models used in a variety of different crafts. For example, in 1474 the sculptor Michau Colombe and the painter Jean Fouquet were paid for a small stone *patron* and a painted *patron* on parchment, which showed a tomb they had been commissioned to design. In the 1530s, the Italian architect Domenico da Cortona was paid for *patrons* and *levées de bois* (wooden barriers against floods) of the châteaux, bridges and windmills which he had designed for the king, François I. In both examples, *patron* referred both to a three-dimensional model and to a two-dimensional drawing. In a different example, from 1535, the painter Jehan Bacheler was commissioned to make *patrons* of new cannons and artillery pieces for the city of Douai.[84] Thus, the *patroni* commissioned by the chapter on various occasions should probably be interpreted as scale models in a general sense: given the survival of the papier-maché model of St-Maclou (fig. 67), it cannot be excluded that they were three-dimensional. The verbs used to refer to the making of these architectural representations in Appendix nos. 11 and 13, *construo* and *compono*, could mean 'to make up, fabricate' in both a physical and an abstract sense. In Appendix no. 3, instead, the document couples "*patronis*" with "*protractibus*", which has a more specific meaning in architectural draughtsmanship.

Protractus or the French equivalent, *portrait*, derive from the Latin *protrahere*. In classical Latin this verb meant 'to bring out with great effort', but it later came to mean 'to bring forth' or 'to reveal', a process associated with the act of creation, although not necessarily with drawing. Fairly widespread in early sixteenth-century construction accounts, the word also had a specific meaning in contemporary architectural jargon, indicating a drawn plan or, more typically, elevation – as opposed to the written *devis*, or the specific term for plan, *plana forma*.[85]

At the same time, the term *portrait* had a wider and more abstract meaning. It could signify a mental image, and, from the middle of the thirteenth century, a plan intended to guide an individual's actions, especially in the negative sense associated with the modern expression 'to have designs'.[86] Given the context in which he noted the chapter's decision to commission the Rouen drawing, the Cathedral's *tabellarius* could feasibly have had this latter connotation in mind.

Detail of the Rouen tower drawing
showing use of grey wash

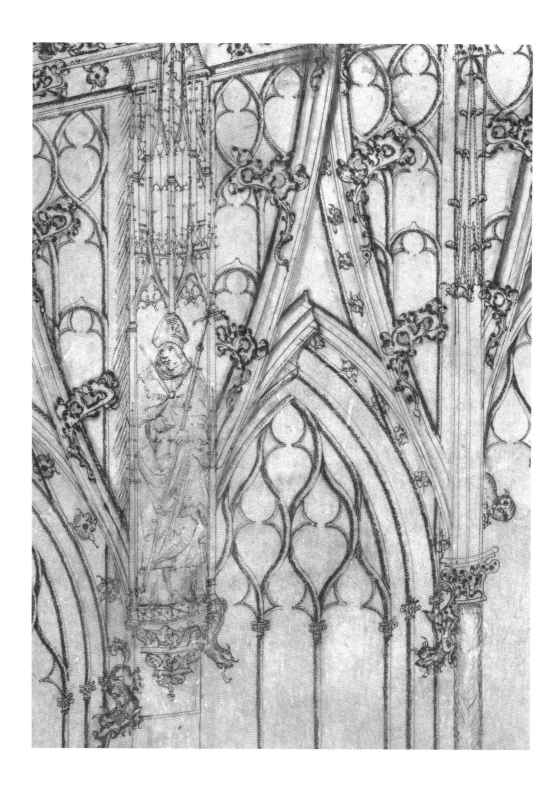

Centuries before the Rouen tower drawing was commissioned, the
word *protractus* had been used in Villard de Honnecourt's 'portfolio' to
indicate the geometrical rules of harmony and proportion which should
guide the hand of the artist in representing the human figure, everyday
objects and architectural designs. In this sense, it meant an object's
nature, its essential skeleton; when applied to people, the word denoted

USING AND DESCRIBING DRAWINGS

actions or poses in which one's character was most readily apparent. Although the author of the Rouen tower drawing elected not to follow standard architectural geometry, his creative use of perspective enabled him, in some ways, to offer a truthful *portrait* of the crossing tower – not a technical device, but a representation of the essential character of the tower as it would have been encountered in the everyday life of the city.[87]

When describing the drawing presented by Roulland to the chapter on 8 March 1516 (Appendix, no. 31), the *tabellarius* qualified it as "*cum pictura*", meaning 'with painting'. The association between the Latin term, the modern translation and the Rouen tower drawing is less straightforward than it might seem at first glance. Although the wash on the Rouen drawing was applied with a brush, would such a monochrome object qualify as "painted" (fig. 71)?

As in the case of the modern term 'painting', *pictura* referred both to the art of painting and to its practical processes and applications. Early Renaissance treatises such as Leon Battista Alberti's *De pictura* of 1435 placed great emphasis on drawing as the foundation of painting, as it enabled the artist to define perspectival relations and compose figures and scenes.[88] But *pictura* was also associated with colour. Evidence for this usage in Rouen is found in a contract signed between the city councillors and the clockmaker Colin Bernat in 1427, in which it was agreed that Bernat would make a clock, but was not responsible for the "painting on the face" of the clock.[89] In a somewhat clearer case from Montpellier in 1367, "*pictura*" was used to refer to images on a banner for Ascension Day, with the specification that the object should be "dyed well and sufficiently".[90] Nevertheless, *pictura* could also be connected with the ink wash technique used in the Rouen tower drawing (and strongly associated with architectural draughtsmanship during the Renaissance and later periods). For example, a treatise published in 1722 by the French engineer Nicolas Buchotte was entirely dedicated to the promotion and regulation of the use of ink wash in architectural drawing. Defining this technique as *lavis*, Buchotte criticized its description as "*painture*", which suggests the widespread contemporary usage of the latter term.[91] Closer to the Rouen tower drawing, the representation of the rampart of Méaulens (fig. 38) has been linked with the record of a payment to the painter Vincent Corroyer for "having made and painted the *devise*" ("*avoir faict et paint la devise*").[92] This drawing features no colour or wash, so if this record does indeed refer to it, *pictura* must describe its use of cross-hatching or, perhaps, perspective. The description of Roulland's drawing as "*cum pictura*" may thus refer to its having three-dimensionality as well as to its wash. The importance of this three-dimensionality will be further explored in the next chapter.

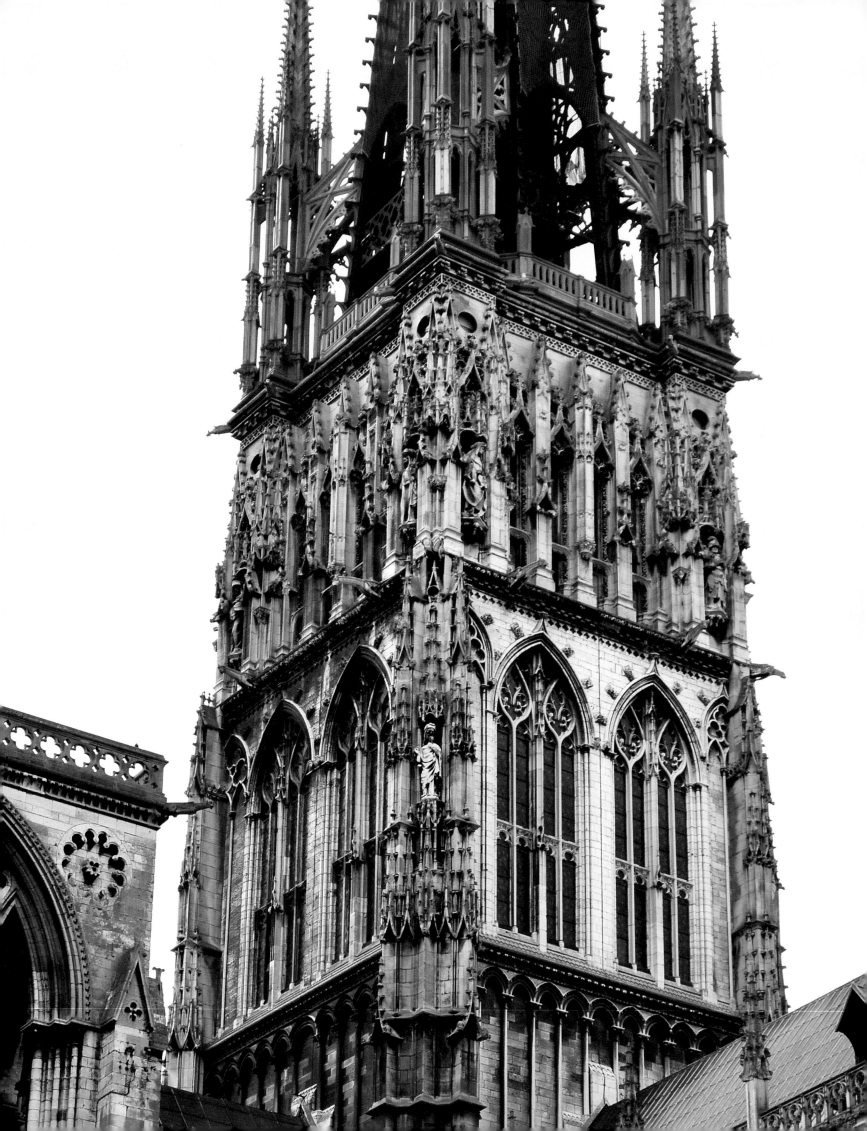

V. The Drawing in Perspective

A privileged viewpoint

THE USE OF PERSPECTIVE IN THE ROUEN TOWER DRAWING IS both rhetorical and carefully engineered, as we have seen. One of the tower's corners is placed precisely in the middle of the drawing, maximizing the difficulty of the reverse perspective; moreover, the observer is made to look down on a tower which would actually soar to a height of more than eighty metres. Although the recession of planes creates a convincing spatial relationship between the observer and the drawing, the relationship seems an unreal one – but is it? Although the drawing by no means portrays the tower in a realistic setting, it partially reflects the urban organization of early sixteenth-century Rouen.

Today, the Cathedral's crossing tower can properly be seen only from afar, and not from the square in front of the west façade (fig. 72). The tower would have been even less visible in the medieval period, when houses and small shops were distributed around the Cathedral walls, and the *parvis* in front of the Cathedral's entrance was separated from the rest of the square by a wall.[93]

Nevertheless, the great building projects of early sixteenth-century Rouen were complemented by efforts to open up and beautify the city, first in 1508 with the paving of the principal streets, and later by the outlawing of practices such as *avant-solier* and *encorbellement*, whereby houses were enlarged into the street at ground or first-floor level. These changes had a major impact on busy streets, such as the rue St-Romain, north of the Cathedral, which ran along the Archbishop's Palace and was used for the city's most important liturgical processions on the feast of St Romain.

One section of this street, just north of the cathedral square, is known as the Cour d'Albane, and is still partially occupied by the thirteenth-century Cathedral cloister, of which only the south and east walks were ever completed. In the later Middle Ages, it was a semi-public space offering easy access from the canons' houses to the Cathedral's treasury, library and chapter house. It was also close to the Cour des Libraires, a space in front of the Cathedral's north portal that was rented out to booksellers and other merchants during the late fifteenth and early sixteenth centuries. Clearly an important and busy space, the Cour d'Albane offered the closest complete view of the Cathedral crossing tower, seen at approximately the same angle as shown in the Rouen tower drawing, albeit from a much lower perspective (facing page).[94]

The beautification of Rouen's urban spaces at the beginning of the sixteenth century was also connected to the political importance of the city and with the increasingly splendid royal entries, the ceremonies which accompanied a new king's arrival in the cities of his realm. From the entry of Charles VIII in 1485 to that of Charles IX in 1563, royal

72

Rouen, Cathédrale Notre-Dame,
view of the façade from the Place de
la Cathédrale

73

Drawing of a crossing tower,
1st half 16th century, pen and ink
on parchment, 130.8 × 34.6 cm
Bibliothèque nationale de France,
Paris, inv. no. VA-440-FT 6

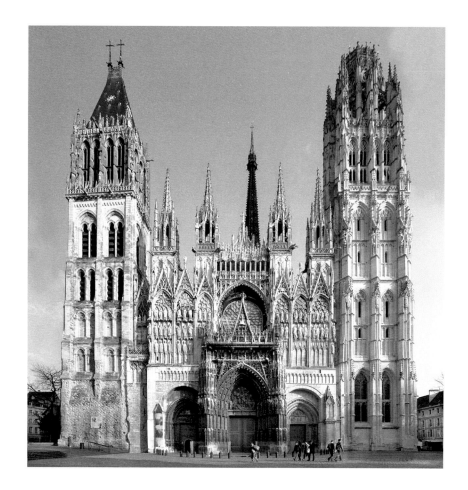

visits all followed the same, well-established route through the city
centre. The king and his retinue arrived from Grandmont, on the left
bank of the Seine, then crossed the Grand Pont, the city's only bridge,
leading to the city's entrance, the rue du Grand Pont, and eventually the
cathedral square. Each civic landmark, including the city's bell tower,
was the site of theatrical performances and triumphs. Approaching the
city from the south bank of the river and the Grand Pont afforded views
of the Cathedral from the south-west, partially similar to the point
of view of the Rouen tower drawing. Views of the city also invariably
represent it from the hills to the south-west, as in *Le Livre des Fontaines*
(fig. 62) and the *Civitates Orbis Terrarum* of 1572–1617.[95]

Towers were not only there to be looked at, however: they were also
climbed. An anonymous Milanese merchant who probably visited Rouen
around 1517 noted, for instance, that "the cathedral church is extremely
beautiful and 200 paces long, and 55 wide, and has an extremely
beautiful façade and two extremely tall bell towers, from which one
can see the city, and they are 402 steps high". He also mentioned the
destruction of the crossing tower in the fire of 1514, remarking that

THE DRAWING IN PERSPECTIVE

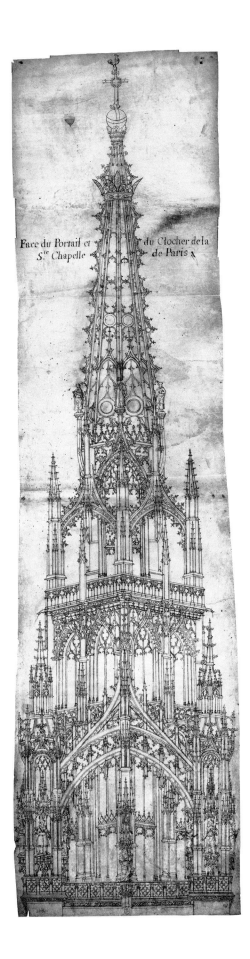

Face du Portail et du Clocher de la
S.te Chapelle de Paris

the crossing tower was still under construction but that a stone tower would eventually take the place of the half-stone, half-wood building which existed before the fire. Travelling in the following year, Antonio de' Beatis, the famous personal secretary to Cardinal Luigi d'Aragona, similarly remarked on the unfinished status of the tower. As the first of these accounts suggests, climbing the Cathedral's two western towers afforded a magnificent view of the crossing, or rather, of the destruction caused by the fire of 1514. In fact, the drawing's viewpoint mimics very precisely the view of the Cathedral's modern crossing tower presented from the passage at the base of the crown of the Tour de Beurre (figs. 74 and 75). It is not clear if ordinary visitors would have been permitted to climb the narrow staircase that gave access to this final storey, but it seems unlikely that its rich sculptural decoration was enjoyed only by those working on the Cathedral. Indeed, the anonymous merchant and Antonio de' Beatis both describe the Georges d'Amboise bell, which hung in the storey just below the crown of the Tour de Beurre.[96]

Perspective and rhetoric

Although the perspective of the Rouen tower drawing can be related to the topography of contemporary Rouen, the use of a 45° point of view in crossing tower projects is not unparallelled in Renaissance Gothic. For example, a similar viewpoint was used in the drawing of a crossing tower (fig. 73) recently studied by Dany Sandron, who has shown that it relates to the Cathedral of Orléans in the 1530s, and not to the Sainte-Chapelle in Paris. Minimal spatial clues were also used in the drawing for the wooden *cathedra* of Rouen Cathedral discussed in Chapter IV. More technical and schematic than the Rouen tower drawing, this design does not use hatching or wash to emphasize different components. Nevertheless, it contains elements of perspective, visible in the distorted arches at the bottom right, and in the downward curve of the lines distinguishing the different storeys of the baldachin (fig. 69).[97]

Whilst the *cathedra* drawing is economical and requires some technical knowledge to be interpreted correctly, the Rouen drawing relies on impact rather than precision. As already noted, there are many mistakes in the construction of the perspective, which suggest that Roulland le Roux was not fully acquainted with the theoretical principles of perspectival representation. Perhaps he had learned his skill from handbooks such as the *Kunstbücher*, illustrated manuals for apprentices, which taught the rules of representation and perspective and became popular in Germany during the first half of the sixteenth century. These treatises describe simplified systems of perspectival projection based on the use of templates or string to represent receding

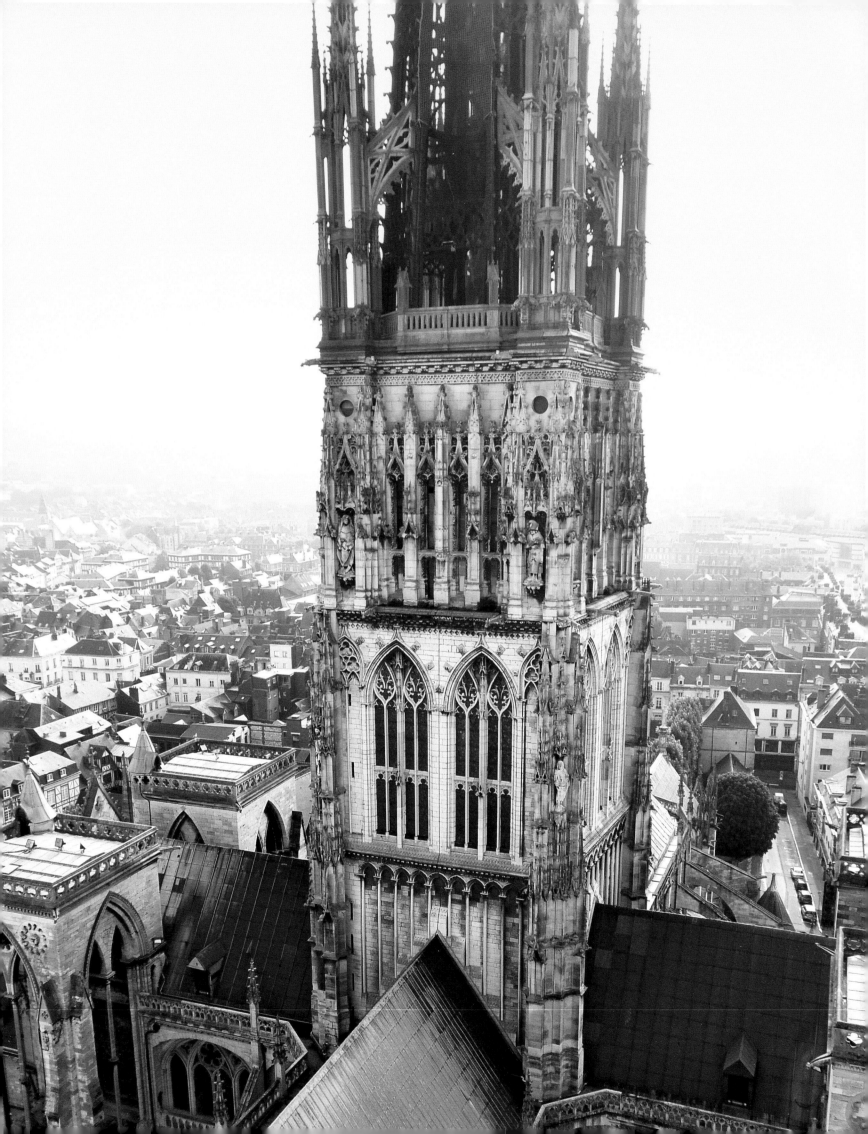

74
Rouen, Cathédrale Notre-Dame,
view of the crossing tower from the base
of the crown of the Tour de Beurre

75
Detail of the Rouen tower drawing
showing first and second storeys

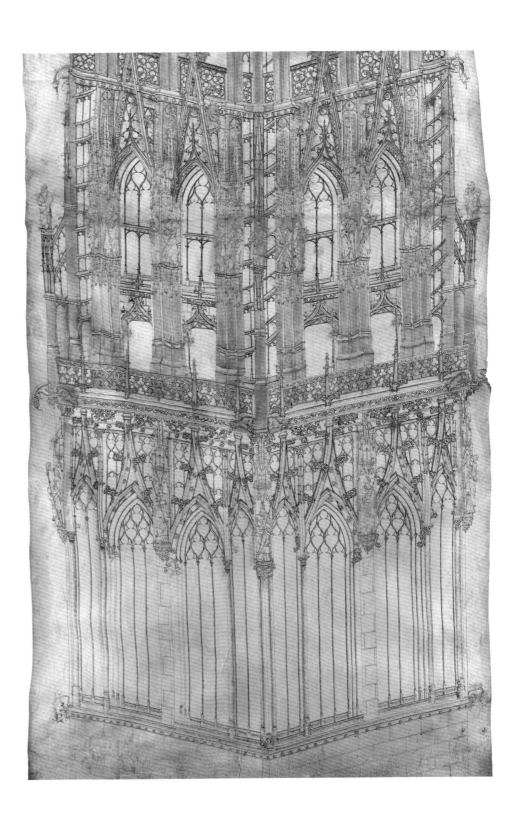

lines. In their manuals of 1543 and 1571, Augustin Hirschvogel and Hans Lencker stressed the utility of such techniques to stonecutters and architects. Lencker also emphasized that it was necessary to draw plans of buildings before representing them in perspective with the help of templates. The technique was well-suited to architects, he argued, because they were skilled at drawing plans and could use perspective as a way of showing an entire structure, rather than just one side or façade, as in an orthogonal drawing.[98]

This possibility of representing structures in their entirety was exploited in several Renaissance drawings, as in the striking view of St Peter's in Rome drawn by Baldassare Peruzzi at the beginning of the sixteenth century (fig. 76). Despite its virtuoso complexity, this drawing presents many uncertainties, and it may be that the drawing was intended to reveal problematic spatial relationships amongst the building's different parts. Indeed, it was made when the design for the choir and ambulatories of St Peter's was not yet fully determined, owing to fundamental disagreements between Pope Julius II and the project's head architect, Donato Bramante. Reflecting the arrangement and dimensions championed by Bramante, the drawing perhaps attempted to give a concrete and persuasive appearance to the architect's designs.[99]

Persuading the Cathedral canons would have been equally important for Roulland when he presented his drawing to the chapter on 8 March 1516. Having been caught disobeying the chapter's orders, he needed to convince the canons of his skill, and of the viability of the project he had already started to build. This would have been all the more important given the danger and expense of building large stone towers, and the significance of the project for the city as a whole. Roulland responded by using perspective and a carefully chosen viewpoint to represent his tower project as if already built. Representing the tower in the three dimensions, his drawing differed from more traditional orthogonal Gothic drawings in which, as Bork has recently argued, space originated as a "by-product" of the intersection between a flat plan and a flat elevation.[100] At this 'presentation drawing' stage, and probably throughout the project, spatial thinking was clearly essential to Roulland's visualization of the tower, though not therefore incompatible with Gothic design methods. By virtue of its divergence from Gothic drawing traditions and debt to Renaissance architectural and pictorial theory, the drawing offered a persuasive, rhetorical assertion of Roulland's confidence and innovative skill. His capacity for Flamboyant design was equal to Martin Chambiges's, but he also contributed to the construction of the Renaissance Bureau des Finances in Rouen in 1509–10 and would later design the all'antica tomb of Georges I d'Amboise (1515–25; fig. 77).

76

Perspective drawing of St Peter's, Rome,
53.8 × 67.7 cm, c. 1506
Gabinetto dei Disegni e delle Stampe degli
Uffizi, Florence, inv. GDSU, cat. A, n. 2

77
Rouen, Cathédrale Notre-Dame,
Tomb of Georges I d'Amboise, 1515–25

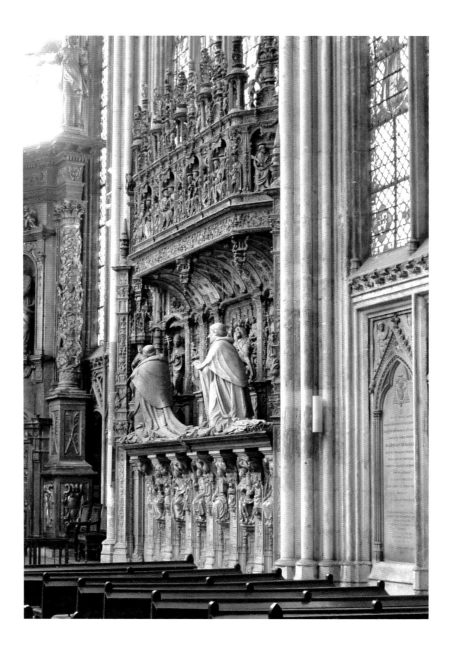

Early Renaissance architectural theorists were well aware of perspective's rhetorical power. For example, although Alberti's *De pictura* contains the first written account of pictorial perspective, his *De re aedificatoria* proscribed architects from using it, recommending orthogonal drawing with true dimensions and angles instead. Indeed, orthogonal drawing would eventually return to dominate architectural representation, as was true in Italy by the mid sixteenth century.[101] Of course, Roulland le Roux's tower drawing would also 'fail', and the project he so skilfully designed would never be actually built. And yet the chapter and the drawing's subsequent owners were clearly impressed, and the Rouen tower drawing has been preserved in excellent condition for precisely five hundred years at the time of writing.

Conclusion

PREVIOUSLY UNKNOWN TO SCHOLARS, THE ROUEN TOWER DRAWING reappeared in 2014. Without a signature, date or obvious connection to any extant Gothic tower, it was unclear in what circumstances this extraordinary drawing had been created, by whom or when. But the inscription on its reverse links it to early modern Rouen, and close visual parallels suggest that Roulland le Roux, master architect at Rouen Cathedral, conceived the design in the early sixteenth century. In particular, the drawing can be linked to the fire of 1514 and the troubled reconstruction of the Cathedral's crossing tower, and thus to a rich series of documents which clarify very precisely what was at stake when Roulland conceived an ambitious new project for it.

As revealed by the documents contained in the Appendix to this book, the Rouen tower drawing was not shaped by Roulland's vision. The tower's construction emerged instead from collaboration between the city's masons, carpenters, Cathedral canons and civic authorities. Unlike Renzo Piano's purportedly casual sketch, the Rouen tower drawing offers only a partial glimpse into the architect's mind. Instead, the drawing and the documents that refer to it offer a series of remarkable insights into the buzzing creative atmosphere of a Renaissance Gothic city, where innovative building projects were being erected with the expertise of the very best local and foreign architects of the time.

Roulland was certainly one of them: confident of his skill, he did not hesitate to build the crossing tower to his own designs, even in flagrant disregard of the chapter's instructions. Yet he was also the chapter's employee, ultimately required to follow its orders. Caught building behind the backs of the Cathedral canons, Roulland drew up a huge and impressive vision of the tower he wished to build, one which commanded the most sophisticated contemporary motifs and techniques, and which would persuade the canons to let him continue, almost seducing them into believing that they contemplated a real tower. This is the Rouen tower drawing. Five hundred years after it was first shown to the canons at Rouen, it has lost none of its compelling power.

Notes

1 Tom Lamont, 'Renzo Piano: My Inspiration for the Shard', *The Guardian*, 30 December, 2012, http://www.theguardian.com/artanddesign/2012/dec/30/shard-renzo-piano-inspiration; on the construction of the Shard, see 'The Vision', *The Shard*, http://www.the-shard.com/shard/the-vision/, accessed 7 November 2015.

2 Annette Spiro, 'The Working Drawing: an Alphabet of Its Own', in Annette Spiro and David Ganzoni (eds.), *The Working Drawing: The Architect's Tool* (Zürich, 2014), p. 6.

3 Louis Boyd, 'Constructions for Posterity: The Architectural Drawings of Cologne Cathedral' (MA dissertation, Courtauld Institute of Art, 2014), pp. 3–29.

4 On templates, see Tracy E. Cooper, '*I modani*: template drawings', in Henry Millon and Vittorio Magnago Lampugnani (eds.), *The Renaissance from Brunelleschi to Michelangelo: The Representation of Architecture*, exh. cat., Palazzo Grassi, Venice (London, 1994).

5 Matthäus Roriczer, 'Büchlein von der Fialen Gerechtigkeit (Booklet Concerning Pinnacle Correctitude)', in Matthäus Roriczer and Hanns Schmuttermayer, *Gothic Design Techniques: The Fifteenth-Century Design Booklets of Mathes Roriczer and Hanns Schmuttermayer*, ed. Lon Shelby (Carbondale, 1977), p. 47.

6 Ibid., pp. 46–49; for a complete overview of Gothic geometry and Gothic design methods, see Robert Bork, *Geometry of Creation: Architectural Drawing and the Dynamics of Gothic Design* (Farnham, 2001).

7 Bork, *Geometry of Creation*, p. 13 and passim.

8 For more information on this drawing: Hans Josef Böker, *Architektur der Gotik. Ulm und Donauraum: ein Bestandskatalog der mittelalterlichen Archtekturzeichnungen aus Ulm, Schwaben und dem Donaugebiet* (Salzburg, 2011), p. 189, cat. 97; for the history of the church of Our Lady, Friedhelm Wilhelm Fischer, 'Die Stadtpfarrkirche zur Schönen Unserer Lieben Frau', in Theodor Müller, Wilhelm Reissmüller, and Siegfried Hofmann, *Ingolstadt: Die Herzogsstadt, Die Universitätsstadt, Die Festung* (Ingolstadt, 1974).

9 Bork, *Geometry of Creation*, p. 230. For the collections of drawings in Vienna, see Böker, *Architektur der Gotik: Bestandskatalog der weltgrössten Sammlung an gotischen Baurissen (Legat Franz Jäger) im Kupferstichkabinett der Akademie der bildenden Künste Wien: mit einem Anhang über die mittelalterlichen Bauzeichnungen im Wien Museum Karlsplatz* (Salzburg, 2005). On other German examples, Böker, *Architektur der Gotik. Ulm und Donauraum*; Böker, *Architektur Der Gotik. Ein Bestandskatalog der mittelalterlichen Architekturzeichnungen: Rheinlande* (Salzburg, 2013).

10 Böker, *Architektur der Gotik. Ein Bestandskatalog der mittelalterlichen Architekturzeichnungen: Rheinlande*, p. 101, no. 16.829; Sergio Sanabria, 'A Late Gothic Drawing of San Juan de Los Reyes in Toledo at the Prado Museum in Madrid', *The Journal of the Society of Architectural Historians*, vol. 51, no. 2 (1992), pp. 161–73, with a detailed analysis of the drawing's three-dimensionality; Dany Sandron, 'Un projet de flèche gothique pour la cathédrale d'Orléans (vers 1530) chez Robert de Cotte', *Hommages au professeur Claude Mignot* (Paris, forthcoming); Pieter Martens, 'An Early Sixteenth-Century Drawing of Two Bulwarks at Arras', *Fort*, vol. 27 (1999), and Alain Salamagne, 'Deux plans inédits d'Arras', *Histoire et Mémoire*, no. 26 (2001).

11 Filarete, *Filarete's Treatise on Architecture*, ed. John R. Spencer (Ann Arbor, Mich., 1990), p. 102 (Book VIII, fol. 59v).

12 Giorgio Vasari, *The Lives of the Artists*, trans. by Julia Conway Bondanella and Peter Bondanella (Oxford, 1991), p. 110.

13 Henri Zerner, *Renaissance Art in France* (Paris, 2003), p. 16; Ethan Matt Kavaler, *Renaissance Gothic: Architecture and the Arts in Northern Europe, 1470-1540* (New Haven, 2012), p. 242.

14 On the pendant vault of Caudebec en Caux, see Antoniette Sangouard and Jacques Sangouard, 'Les sources normandes dans l'achèvement de la cathédrale d'Albi à la fin du Moyen Âge', *Bulletin Monumental* vol. 169, no. 4 (2011), p. 324; Henri Jullien, 'Clé de voute de a chapelle de la Vierge à Caudebec-en-Caux,' *Les Monuments historiques de la France*, vol. 1, no. 3 (1955). On Beauvais: Meunier, *Martin et Pierre Chambiges: architectes des cathédrales flamboyantes* (Paris, 2015), p. 219; on Prague: Kavaler, *Renaissance Gothic*, p. 140.

15 Kavaler, *Renaissance Gothic*, pp. 5, 33–34, 47–68, 96, 201, 119–229; Jacques Baudoin, *La sculpture flamboyante en Normandie et Ile-de-France* (Florat, 1992), pp. 65–68; Felipe Pereda, 'The Shelter of the Savage: 'From Valladolid to the New World'', *Medieval Encounters*, vol. 16, nos 2–4 (2010), pp. 268–359.

16 Kavaler, 'Renaissance Gothic: Pictures of Geometry and Narratives of Ornament', *Art History*, vol. 29, no. 1 (2006), p. 33; Kavaler, *Renaissance Gothic*, 72–96; Meunier, *Martin et Pierre Chambiges*, pp. 188–98.

17 Kavaler, *Renaissance Gothic*, 57–59; François Bucher, *Architector: The Lodge Books and Sketchbooks of Medieval Architects* (Norwalk, Conn., 1979), pp. 195–99.

18 Robert Branner, 'Villard de Honnecourt, Reims and the Origin of Gothic Architectural Drawing', *Gazette ses Beaux-Arts* (1963), p. 140; Peter Kurmann, 'Architecture, vitrail et orfèvrerie. À propos des premiers dessins d'édifices gothiques', in Robert Tollet (ed.), *Représentations architecturales dans les vitraux: colloque international, Bruxelles, Palais des académies, 22-27 août 2002* (Liège, 2002), pp. 32–41.

19 Franklin Toker, 'Gothic Architecture by Remote Control: An Illustrated Building Contract of 1340', *The Art Bulletin* vol. 67, no. 1 (March 1, 1985), pp. 67–95.

20 Meunier, *Martin et Pierre Chambiges*, 72; Nikolaus Pevsner, 'The Term 'Architect' in the Middle Ages', Speculum, vol. 17, no. 4 (1942), especially p. 561.

21 Henri Zerner, *Renaissance Art in France*, p. 20.

22 Pierre-Yves le Pogam, 'Le paysage artistique vers 1500: les mots et les choses', in Geneviève Bresc-Bautier, Thierry Crépin-Leblond and Elisabeth Taburet, *France 1500: entre Moyen Age et Renaissance*, exh. cat., Grand Palais, Paris (Paris, 2010), pp. 31–37.

23 Paul Crossley, 'The Return to the Forest: Natural Architecture and the German Past in the Age of Dürer', in *Künstlerischer Austausch: Artistic exchange, Akten des XXVIII internationalen Kongresses für Kunstgeschichte* (Berlin, 2003), pp. 71–77.

24 Bork, 'The 'Unspeakable' Logic of Gothic Architecture', in Monique Chatenet (ed.), *Le Gothique de la Renaissance: actes des quatrième Rencontres d'architecture européenne, Paris, 12–16 juin 2007* (Paris, 2011), p. 188.

25 Bork, 'Gothic Drawing and the Shaping of Space', in Meredith Cohen and Fanny Madeline (eds.), *Space in the Medieval West: Places, Territories, and Imagined Geographies* (Farnham, 2014), p. 431.

26 Crossley, 'The Return to the Forest', in *Künstlerischer Austausch*, pp. 71–77; Joseph Rykwert, *On Adam's house in Paradise: the idea of the primitive hut in architectural history* (New York, 1972), pp. 93–141.

27 Henry Preston Rossiter, 'Maximilian's Triumphal Arch', *Bulletin of the Museum of Fine Arts*, vol. 49, no. 278 (1951), p. 98.

28 Larry Silver and Elizabeth Wyckoff (eds.), *Grand Scale: Monumental Prints in the Age of Dürer and Titian*, exh. cat., Davis Museum and Cultural Center, Wellesley (New Haven, Conn., 2008), pp. 94–96; Susan Dackerman (ed.), *Painted Prints: The Revelation of Color in Northern Renaissance & Baroque Engravings, Etchings, & Woodcuts*, exh. cat., The Baltimore Museum of Art, Baltimore (University Park, Penn., 2002), pp. 123–25, no. 14.

29 Bork, *Great Spires: Skyscrapers of the New Jerusalem* (Cologne, 2003), p. 5.

30 On spires in general, see Bork, *Great Spires*. On Strasbourg, Charlotte A. Stanford, 'Architectural Rivalry as Civic Mirror: The Dominican Church and the Cathedral in Fourteenth-Century Strasbourg', *Journal of the Society of Architectural Historians*, vol. 64, no. 2 (1 June 2005), p. 186. On Florence, Marvin Trachtenberg, *Dominion of the Eye: Urbanism, Art, and Power in Early Modern Florence* (Cambridge, 2008), p. 81. On Verneuil sur Avre, Baudoin, *La sculpture flamboyante en Normandie et Ile-de-France*, p. 25.

31 Jonathan Bikker, 'Cologne, the 'German Rome,' in Views by Berckheyde and van Der Heyden and the Journals of Seventeenth-Century Dutch Tourists', *Simiolus: Netherlands Quarterly for the History of Art*, vol. 32, no. 4 (2006), p. 285.

32 François Verdier, 'Le Beurre et la Couronne', *In Situ*, no. 1 (2001), p. 29.

33 Bork, *Great Spires*, pp. 7, 358.

34 Achim Timmermann, 'Microarchitecture in the Medieval West, 800–1550', in *The Cambridge History of Religious Arcihtecture of the World* (New York and Cambridge, forthcoming). On Adam Kraft's self-portrait, Kavaler, *Renaissance Gothic*, p. 166.

35 Timmermann, 'Sacrament Houses and the Vision of God in the Age of 'Renaissance Gothic' C. 1475–1525', in Monique Chatenet (ed.), *Le Gothique de la Renaissance*, p. 315.

36 Timmermann, *Real Presence: Sacrament Houses and the Body of Christ, c. 1270-1600* (Turnhout, 2009), especially pp. 92–95 and 126–29 for the Leuven and Heilbronn examples.

37 On parchment in general, see Christopher De Hamel, *Scribes and Illuminators* (Toronto, 1992); Eltjo Buringh, *Medieval Manuscript Production in the Latin West: Explorations with a Global Database* (Leiden, 2010), especially p. 431. On the technique of Gothic architectural drawings, Peter Völke, 'Die Zeichentechnik der Gotik: Materialien, Werkzeuge und Zeichenvorgang', in Böker, *Architektur der Gotik. Rheinlande* (Salzburg, 2013), pp. 15–25.

38 Diane E. Booton, *Manuscripts, Market and the Transition to Print in Late Medieval Brittany* (Farnham, 2010), p. 17; Stephen Murray, 'The Gothic Facade Drawings in the "Reims Palimpsest"', *Gesta*, vol. 17 (1978), p. 51.

39 Völke, 'Die Zeichentechnik der Gotik: Materialien, Werkzeuge und Zeichenvorgang', in Böker, *Architektur der Gotik. Rheinlande*, p. 15.

40 Böker, *Architektur Der Gotik. Rheinlande*, pp. 114ff., cat. 31.

41 Thierry Crépin-Leblond, 'Jubé de la cathédrale du Mans', in Bresc-Bautier, Crépin-Leblond, and Taburet, *France 1500*, p. 60, cat. 2.

42 Bork, *Geometry of Creation*, 22.

43 Robert Bork has recently formulated an alternative perspective, suggesting that a geometrical framework comparable to that of other Gothic orthogonal drawings underpins the Rouen tower example. His interpretation will be presented and published shortly and, no doubt, deepen our understanding of the piece.

44 Pieter Martens, 'An Early Sixteenth-Century Drawing of Two Bulwarks at Arras', footnote 10; Alain Salamagne, 'Deux plans inédits d'Arras', pp. 2–3.

45 Sergio Sanabria, 'A Late Gothic Drawing of San Juan de Los Reyes in Toledo at the Prado Museum in Madrid', *The Journal of the Society of Architectural Historians*, vol. 51, no. 2 (1992), pp. 167–68.

46 Étienne Hamon, 'Le dessin et l'architecte au soir de l'âge gothique: le projet de portail du fonds de l'hôtel-dieu d'Amiens', in Hamon, Dominique Paris-Poulain, and Julie Aycard (eds.), *La Picardie flamboyante: arts et reconstruction entre 1450 et 1550* (Rennes, 2015).

47 Henri de Frondeville and Alexandre Bigot Monville, *Les présidents du Parlement de Normandie, 1499–1790. Recueil généalogique établi sur la base du manuscrit Bigot, de la Bibliothèque de Rouen* (Rouen, 1953), p. 477.

48 Joseph-André Guiot, *Les Trois Siècles palinodiques, ou, Histoire générale des palinods de Rouen, Dieppe, Etc.*, ed. Albert Tougard (Rouen, 1898), p. 65.

49 Edmé-François Gersaint, *Catalogue raisonné d'une collection considérable de diverses curiosités en tous genres contenues dans les cabinets de Feu Monsieur Bonnier de La Mosson, Bailly et Captaine des chasses de la Varenne des Thuilleries & Ancien Colonel du Regiment Dauphin* (Paris, 1744), pp. 30, 210 and passim; Louis Grasset-Morel, *Les Bonnier, ou Une Famille de financiers au XVIIIe siècle: Joseph Bonnier, M. de La Mosson, la Duchesse de Chaulnes, le Président d'Alco* (Paris, 1886).

50 Christopher Wilson, *The Gothic Cathedral: The Architecture of the Great Church, 1130-1530* (London, 1990), pp. 120–40.

51 Ethan Matt Kavaler, *Renaissance Gothic:*

Architecture and the Arts in Northern Europe, 1470–1540 (New Haven, 2012), pp. 117–19; Bork, *Great Spires*, pp. 356–400; Florian Meunier, 'Tours et clochers gothiques flamboyants: les XVe et XVIe siècles en Normandie et en France septentrionale', in *Revue archéologique de Bordeaux*, special issue: Samuel Drapeau and Philippe Araguas (eds.), *Les clochers-tours gothiques de l'arc atlantique de la Bretagne à la Galice*, vol. 104 (2013).

52 For the history of Rouen in this period, Michel Mollat, 'Mue d'une ville médiévale (environ 1475–milieu XVIe siècle)', in Michel Mollat (ed.), *Histoire de Rouen* (Toulouse, 1979), especially p. 145. On patrons, Yves Bottineau-Fuchs, 'Maîtres d'ouvrage et maîtres d'oeuvre en haute-Normandie à la fin du Moyen Age', in Maylis Bailé (ed.), *L'architecture normande au Moyen Age*, vol. 1 (Caen, 1997), pp. 315–36. For St-Ouen, André Masson, *L' Église abbatiale Saint-Ouen de Rouen* (Paris, 1927); for the cathedral, Anne-Marie Carment-Lanfry, *La Cathédrale de Rouen* (Rouen, 2010), especially pp. 47–52. Comments on the castle of Gaillon were made in a letter sent by the Ambassador Bonaventura Mosti to the Duke of Ferrara, dated Louviers, 24 September 1508, quoted in Marc H. Smith, 'Rouen-Gaillon: Témoignages italiens sur la Normandie de Georges d'Amboise', in Bernard Beck, Pierre Bouet, Claire Étienne and Isabelle Lettéron (eds.), *L'architecture de la Renaissance en Normandie*, vol. 2 (Rouen, 2004).

53 Isabelle Lettéron, 'Les hôtels de Rouen à la Renaissance'; Lucien-René Delsalle, 'Les fontaines de Rouen', in Beck, Bouet, Étienne and Lettéron (eds.), *L'Architecture de la Renaissance en Normandie*, vol. 2.

54 M. E. de La Quérière, *Saint-Laurent, église paroissiale de Rouen, supprimée en 1791* (Rouen, 1866), p. 8.

55 This object is in deposit at the cathedral, but originates from the village of Yvetot, about 30 kilometres north-west of Rouen. An illustration and a description of the object can be found on the Palissy database, ref. PM76001326, and Marie-Hélène Didier, 'Monstrance', in *Le Trésor de la Cathédrale de Rouen*, exh. cat., Musée des antiquités de la Seine-Maritime (Rouen, 1993), pp. 52–53, cat. 30; Catherine Arminjon, 'Monstrance', in Catherine Arminjon and Sandrine Berthelot (eds.), *Chefs-d'oeuvre du Gothique en Normandie: sculpture et orfèvreries du XIIIe au XVe siècle*, exh. cat., Musée de Normandie, Caen, and Ensemble conventuel des Jacobins, Toulouse (Milan, 2008), p. 191, cat. 88.

56 Claude Chastillon, *Topographie francoise ou Representations de plusieurs villes, bourgs, chasteaux, plans, forteresses, vestiges d'antiquité, maisons modernes et autres du royaume de France: la pluspart sur les desseings de deffunct Claude Chastillon, ingenieur du Roy* (Paris, 1655). The engraving's arrangement was apparently confirmed by an unpublished and now lost drawing discovered by André Pottier in 1851: Masson, *L'église abbatiale Saint-Ouen de Rouen*, p. 19. Different interpretations on the shape and date of the original façade have been offered in Bork, *Great Spires: Skyscrapers of the New Jerusalem* (Cologne, 2003), 374; Peter Kurmann, 'Filiation ou parallèle? À propos des façades et des tours de Saint-Guy de Pragues et de Saint-Ouen de Rouen', *Umení*, vol. 49, no. 3 (2001), p. 217.

57 Franck Thénard-Duvivier, 'Images et culte des saints évêques: Cathédrale de Rouen et Abbaye Saint-Ouen: une concurrence asymétrique au 14e s.?', in Catherine Vincent and Jacques Pycke (eds.), *Cathédrale et pèlerinage aux époques médiévale et moderne* (Louvain-la-Neuve, 2010), p. 295.

58 Linda Neagley, *Disciplined Exuberance*, p. 22; Paul Frankl, *Gothic Architecture*, intro., biblio., and notes by Paul Crossley (New Haven, 2001), p. 358, note 151; Kavaler, *Renaissance Gothic*, p. 122; Baudoin, *La sculpture famboyante en Normandie et Ile-de-France*, pp. 7, 77, 86.

59 "… extraordinaires figures de prophètes en costumes de théâtre, coiffés d'énormes chaperons": Carment-Lanfry, *La Cathédrale de Rouen*, p. 239.

60 Bottineau-Fuchs, *Haute-Normandie gothique* (Paris, 2001), p. 379; Baudoin, *La sculpture famboyante en Normandie et Ile-de-France*, pp. 25, 26, 261–64, 271–73; Bottineau-Fuchs, 'Maîtres d'oeuvre, maître d'ouvrage: les Le Roux et le chapitre cathédral de Rouen', in Xavier Barral i Altet (ed.), *Artistes, artisans et production artistique au Moyen Âge: colloque international*, vol. 1 (Paris, 1986–90), p. 188.

61 Yves Bottineau-Fuchs, 'La Statuaire monumentale de la façade de la cathédrale de Rouen (XIVe-XVe siècle)', in Sylvette Lemagnen and Philippe Manneville (eds.), *Chapitres et cathédrales en Normandie* (Caen, 1997), p. 378; Anne-Marie Carment-Lanfry, *La Cathédrale de Rouen*, p. 81.

62 Charles de Robillard de Beaurepaire, *Inventaire-Sommaire des archives départementales antérieures à 1790*, vol. 2 (Paris, 1874); Wim Vroom, *Financing Cathedral Building in the Middle Ages: The Generosity of the Faithful* (Amsterdam, 2010), pp. 37–39.

63 Vroom, *Financing Cathedral Building in the Middle Ages*, pp. 37–39; François Janin, 'Georges d'Amboise, Archevêque de Rouen, et son chapitre (1493–1510)', in Lemagnen and Manneville (eds.), *Chapitres et cathédrales en Normandie*, pp. 123–38.

64 Hamon, 'Le Cardinal Georges d'Amboise et ses architectes', in Fabienne Joubert (ed.), *L'artiste et le clerc: commandes artistiques des grands ecclésiastiques à la fin du Moyen Âge* (Paris, 2006), pp. 334–35; Janin, 'Georges d'Amboise, Archevêque de Rouen, et son chapitre (1493–1510)', p. 124.

65 Vroom, *Financing Cathedral Building in the Middle Ages*, pp. 47–48; Vincent Tabbagh, *Fasti ecclesiae gallicanae*, vol. 2 (Turnhout, 1998), pp. 8–11; Beaurepaire, *Inventaire-sommaire*, vol. 2. No accounts survive between G 2525 (1512–13) and G 2526 (1521–22), although G 2628 contains some varied documentary evidence relating to the *fabrica* in the years 1505–24.

66 Tabbagh, *Fasti ecclesiae gallicanae*, vol. 2, pp. 10–12.

67 Gervase of Canterbury, 'Tractatus de combustione et reparatione cantuariensis ecclesiae (c. 1200)', in *Gervasii cantuariensis opera historica*, ed. William Stubbs, vol. 1 (London, 1897); Thomas W. Gaehtgens, 'Bombing the Cathedral of Reims', *The Getty Iris*, January 23, 2015, http://blogs.getty.edu/iris/bombing-the-cathedral-of-rheims/.

68 Beaurepaire, *Inventaire-sommaire*, vol. 2, G2149.

69 Jacques Baudoin, *La sculpture flamboyante en Normandie et Ile-de-France*, p. 37; Meunier, *Martin et Pierre Chambiges*, p. 72.

70 Hamon, *Une capitale flamboyante: la création monumentale à Paris autour de 1500* (Paris, 2011), p. 208.

71 Stephen Murray, *Building Troyes Cathedral: The Late Gothic Campaigns* (Bloomington, 1987), p. 33; Jacques Henriet, *A l'aube de l'architecture gothique* (Besançon, 2005), p. 174; Hamon, 'Le Financement du chantier de la tour nord de la cathédrale de Bourges au début du XVIe siècle', in Odette Chapelot (ed.), *Du Projet au chantier. Maîtres d'ouvrage et maîtres d'oeuvre* (Paris, 2001), pp. 117–39.

72 James S. Ackerman, "Ars Sine Scientia Nihil Est' Gothic Theory of Architecture at the Cathedral of Milan', *The Art Bulletin*, vol. 31, no. 2 (1949).

73 Ibid., p. 29.

74 Meunier, *Martin et Pierre Chambiges*, p. 28.

75 Eustache Hyacinthe Langlois, *Notice sur l'incendie de la Cathédrale de Rouen: occasionné par la foudre, le 15 septembre 1822, et sur*

l'histoire monumentale de cette église: ornée de six planches (Rouen, 1823).

76 Arthur L. Frothingham, 'Le Modèle de l'église Saint-Maclou à Rouen', *Monuments et mémoires de la fondation Eugène Piot*, vol. 12, no. 2 (1905); Neagley, *Disciplined Exuberance*, p. 147.

77 Drawings from Rouen include a drawing for the *cathedra* (see below), the Cloisters drawing, and the lost piece mentioned by André Masson, *L'église Abbatiale Saint-Ouen de Rouen*, p. 19. For the drawings of Gaillon, see Xavier Pagazani, 'La chapelle de Gaillon', *L'Art des frères d'Amboise*, exh. cat., Musée national du Moyen Âge, Paris, and Musée national de la Renaissance, Écouen (Paris, 2007).

78 Neagley, 'Elegant Simplicity: The Late Gothic Plan Design of St.-Maclou in Rouen', *The Art Bulletin*, vol. 74, no. 3 (1992), p. 395. On St-Maclou in general, see Neagley, *Disciplined Exuberance*.

79 Neagley, 'A Late Gothic Architectural Drawing at The Cloisters', in Elizabeth Sears and Telma Thomas (eds.), *Reading Medieval Images: The Historian and the Object* (Ann Arbor, Mich., 2002), p. 95.

80 Abbé Sauvage, 'Notes sur un dessin original du XVe siècle appartenant au chapitre de Rouen', *Revue de l'art chrétien*, vol. 7 (1889); Jens Moesgaard, 'Plan et élévation d'une flèche' in *Le Trésor de la Cathédrale de Rouen*, pp. 99–100, cat. 83; Sangouard, and Sangouard, 'Les sources normandes dans l'achèvement de la cathédrale d'Albi à la fin du Moyen Âge', pp. 324–27. For the payement, Beaurepaire, *Inventaire-sommaire*, vol. 2, G2501; for wider discussion of the *cathedra* and Laurent Adam, Philippe Landin, 'Le chantier des stalles de la cathédrale de Rouen (1457-1471)', in Elaine C. Block and Frédérick Billie (eds.), *Les Stalles de la cathédrale de Rouen* (Rouen, 2003), p. 64.

81 Beaurepaire, *Inventaire-Sommaire*, vol. 2, G2149; Bottineau-Fuchs, 'Maîtres d'oeuvre, maître d'ouvrage: les Le Roux et le chapitre cathédral de Rouen', in Xavier Barral i Altet (ed.), *Artistes, artisans et production artistique au Moyen Âge*, p. 186.

82 Beaurepaire, 'Notes sur les architectes de Rouen: Jean Richier, Les Pontifs, Jacques Le Roux, Guillaume Duval, Pierre le Signerre et Autres (seconde moitié du XVe siècle)', *Bulletin des amis des monuments rouennais* (1903), p. 66; Bottineau-Fuchs, 'Maîtres d'ouvrage et maîtres d'oeuvre en Haute-Normandie à la fin du Moyen Age', in Bailé (ed.), *L'architecture normande au Moyen Âge*, p. 317.

83 Meunier, *Martin et Pierre Chambiges*, pp. 84–85.

84 All the examples are quoted in Victor Gay, 'Patron', *Glossaire archéologique du Moyen Age et de la Renaissance* (Paris, 1887), pp. 212–13.

85 Robert Scheller, 'Towards a Typology of Medieval Drawings', in Walter Strauss and Tracie Felker (eds.), *Drawings Defined* (New York, 1987), 20; Meunier, *Martin et Pierre Chambiges*, pp. 84–85.

86 Stephen Perkinson, *The Likeness of the King: A Prehistory of Portraiture in Late Medieval France* (Chicago, 2009), p. 52.

87 Perkinson, *The Likeness of the King*, p. 52.

88 Stephen Parcell, *Four Historical Definitions of Architecture* (Montreal and London, 2012), pp. 132–33.

89 'Documents', *Mémoires de la Société Archéologique de Montpellier*, vol. 2 (1841), pp. 329–30, no. 85.

90 Gretchen Peters, *The Musical Sounds of Medieval French Cities: Players, Patrons, and Politics* (Cambridge, 2012), p. 171.

91 M. Buchotte, *Les Règles du dessin et du lavis pour les plans particuliers des ouvrages et des bâtimens* (Paris, 1722), p. 20.

92 Salamagne, 'Deux plans inédits d'Arras', pp. 2–3.

93 Philippe Manneville, 'L'isolement' de la Cathédrale de Rouen', in *Chapitres et Cathédrales en Normandie*, pp. 425–38; Beaurepaire, *Notes sur le parvis de la cathédrale de Rouen* (Rouen, 1883), p. 14.

94 Linda Neagley, 'Late Gothic Architecture and Vision: Representation, Scenography, and Illusionism', in Matthew Reeve (ed.), *Reading Gothic Architecture* (Turnhout, 2000), pp. 37–55; Beaurepaire, 'Notice sur la Cour d'Albane', in Henri Allais, Beaurepaire, Georges Dubosc, Julien Félix, Jules Hédou, Henri de Lapommeraye, and François Lalanne, *Rouen pittoresque* (Rouen, 1886); Emmanuelle Lefebvre, 'La Cour des Libraires de la Cathédrale Notre-Dame de Rouen', in *Chapitres et cathédrales en Normandie*, pp. 417–24.

95 Neagley, 'Late Gothic Architecture and Vision: Representation, Scenography, and Illusionism', p. 50; Neil Murphy, 'Building a New Jerusalem in Renaissance France: Ceremonial Entries and the Transformation of the Urban Fabric, 1460-1600', in Katrina Gulliver and Heléna Tóth (eds.), *Citiscapes in History: Creating the Urban Experience* (Farnham, 2014), p. 190; Bottineau-Fuchs, 'Georges Ier d'Amboise et la Renaissance en Normandie', in Yves Esquieu (ed.), *Du Gothique à la Renaissance. Architecture et décor*

en France (1470–1550) (Aix-en-Provence, 2003), p. 92.

96 *Un mercante di Milano in Europa: diario di viaggio del primo Cinquecento*, ed. Luigi Monga (Milan, 1985), p. 65; Antonio de Beatis, *The Travel Journal of Antonio de Beatis: Germany, Switzerland, the Low Countries, France and Italy, 1517-8*, ed. John Rigby Hale (London, 1979), p. 109.

97 On the drawing for the tower of Orleans cathedral, see Sandron, 'Un projet de flèche gothique pour la cathédrale d'Orléans (vers 1530) chez Robert de Cotte'.

98 Jeanne Peiffer, 'Constructing Perspective in Sixteenth-Century Nuremberg', in Mario Carpo and Frédérique Lemerle (eds.), *Perspective, Projections and Design: Technologies of Architectural Representation* (Abingdon, 2013).

99 Wolfgang Jung, 'Verso quale nuovo S. Pietro? Sulla prospettiva a volo d'uccello U 2 A di Baldassarre Peruzzi', in Gianfranco Spagnesi (ed.), *L'architettura della basilica di San Pietro: storia e costruzione* (Rome, 1997), pp. 152–54; Ann C. Huppert, 'Envisioning New St. Peter's: Perspectival Drawings and the Process of Design', *Journal of the Society of Architectural Historians*, vol. 68, no. 2 (2009), pp. 165–68.

100 Robert Bork, 'Gothic Drawing and the Shaping of Space', *Space in the Medieval West*, pp. 73–74.

101 Christoph Luitpold Frommel, 'Reflections on the Early Architectural Drawings', in Millon and Magnago Lampugnani (eds.), *The Renaissance from Brunelleschi to Michelangelo*, p. 105; Ackerman, 'The Origins of Architectural Drawing in the Middle Ages and Renaissance', in *Origins, Imitations, Conventions* (Cambridge, Mass., 2002), p. 16.

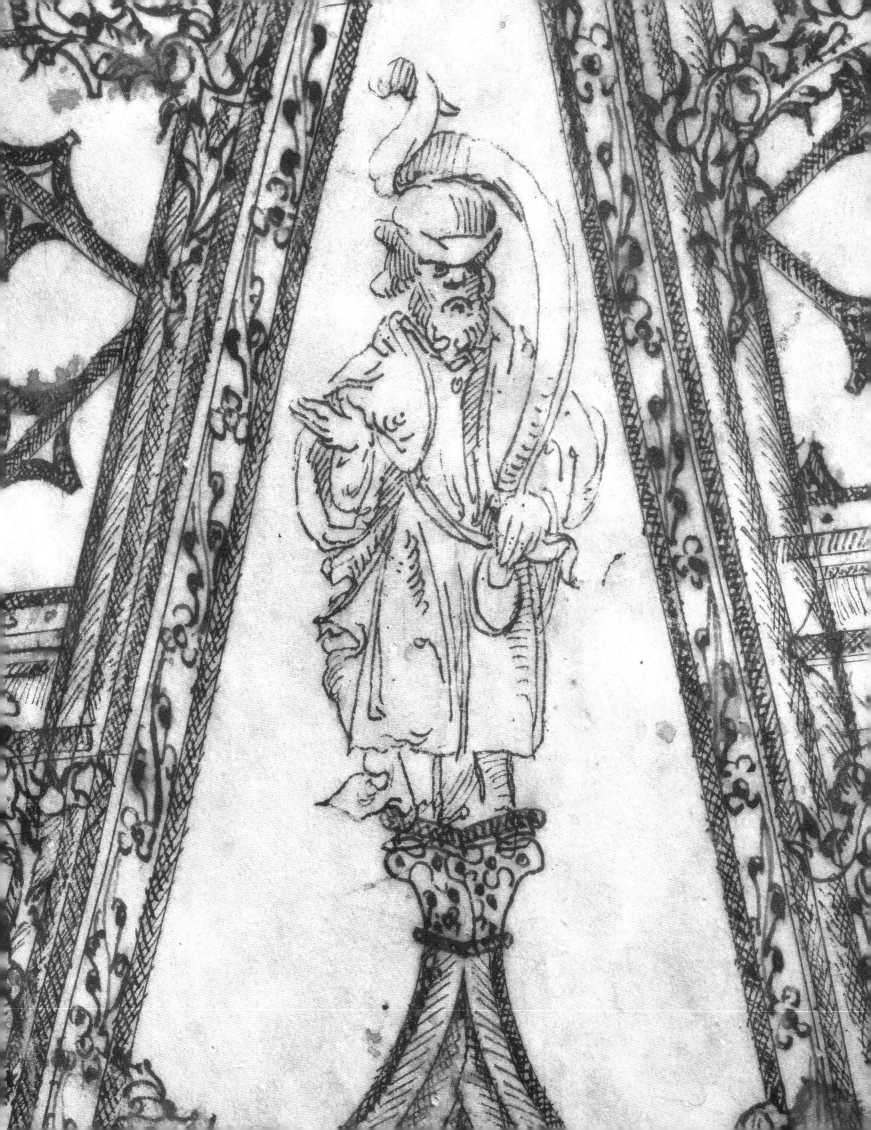

Appendix

BY EXTRAORDINARILY GOOD FORTUNE THE CIRCUMSTANCES IN WHICH the Rouen tower drawing was made can be recovered from the surviving records of the assemblies of the cathedral chapter for the years 1514 to 1517. These documents are found in the Archives départementales de Seine-Maritime in Rouen, in a register of 396 paper pages, inventoried with the number G2149, of which they compose only a small part. Overall, the register covers the period from 15 October 1513 to 1 June 1519, and was compiled by Jacques Lemoine, the chapter's *tabellarius*, an official chosen from among the lesser ranks of the canons to record the chapter's deliberations. The entire content of this register was summarized by the archivist Charles de Robillard de Beaurepaire, who published a seven-volume *Inventaire-sommaire* of the city's ecclesiastical archives in 1874.[1] Nevertheless, the documents relevant to the reconstruction of the crossing tower have never before been published in full. Transcriptions and translations of the most relevant documents are given below, introduced by translations of Beaurepaire's useful summaries, where they exist.

As is clear from the register, chapter assemblies were held almost every day, despite a decision of 1428 to meet only on Mondays, Wednesdays and Fridays. Not all canons attended every assembly, but each record begins with a list of the canons in attendance, as this determined their rights to various financial rewards. These lists have been omitted in the transcriptions below, unless the presence of particular canons is especially relevant. Similarly, discussions that do not directly relate to the Cathedral tower have not been transcribed, even if held during the same assembly.

Although the accounts are written in Latin, Rouen's canons probably conversed in French most of the time. As a result, French words are sometimes found among the Latin, and the classical spelling of some Latin words is altered to reflect contemporary French usage.

Common words were often abbreviated for the sake of speed. There are special signs for prefixes and groups of letters such as 'prae', 'pro, 'ser'; other common words are abbreviated in consistent ways, such as 'ecclia' for *ecclesia* (church) or 'tpe' for *tempore* (time). All abbreviations have been written out in full in the transcriptions below, in italic, but parts of abbreviated words which do not use conventional signs but were reconstructed on the basis of context appear in roman. The Latin text has minimal punctuation and inconsistent capitalization, features which have been respected in the transcription but not in the translation. As in contemporary chapter accounts from other cathedrals (Troyes, for example), Latin verbs do not always follow the expected sequence of tenses. Thus a verb in the past may sometimes introduce a description of events in the present or vice versa, a feature which has not been respected in the translation.

The original records note the day, date and month of each deliberation, but not the year. In France (and elsewhere) the new year typically began on the Feast of the Annunciation (25 March) until the New Style of dating was introduced in the second half of the sixteenth century, but to avoid confusion the year has been calculated and given in the New Style in the transcriptions below.

1. Charles de Robillard de Beaurepaire, *Inventaire-sommaire des archives départementales anterieures à 1790* (Paris, 1874); Léopold Delisle, 'Charles de Robillard de Beaurepaire (1828–1908)', *Bibliothèque de l'école des chartes*, vol. 70, no. 1 (1909), p. 216.

No. 1 (fols. 83r–83v): Wednesday, 4 October 1514

4 October, Feast of St Francis, between Nones and 10 in the morning, fire in the spire of the cathedral, called l'aiguille [l'esguille] *… prayers are ordered, the choir burns down to the masonry, the lead drips like rain, and drops fly as far as St-Ouen. The four bells are destroyed.*

1. The *esguille* was a spire made of wood covered with lead, standing on a masonry base.

2. About twenty-five houses just north of the cathedral were owned by the chapter and used by the canons, the cathedral chaplains, or lay lodgers (Tabbagh, *Fasti ecclesiae gallicanae*, vol. 2, p. 10).

3. The monastery of St-Ouen is located about half a kilometre north-east of the cathedral.

4. St-Maclou is a parish church located just east of the cathedral.

5. For another translation of this passage, see Achille Delville, 'Lettre adressée à Monsieur Alavoine', *Précis analytique des travaux de l'Academie des sciences, belles-lettres et arts de Rouen* (1831), pp. 176–77.

6. The two superintendents of the *fabrica* were chosen from among the chapter. This was a prestigious and sought-after position (Tabbagh, *Fasti ecclesiae gallicanae*, vol. 2, p. 10).

Ipsa die mercurii quarta mensi octobris festiva sancti francisci post exitum capituli inter nonam et decimas horas demantitudine prefatis dominis existentibus in choro dicte ecclesie circa inicium misse diei illius in turri consistenti inter dictum chorum et navim ecclesie predicte que vulgari sermone lesguille gallice nuncupatur / visus fuit fummus in quantitate permaxima / tuncque insurrexit clamor per ecclesiam et totam civitatem / quod dicta turris erat igne accensa / et uno instanti commota fuit tota civitas / populusque copiose et maxima multitudine ad ecclesiam festinanter accedens / et undique portando aquas in altum ascendens / non tamen potuit ignis huiusmodi ab hominibus superari / quin statim cunctis proh dolor cernentibus dicta turris circunquaque inflammata fuerit / nec erat aliquis qui posset eidem subvenire / quoniam ymo tota dicta turris ex plumbo sumptuose cooperta infra unam horam funditus corruit / et crux in illius summitate collocata igne inflammata supra dictum chorum pariter ex plumbo coopertum cecideret et testitudinem eiusdem chori confregit et penetravit et cooperturam illius omnino inflammavit ita quod putabatur totam civitatem debere igne cremari / Et tunc in singulis monasteriis ecclesis et conventibus per civitatem fiebant processiones / ac preces et oraciones deferendo reliquias capsas et cruces cum fletibus et lacrimis / Et statim divina favente clemencia circa meridiem ignis temperatus fuit et moderatus atque paulatim extintus / postque chorum predictum omnino combussit usque ad lathomiam / eo cessante quod aliqua domus circumvicina fuerit quovismodo dampnificata / quamvis tunc plumbus per sillicidia flueret instar pluvie atque cum flammis huic et inde supra domos volitaret eciam usque ad monasterium sancti Audoeni Rotomagensis / in quo incendio fuerunt quatuor campane in dicta turri existentes omnino consumpte et demolite / Quo pendente tempore domini canoni et cappellani capsas feretra tabula ornamenta et res preciosas dicte ecclesie reverenter detulerunt usque ad ecclesiam sancti Macuti Rhotomagensis ac in domibus et locis propinquis pro eorum conservacione fuitque ipsa ecclesia omnino

On that same day, Wednesday 4 October, the feast of St Francis, after the end of the chapter meeting, between nine and ten in the morning, when the Lords [members of the chapter] were in the choir of the said church, as the daily mass was beginning, very heavy smoke was seen [coming] from the tower known in French as *l'esguille*, located between the said choir and the nave of the church. Immediately the rumour spread in the church and throughout the city that the tower was on fire. The whole city instantly panicked. Crowds of people ran to the church, bringing water and lifting it to the tower. But it was impossible for human efforts to stop the fire thus. Soon, oh sorrow! before everybody's eyes the whole tower, which was so sumptuously covered in lead,[1] collapsed within the hour, having been ablaze from all sides, and nobody could save it. The cross that was at its top, all aflame, fell onto the roof of the said choir (also covered in lead), broke it, and, reaching the wooden rafters, set them on fire so that it seemed that the whole city was going to be set alight. In every monastery, church, convent, and throughout the city there were prayers, orations and processions with relics, shrines and crosses amidst moans and tears. Immediately, thanks to divine providence, around midday, the fire gradually died down, after the said choir had burned down to the masonry. After it was over, none of the houses located around the church[2] was damaged, although lead fell through the gutters like rain, and flew over the roofs with small flames as far as the monastery of St-Ouen of Rouen.[3] In this fire, four bells that were in the tower were burnt down and lost. And during this uncertain time, the canons and the chaplains reverently carried the shrines, relics and other precious things to the church of St-Maclou[4] and nearby homes to protect them. The church was completely gutted and emptied, and was filled with so much water that it was impossible to say

1. Connected to the Latin for 'father', *patronus* could mean archetype or exemplar in medieval Latin; it indicated preparatory, two- or three-dimensional representations of artworks yet to be made, for example a drawing or model to be shown to patrons. *Protractus* derives from *protrahere*, initially 'to bring out with great effort', but 'to bring forth' or 'reveal' in the medieval period. The term was specifically used to indicate the drawings of buildings in plan or elevation (see Chapter III, 'Describing Drawings').

2. These were officials of the king, clergy and local notables who administered civic matters in the city's communal hall at the Palais du Neuf Marché, the western wing of the Palais de Justice.

vacuata et spoliata ac ex habundancia aquarum ibidem delatarum repleta quod non potuisset in ea divinum servicium celebrari occasione cuius incendii dicta ecclesia maximum et quasi inestimabile passa est detrimentum Quod quidem incendium ut fertur provenit ex incuria et negligencia plumbatorum qui tunc circa reparacionem dicte turris operabantur.

Qua die postmeridiem convenientibus in maiori aula maneri archiepiscopalis Rothomagensis

Insuper fuit ordinatus quod domini superintendentes fabrice provideant de recolligi faciendo materias restantes ne furentur

Item domini Le Lyeur Henze et Voysin fuerunt commissi ad visitandum cum tota diligencia dictam ecclesiam in omnibus locis et provideant quantum poterint ne ignis remaneat in aliquo loco ad vitandum periculum noctis.

mass there. The fire caused an incalculable loss to the church. It was caused, so it was said, by the negligence of the lead-workers attending to the repair of the tower.[5]

On the same day in the afternoon, having met in the largest hall of the archiepiscopal palace of Rouen

[The chapter] ordered that the lords superintendents of the *fabrica*[6] undertake to collect surviving building materials, so that they would not be stolen. In the same way, Lords Le Lyeur, Henze and Voysin were nominated to visit every part of the whole church with great zeal, and undertook to extinguish the fire which remained in some places as well as they could, in order to avoid danger overnight.

No.2 (fol. 90r): Tuesday, 24 October 1514

Exposito quod plombator ecclesie qui tempore incendii eclesie in ea operabatur | et qui misericordie occasione dicti incendii est fugitivus supplicabat per dictos dominos audiri super iustificatione sua placuit prefatis dominis quod veniat ipse plombator sub salvo conductu eorumdem eo cessante quod detineatur aut apprehendatur quonismodo.

When it emerged that the lead-worker who was working on the church at the time of the fire and had run away during its pitiful destruction was begging to be heard by the said lords to explain himself, they decided that the said lead-worker should come with their safe conduct, forbidding him from being detained or seized in any way.

No.3 (fol. 90v): Friday, 27 October 1514

"Portraits" of the reconstructed tower have been made and will be shown to the city councillors.

Exhibitis nonnullis patronis seu protractibus per plures artifices huius civitatis factis super turre construenda prefati domini concuserunt quod dicti patroni recolligantur et exhibeantur dominis consilliariis ville ut super dicto edificio usatur eorum consilium.

After the display of some models or likenesses of the tower to be built,[1] made by several masters of this city, the said Lords concluded that the said models should be gathered and shown to the city councillors[2] in order to hear their advice regarding the said building.

1. Between the twelfth and the sixteenth centuries this Latin term commonly referred to carpenters and roofers (rather than architects in the modern sense of the term), probably as a result of the confusion between the Greek *tekton*, builder, and the Latin *tectus*, roof (Pevsner, 'The Term 'Architect' in the Middle Ages', p. 557; Meunier, *Martin et Pierre Chambiges*, p. 72).

2. Robertus Fortin was a canon of Rouen Cathedral between 1480 and his death in March 1523. Originally from Bernières in the diocese of Bayeux, he was also parish priest of the village of Rougemontiers. He had had a successful career before becoming a canon of Rouen cathedral, living in Rome as secretary to Cardinal Guillaume d'Estouteville (1403/12–1483), who was also Archbishop of Rouen in the years 1453–83 (Tabbagh, Fasti *ecclesiae gallicanae*, vol. 2, p. 351).

3. The *chancelier* was the lowliest of ten important dignitaries in the chapter, and was appointed by the archbishop (Tabbagh, *Fasti ecclesiae gallicanae*, vol. 2, p. 12).6 At this time, the *chancelier* was Jacques de Castignoles, who served from 1504 until his death on 28 July 1516. He was succeeded by Pierre de Mélincourt (Jean François Pommeraye, *Histoire de l'Eglise cathedrale de Rouen: metropolitaine et primatiale de Normandie* [Rouen, 1686], p. 412).

4. Guillermus de Sandouville, born in 1446, was a canon between 1486 and his death in 1528. He was a priest and a nobleman, and lived in his castle of Anvéville or sometimes with the royal court. He had a successful career, becoming an apostolic notary in 1486, and in 1488 *maître des requêtes ordinaires de l'hôtel du Roi*, a judge in charge of examining petitions to the royal household. In that year, the king endorsed him as a candidate for the position of dean of the cathedral chapter, but he did not receive sufficient support from other canons (Tabbagh, *Fasti ecclesiae gallicanae*, vol. 2, p. 462).

No.4 (fol. 94r): Monday, 20 November 1514

Ea die comparverunt in capitulo quam plures artifices lathomi carpentatores architectores et alii experti / cum quibus habita deliberacione super modo construendi turrim ecclesie videlicet si deberet fieri ex tota lathoma aut carpenteria / Tandem propre diversas et varias eorum opiniones nichil fuit conclusum.

On that day as many master masons, carpenters, architects[1] and other experts as possible appeared before the Chapter, with whom there was a discussion of how to build the tower of the church, namely if it should be made entirely out of stone or carpentry. But nothing was decided due to the diversity and variety of opinions.

No.5 (fol. 94r): Tuesday, 21 November 1514

Transeat dominus Fortin hodie ad domum ville et requirat dominos consiliarios huius civitatis / ut velint deliberare cum prefatis dominis et eos consulere super modo construendi turrim ecclesie an videlicet construi debeat ex boscis aut lapidibus.

Today Lord Fortin[2] went over to the town hall and inquired whether the city councillors wished to discuss with the said lords and advise them how to build the church tower, namely if it should be built of wood or stone.

No.6 (fols. 94r-94v): Wednesday, 22 November 1514

Ea die dominus Fortin retulit hesterna die addiisse domum ville et solum invenisse procuratorem qui policitus est congregari facere dominos consiliarios et burgenses huius urbis / ad fines sibi declaratos fiat die sabbati proxima congregacio capituli per juramentu ad deliberandum super impetracione indulgenciarum pro reperacione ecclesie.

On that day Lord Fortin explained that on the previous day he had gone to the town hall and found only a steward who promised to have the said lords, councillors and burghers of this town congregate. For that purpose the following Saturday there would be a meeting of the chapter under oath to discuss procuring indulgences for the church's repair.

No.7 (fol. 94v): Saturday, 25 November 1514

Habita deliberacione super indulgenciis obtinendis pro reperacione ecclesie prefati domini concluserunt diligenciam fieri pro ipsis obtinere sub summi pontificis beneplacito / et si possible sit ad tollendam confusionem acquirantur die sancto pasche visitando ecclesiam Rothomagi aut suas percolentes ecclesias.

Following discussion on obtaining indulgences for the church's repair the said lords agreed to work hard to obtain them from the Pope's goodwill and if possible, to avoid confusion, that the indulgences should be earned by those visiting Rouen Cathedral or its dependent churches on Easter day.

No.8 (Fol. 95r): Tuesday, 28 November 1514

Transeant domini cancellarius et Sandouville ad domum ville in qua fiet congregacio ad conveniendo cum dominos consiliariis huius civitatis super modo construendi turrim ecclesie.

The Lord Chancellor[3] and Sandouville[4] go over to the town hall where there will be a meeting with the city councillors on how to build the church tower.

No.9 (fol. 95r): Wednesday, 29 November 1514

At the town hall it was decided to build a stone tower.

Ea die domini cancellarius et Sandiville retulerunt de domo ville et congregacione hesterna die in ea facta | in qua convenerant officiarii domini nostri Regis et consiliarii ac plures burgenses huius civitatis | juxta quorum oppiniones et deliberaciones compertum fuerat quod turris ecclesie erat construenda et omnino reedificanda ex lapidibus et lathomia.

On that day the Lords Chancellor and Sandouville returned from the city hall and from the meeting held there on the previous day, which had gathered together the officials of our lord king and the councillors and several burghers of this city. In accordance with their opinions and deliberations it was agreed that the church tower should be entirely rebuilt out of stones and masonry.

No.10 (fol. 95v): Monday, 4 December 1514

Fiat die mercurii proxima sancti Nicolai congregacio capituli per iuramentum ad deliberandum et concludendum una pro omnibus de modo construendi turrim an videlicet ex lathomia vel carpenteria.

There will be next Wednesday on the feast of St Nicholas (6 December) a meeting of the chapter under oath to discuss and conclude once and for all how to build the tower, namely out of masonry or carpentry.

No.11 (fol. 96r): Wednesday, 6 December 1514

[Conclusio pro constructione turris]
Habita deliberacione super turre ecclesie construenda prefati domini omnibus consideratis concluserunt quod lathomia demolita et deteriorata reperetur et augmentetur ex lapidibus requisitis usque ad quatuor quinque aut sex pedes si necesse fuerit et fieri possit absque deformitate Et residuum fiat ex carpenteria sumptuosa prout melius fieri poterit juxta patronos componendos Et prosequatur opus per dominos superintendentes fabrice vocatis dominis Mesenge et Fillon.

[Conclusion on the construction of the tower]
After discussion about the construction of the tower of the church the said lords, having examined everything, decided that the destroyed and damaged masonry should be repaired and raised with whatever stones necessary, up to a height of four, five or six feet[1] if needed, provided it could be done without damage, and that the rest should be made with sumptuous carpentry, as best as possible, according to models[2] to be drawn up, and to continue the works having nominated Mesenge[3] and Fillon[4] as superintendents of the *fabrica*.

1. In late medieval Rouen a *pied*, or foot, measured between 0.311 and 0.328 m, with an average of 0.324 m. Thus four *pieds* equates to about 1.296 metres, four *pieds* 1.62 metres, and six *pieds* 1.944 metres (Neagley, *Disciplined Exuberance*, p. 53).

2. In contemporary French, *patron* indicated a drawn or painted model, either life-size or to scale (*Dictionnaire du moyen français (1330–1500)* - ATILF - CNRS & Université de Lorraine, http://www.atilf.fr/dmf: 'Patron, 2'; see above, Chapter III, 'Describing Drawings').

3. Petrus Mésenge became a canon in 1493, succeeding his brother Jean. He was a member of the nobility, and acted as treasurer of the archbishopric from 1492 (Tabbagh, *Fasti ecclesiae gallicanae*, vol. 2, p. 320). He was extremely close to Archbishop Georges I D'Amboise, and played a role in directing construction both at the Cathedral and at Georges d'Amboise's palace at Gaillon (Janin, 'Georges d'Amboise, Archevêque de Rouen, et son chapitre (1493–1510)', p. 128; Hamon, 'Le Cardinal Georges d'Amboise et ses architectes', p. 335).

4. Artus Fillon became a member of the chapter in 1507. Of noble descent, he was born in 1468 in Verneuil-sur-Avre, a village near Rouen. After studying at the University of Paris, he became a canon at the Cathedral of Évreux. In 1506 he was appointed vicar-general for Archbishop Georges I d'Amboise, whom he supported throughout his life. He was a successful preacher and writer, producing the *Speculum curatoris*, a manual for parish priests which ran to thirteen editions. Shortly before becoming canon of the Cathedral he was elected rector of the church of St-Maclou in Rouen. Between 1507 and 1522 he represented the clergy and the États de Normandie, a provincial assembly with some political and administrative powers. His political and ecclesiastical career continued with his election as Archbishop of Senlis from 1522 until his death in 1526. As superintendent of the works, Fillon played an important role in directing and financing construction at the cathedral and elsewhere. In 1507 he oversaw the reconstruction of the bell tower of the Madeleine, in his hometown of Verneuil, an extremely ambitious structure that is clearly modelled on Rouen cathedral's Tour de Beurre. Together with other canons, he advised on the sculptural programme of the Cathedral's façade when it was reconstructed after 1507, and partly financed the works. He also donated substantial sums to the Cathedral for the reconstruction of the crossing tower after the fire of 1514 (Émile Picot, 'Artus Fillon, chanoine d'Évreux et de Rouen, puis évéque de Senlis', *Recueil de la société d'agriculture, sciences, arts et belles-lettres du département de l'Eure*, vol. 7 [1910]).

No.12 (fol. 97v): Monday, 18 December 1514

Habita iterum deliberacione super modo procedendi circa constructionem turris ecclesie et materiarum requisitarum perquisicionem concluserunt praefati domini quod Dufour procurator fabrice faciat receptam ordinariam dicte fabrice sicut consuevit necnon misias pro opere portalicii absque eo quod prodictis misiis faciendis aliquid percipiat aut recolligat de denariis qui quotidie per Christi fideles largiuntur pro reparacione ruyne ecclesiae provenientis occasione incendii. Quo facto ad / misias reparacionis dicte turris dominus Thomas Lesuuor fuit commissus ad illas faciendas expectaturus per dominos custodes clavium coffri sibi tradendi de quibus reddet comptum singulis hebdomadis ac / quociens fuerit requisitus.

In the meantime, having held a deliberation on how to proceed with the construction of the church tower and on obtaining the necessary materials, the said lords decided that Dufour,[1] the administrator of *fabrica*, should use the ordinary revenues[2] of the *fabrica* for the said works, as usual, and also the money donated for the works to the portal[3] – minus that which, after donations had been allotted for those things needing them, he would take or collect from the money that is donated daily by the followers of Christ for the repair of the ruin of the church caused by the destruction of the fire. Once the costs of the repairs of the said tower were covered, Thomas Lesuour was nominated to collect money for the repairs of the church and the lords custodians anticipated that he would bring around the key of the safe box, the earnings of which he had to account for every week and whenever required.

No.13 (fol. 103r): Tuesday, 23 January 1515

Drawings of the tower to be built, drawn up by Nicolas Castille, Richard du Bosc and Jean Derbe, "architectores".

Soluat procurator fabrice Nicolas Castille, Ricardo Dubosc, et Johanni Derbe architectoribus sommam decem librarum tournacensis pro patrono per eos constructo super modo componendi turrim ecclesie.

The administrator of *the fabrica* should pay the "architects" Nicolas Castille,[4] Richard du Bosc[5] and Jean Derbe[6] ten pounds for a model fashioned by them which shows how to build the church tower.

1. Jean Dufour was the administrator of the Cathedral works from 1489 until 1522 (Beaurepaire, *Inventaire-sommaire*, vol. 2, passim). Unlike the superintendent of works, the administrator was drawn from amongst the lesser members of the chapter, and took care of practical tasks such as recording the revenues of the *fabrica*, paying for candles and works needed in the church, and keeping accounts of all payments (Tabbagh, *Fasti ecclesiae gallicanae*, vol. 2, p. 10).

2. As an independent body from the chapter, the *fabrica* had its own fixed and regular revenues , which amounted to between 1500 and 2000 *livres* a year around 1500 (Vroom, *Financing Cathedral Building in the Middle Ages*, p. 47; Tabbagh, *Fasti ecclesiae gallicanae*, vol. 2, p. 10).

3. This refers to the funds set aside for works on the cathedral portal, which had almost collapsed in 1508 and was reconstructed after that date, with work on the gables continuing until the fire of 1514 (Carment-Lanfry, *La Cathédrale Notre-Dame de Rouen*, pp. 229–31).

4. Castille was an *huchier*, a woodworker who made furniture rather than large-scale architectural projects. His documented works are the doors for the cathedral's central portal, made with Roger Noblet in 1514, and the stalls and choir screens for the upper chapel of the palace of Gaillon, made between 1507 and 1518 by Castille and the Italian Riccardo da Carpi, and incorporating models derived from Renaissance prints. See Bottineau-Fuchs, 'Maîtres d'ouvrage et maîtres d'oeuvre en haute-Normandie à la fin du Moyen Âge', p. 318; Agnès Bos and Jacques Dubois, 'Les boiseries de la chapelle du château de Gaillon', in *L'Art des frères d'Amboise*, exh. cat., Musée national du Moyen Âge, Paris, and Musée national de la Renaissance, Écouen (Paris, 2007), p. 92.

5. A woodworker, Du Bosc built a pulpit for the church of St-Maclou in 1476; and probably worked at St-Étienne-la-grande-église in 1509–12 (Beaurepaire, *Inventaire-sommaire*, vol. 5, G. 6558, G. 6878).

6. Probably a woodworker, Derbe appraised the new stalls of the Convent of the Augustins in Rouen in 1523 (Beaurepaire, *Inventaire-sommaire*, vol. 2, G. 2149).

No.14 (fol. 103v): Friday, 26 January 1515

Their designs are shown to Jean Du Bosc [sic, instead of Jean du Mouchel], carpenter of the church, and to Roulland le Roux.

1. This carpenter was invited to appraise several works in Rouen and the surrounding area, suggesting that he was well-established and experienced. In particular, in 1483 he visited the archbishop's buildings in Rouen, Deville, Dieppe and other locations to appraise necessary repair. With Castille and others, he visited the quarries to evaluate the quality and quantity of stone for the palace of Gaillon, and he later worked at the parish church of St-Laurent in Rouen between 1515 and 1516. See Flaminia Bardati, 'A Building Site in Early Sixteenth-Century Normandy: the Castle of Gaillon, Organization, Workers, Materials and Technologies', in Malcolm Dunkeld et al. (eds.), *Proceedings of the Second International Congress on Construction History*, vol.1 [Exeter, 2006], 297).

2. This Paris merchant supplied wood to the largest Flamboyant building sites of the Paris area (Hamon, *Une capitale flamboyante*, p. 208).

Exhibita aperte architectorum huius civitatis quade oblatione per ius scripto redacta per quam offerunt alium patronum componere juxta quem offerunt turrim ecclesie sumptuose construtione prefati domini concluserunt quod magistri Johannes Du Mouchel carpentator et Roulandus le Roux lathomus ipsam oblationem videant ac juxta eorum deliberacionem in hoc negotio procedatur.

Once a proposal by "architects" of this city had been displayed publicly in accordance with the law, through which they [the architects] offered to put together another model which would show how the church tower could be built sumptuously, the aforementioned Lords concluded that masters Jean du Mouchel,[1] carpenter, and Roulland le Roux, mason, should look at the said proposal and that the matter should proceed according to their deliberations.

No.15 (fol. 104r): Saturday, 27 January 1515

Ea die dictus dominus de Sandouville exposuit quod hesteria die juxta conclusionem hic habitam monstraverat magistris Johann Du Mouchel et Rulando le Roux oblationem per architectores huius civitatis factam de componendo turrim ecclesie a quibus didiscerat quod licet dicta oblatio sufficiens et optima videretur ac tamen erant oppinionis quod talis structura melius spectabat ad carpentatores / cum eciam sine carpentatoribus dictam turrim costruere nequirent / Quodque prout eisdem videbatur dicta turris construi debebat ad dictas / et non pro pactum aut convencionem pro bono et utilitate ecclesie.

On that day the Lord of Sandouville related that the day before, according to the decision reached there, he had shown the masters Jean du Mouchel and Roulland le Roux the proposal by the "architects" of this city, of how to design the church tower; from the masters he had learned that the said proposal appeared suitable and very good, and yet they were of the opinion that such a structure was more suitable to carpenters. In fact, they did not want to build the said structure without carpenters. It also seemed to them that it was in the interest and for the good of of the church that the said tower should be constructed according to their advice, and not following some pact or agreement.

No.16 (fol. 111r): Wednesday, 14 March 1515

[De bosco turris ecclesie]
Habita deliberacione super convencione per dominum Mesenge nomine ecclesie iunta cum Simoni Aguiton mercatore parisensis super bosco requisito pro constructione et redificacione turris ecclesie praefati domini eandem convencionem tanquam utilem ratificaverunt ratamque et gratam haverunt.

[On the wood for the church tower]
Having discussed the agreement between Lord Mesenge, in the name of the church, and the Parisian merchant Simon Aguiton,[2] regarding the wood necessary for the building and reconstruction of the church tower the said lords ratified this agreement as useful and approved the agreed price.

No.17 (fol. 111r): Thursday, 15 March 1515

1. The *perche* [carrée] was sometimes used as a surface measure, as in this passage. One perch equated to between sixteen and twenty-five *pieds*, or between 5.184 and 8.1 metres (*Dictionnaire du moyen français (1330–1500)*, 'Perche, 1').

2. Martin Desperrois was a well-respected carpenter who designed the wooden spire of the church of St-Maclou in 1517.

3. From the early thirteenth century, the *livre tournois* became the most widely used money of account in France. It was subdivided into twenty *sous* (shillings, *solidus*), and each *sou* into twelve *deniers*.

[*De bosco turris ecclesiae*]
Quia per relacionem expertorum constitit quod ultra boscum per dominum Mesenge pro constructione turris ecclesie emptum restant alie quatuor grosse perce fuit ipse dominus Mesenge conmissus ad illas emendum et super precio earumdem conveniendum.

[On the wood for the church tower] Because it was established through a report of experts that four other large *perche*[1] [of wood] remain in addition to the wood bought by Lord Mesenge for the construction of the church tower, the same Lord Mesenge was entrusted to buy [the remaining pieces of wood] and to agree on their price.

No.18 (fol. 112v): Thursday, 22 March 1515

[*De turre ecclesiae*]
Repetito de edificio turris ecclesie et si debeat fieri convencio cum expertis super toto edificio aut si fieri debeat per dietas prefati domini habita super hoc matura deliberacione concluserunt quod opus huiusmodi fiat per dietas / Et eligantur principaliter duo experti et fideles carpentarii qui habeant totam superintendentiam predicti edificii ad discrecrecionem dominorum superintendentium fabrice / fuitque dictus dominus Mesenge requisitus de ipsos dominos circa opus predictum iurando cum quo prefati domini dispensaverint quod lucretur suas distribuciones domorum et pro agendis dicti edificii vaccabit.

[On the wood for the church tower] Having again discussed the building of the church tower and whether a meeting should be held with experts regarding the whole building or if it should be determined on a daily basis the said lords, following a thorough discussion on the topic, concluded that the work likewise should be determined on a daily basis. And they decided that first two expert and loyal carpenters should be elected, who would have complete charge of the said building, at the discretion of the lords superintendent of the works. And the said Lord Mesenge was required to swear an oath to the said lords regarding the said work, following which the said lords would manage whatever he would earn from his concessionary houses, and leave them empty for the making of the said building.

No.19 (fol. 114r): Wednesday, 4 April 1515

The chapter, which had smade up his mind to have a wooden tower, decided that Martin Desperrois should be the superintendent of the works, with a [yearly] stipend of sixty livres tournois.

Ea die magister Martinus Des Perroys carpentator actenta relacione de sufficientia et industria illius fuit conmissus ad superintendenciam edificii turris ecclesie ad stipendia sexaginta librorum tournacensis durante edificio annuatim ita quo tenebitur quociens opus fuerit circa edificium huiusmodi vaccare et omnimodam superintendenciam illius gerere cum consilio magistri Iohannis du Mouchel usque ad complementum dicti edificii.

On that day, once a report on his suitability and zeal had been considered, master Martin Desperrois,[2] carpenter, was nominated to supervise the building of the church tower, with an yearly stipend of sixty *livres tournois*,[3] for the duration of the construction and on the condition that he will carry out every sort of work that is missing, with the counsel of Jean du Mouchel, until completion of the said building.

No.20 (fol. 115v): Monday, 16 April 1515:

Having purchased supplies of wood from Simon Aguiton of Paris, the canons
ask the Great Seneschal to allow wood to be kept in the Vieux Palais.

1. The seneschal was the king's representative charged with justice and administrative duties. In northern France, this position was more usually identified with the term *bailli*.

2. The Vieux Palais was the fortified royal palace built for Henry V between 1419 and 1443, just after the French reconquest of the city.

[*De bosco turris*]
Ea die dictus dominus Mesenge exhibuit
contractum per eum nomine ecclesie iuratum
cum Simone Aguiton mercator parisiensis
super bosco requisito pro constructione turris
ecclesie quiquid contractus fuit et ex manuali
signo dicti aguiton signatus quem dominus
de Oharmolne remisit atque declaravit que
ipse Aguiton intendit porcionem dicti bosci in
brevi transmictere occasione cuius concluserunt
prefati domini quod dominus magnus
senescallus per missivas requiratur quod
accomodare velit vetus palacium ad recipiendi
dictum boscum.

[*De turre ecclesiae*]
Expediantur domino Thome Lestmondoys
procuratori fabrice III l.t. ut satesfaciat de una
vectura lapidum pro reperacione turris ecclesie.

[On the wood of the tower]
On that day the said Lord Mesenge showed
a contract confirmed by him by oath, in the
name of the church, with Simon Aguiton,
merchant of Paris, regarding the wood
required to build the church tower; and
the contract in fact was signed with an
autograph signature of the said Aguiton;
and the Lord de Oharmolne brought it
back and said that the same Aguiton had
the intention of dispatching part of the
said wood soon, in which case the above-
mentioned Lords decided that the Lord
Great Seneschal[1] be asked in writing if he
would permit the said wood to be stored in
the Vieux Palais.[2]

[On the church tower]
Three *livres tournois* should be given to
Lord Thomas Lestmondoys so that he can
pay for a carriage of stones for the repair of
the church tower.

No.21 (fol. 120v): Friday, 18 May 1515

In response to a request by the chapter of Beauvais Cathedral, Roulland le Roux
is allowed to go to Beauvais to advise on a building under construction.

[*De lathomo pro ecclesia Beluarensis*]
Ad requestam dominorum decani et capituli
ecclesie Beluarensis iuxta missivas eorundem
per quendam canonicum ecclesie prede
capitulariter presentatas placuit prefatis
dominos quod magister Roulandus lathomus
ecclesie transeat aquidem civitate Beluarensis
ad visitandum quoddam edificium quod dicti
domini in eorum ecclesiam construi facere
intendunt.

[On the mason for the church of Beauvais]
Following a request from the Dean and
chapter of the church of Beauvais, received
by letters presented before the chapter
by one of the canons of the church, the
said lords agreed to let master Roulland
travel to the city of Beauvais, to inspect
a structure that the said lords [of the
Beauvais chapter] intend to have built in
their church.

78

Chapter deliberations of 3, 4 and 5 January 1516
Rouen, Archives départementales de Seine-Maritime, fol. 148v

1. Johannes de Batencourt was appointed in 1493 at the Pope's request, and remained a canon until his death in 1530. He was parish priest of Érnemont and later of St-Denis of Rouen (Tabbagh, *Fasti ecclesiae gallicanae*, vol. 2, p. 233).

2. = 2.916 metres.

3. A *toise* equalled six *pieds* or 1.944 m; 7.5 *toises* equates to 14.58 metres.

4. = 4.86 metres.

No.21 (fol. 148v): Thursday, 3 January 1516

Following a visit to the new tower, it is discovered that the masonry to support the wooden spire already exceeds the old masonry by nine feet, instead of four or five.

[*De turre ecclesiae*]
Audita relacione dominorum cancellarii Batencourt et aliorum qui visitaverunt lathomam de novo factam in turri ecclesie qui retulerunt ipsam lathomam cum pluribus expertis in diversis artibus visitasse atque invenisse quod ipsa lathomia nova iam excedit vetus edificium de novem pedibus quamvis fuisset conclusum quod solum augmentavetur de quinque aut sex pedibus Quodque ipsa lathomia non posset remanere in illo statu absque maxima deformitate nisi continuaretur de septem thesiis cum dimidia prefati domini habita super hoc deliberacionem concluserunt quod magister lathomus veniat die crastina in presenti capitulo ad experiendum qua auctoritate hoc fecit.

[On the church tower]
A report was heard, delivered by the Lord chancellor Batencourt[1] and others who had inspected the new stonework on the church tower, who reported that they inspected the same masonry with several experts in various crafts and found that this same new masonry already exceeds the old building by nine feet,[2] even though it had been decided that it would only be increased by five or six feet; and that in their opinion that masonry could not stay as it was, and would be severely compromised if it were not continued by seven and a half *toises*,[3] the said lords having had a discussion over this matter, concluded that the master mason should come the next day before the chapter there assembled in order to investigate on whose authority he did that.

No.22 (fol. 148v): Friday, 4 January 1516

Comparuit magistri Roulandus le Roux lathomus ecclesie qui inquisitus quare excesserat in turri ecclesie altitudinem sibi per capitulum ordinatam in lathomia per eum facta respondit hoc fecisse ad sumptuositatem et decorem ecclesie et cum consilio aliorum expertorum maxime magistri Martini Des Perroys et quod neccessarium erat opus predicta continuare de septem thesiis cum dimidia pro illius sumptuositate posset tamen remanere in altitudine XVcim pedum sed non esset tam sumptuosa Quo audito domini concuserunt quod dictus Des Perroys super hoc audiatur et quod ipse lathomus faciat unum patronum de edificio quod facere intendit ut deliberetur.

Master Roulland le Roux appeared, and having been asked why the masonry he had made for the church tower had surpassed the height decreed by the chapter, he answered that he had done this for the sumptuousness and decorum of the church and with the counsel of other experts and especially of master Martin Desperrois, and that to ensure its sumptuousness it was necessary to continue the aforesaid work up to seven and a half *toises*, although it could also remain at the height of fifteen feet[4] but would not be as sumptuous. Having heard this the lords concluded that the said Desperrois should be heard on this topic and that the same mason should make a model of the structure he had hoped to make, so that it could be discussed.

79
Chapter deliberations of 7 January 1516
Rouen, Archives départementales de
Seine-Maritime, fol. 149r

1. The lord general lieutenant was one of the officers assisting the *bailli*, or the king's representative charged with justice and administrative duties.

No.23 (fol. 149r): Monday, 7 January 1516

[*De turre ecclesiae*]
Ea die magister Roulandus lathomus ecclesie exhibuit unum [pra'mmi?] de lathomia quam facere intendit et incepit in turre ecclesie Quo viso domini concluserunt illum conmunicari per dominos canonicorum Fane et Fillon cum expertis ac aliquibus notabilibus personis et officiariis huius civitatis ut in ipso negotio procedatur cum matura deliberacione.

[On the tower of the church]
On that day Master Roulland, mason of the church, exhibited [a proposal?] regarding the masonry that he had planned and had begun on the church tower.
Once this had been inspected, the Lords decided that it would be shown by the Lords canons [although the text says "of canons," presumably a mistake] Fane and Fillon to experts and some notable people and officials of this city so that they could proceed with a thorough discussion on this matter.

No.24 (fol. 150v): Friday, 18 January 1516

[*De turre ecclesiae*]
Repetito de turre ecclesie in qua lathomus non cessavit operari et de providendo ad residuum dicti edificii placuit prefatis dominis capitoli congregari per iuramentum ad diem martis proxime ut provideatur.

[On the church tower]
Having discussed again the church tower in which the mason had not stopped working, and how to provide for the rest of the said building, it seemed right to the said lords that the chapter should meet under oath on the following Tuesday to resolve this.

No.25 (fols. 151r-151v): Tuesday, 22 January 1516

[*De turre ecclesiae*]
Repetito de constructione turris ecclesie concluserunt prefati domini post maturam deliberacionem inter eos habitam pro honestate et exoneracione eorundem dominum locuntenentem generalem domini baillivi Rothomagensis ac nonnullos officiarios consiliarios et burgenses huius civitatis comircari hodie postmeridiem in presenti capitulo ad audiendum opiniones et deliberaciones expertorum tam in lathomia quam carpentaria qui opus inceptum visitabunt ut ipsorum expertorum deliberacionibus et oppinionibus ad sancta dei evangelia affirmatis et auditis deliberetur quid sit agendum pro utilitate et securitate ecclesiae ad quam convencionem faciendam transmiserunt nuncium capituli.

[On the church tower]
Having discussed again the construction of the church tower the said lords concluded, after a thorough discussion amongst themselves, and for the sake of transparency and for their own relief, that the lord general lieutenant of the bailiff[1] of Rouen and some official councillors and burghers of this city should meet this afternoon with the chapter here present to hear the opinions and discussions of experts of both masonry and carpentry who should inspect the work already begun so that what should be done for the benefit and security of the church can be discussed, taking into account the opinions of the same experts, sworn on the gospels. And they [the said lords] had sent the messenger of the chapter to arrange the said meeting.

No.26 (fol. 152v): Friday, 1 February 1516

[*De turre ecclesie*]
Repetito de providendo ad edificium turris ecclesie domini concluserunt congregari die lune prope postmeridiem per juramentum ut provideatur.

[On the church tower]
Having discussed again how to provide for the building of the tower, the lords decided to assemble on Monday afternoon, to make a decision under oath.

No.27 (fol. 153r): Monday, 4 February 1516

Two expert architects, one living in Chartres and the other in Beauvais, will be consulted.

[*De turre ecclesie*]
Ipsamet die lune postmeridiem capitularibus praefatis dominis unanimiter dominis cancellario Fare Dantemy Le Lieur Challenge Carre Tulles Delatteille. Qui quidem domini per iuramentum congregati ad deliberandum et ordinandum super modo constructionis turris ecclesie habita inter eos super ipso negocio deliberacione matura actentis variis eorum opinionibus concluserunt quod bonum est habere consilium expertorum extraneorum factaque advertencia de duobus lathomis qui reputatur expertissimi uno in civitate Carnotense et alio Beluarense degentibus placuit prefatis dominis illos et alios de quibus advisabitur audiri ita quod non loquantur cum expertis huius civitatis quousque super ipso negocio inquisiti fuerint metu subornacionis.

[On the church tower]
On that same Monday afternoon in chapter the said Lords[1] unanimously with the Lords Chancellor, Fare, Dantigny,[2] Le Lieur, Challenge, Carre, Tulles, Delatteille, assembled under oath to discuss and decree how to build the church tower. After much discussion between them with various reasoned opinions, they reached the conclusion that it would be good to have the advice of external experts, and advised of two masons who are considered very expert,[3] one living in Chartres and the other in Beauvais, it seemed sensible to the said lords to advise those two and others that they would be consulted, so as to ensure that they would not speak with the experts of this city before being interrogated on this topic in order to avoid subornation.

No.28 (fol. 155v): Monday, 11 February 1516

[*De turre ecclesie*]
Comparuit magister lathomus civitatis Charnotensis cum missivis dominorum de capitolo ecclesie Carnotensis cui prefati domini exhibuerunt articulos tangentes dubia constitucionis turris ecclesie ipsumque rogaverunt quantus visitet debite dictam turrim et quod super qualis dictorum articulorum stabat suam oppinionem ut melius deliberari possit.

[On the church tower]
The mason of the city of Chartres appeared with letters from the lords of the chapter of Chartres. The said lords explained points of doubt to him concerning the construction of the church tower and asked the same mason how big he thought the said tower should be and which of the alternatives presented to him he preferred, so as to deliberate better.

1. These were the dean and chanter, and the Lords Delaître [de Atrio], Fortin, De Sandouville, D'Ombreville, Petrus Mésenge, Johannis De Croismare, Mésenge, Batencourt, Haro, De Tuiles, De la Houssaye, Persol, Fillon, Henbe (?), De la Perlaye, Dufay, Massolin.

2. Guillermus Dantigny became a canon in 1484, when he also received a degree in theology from the university of Paris. He remained a canon until his death in 1525. He was a nobleman from Rouen, and also a parish priest of Varneville and, later, Fresne le Plan (Tabbagh, *Fasti ecclesiae gallicanae*, vol. 2, p. 195).

3. Although these two masons are not named, their fame and provenance suggest probable identifications. In 1516, the master of the Cathedral of Chartres was Jehan Texier (before 1474–Chartres, 1529), better known as Jehan de Beauce, who designed the façade of La Trinité in Vendôme (fig. 43), and then the spire of the northern tower of Chartres Cathedral. The master at Beauvais was Martin Chambiges (c. 1460s–Beauvais, 1532), who designed the transept façades of Beauvais Cathedral and the façades of the Cathedrals of Troyes and Senlis (Florian Meunier, 'Une Rencontre au sommet: les maîtres maçons des cathédrales de Rouen, Beauvais et Chartres réunis en 1516', in Agnès Bos, Xavier Dectot and Jean-Michel Leniaud, *Materiam superabat opus: Hommage Alain Erlande-Brandenburg* [Paris, 2006], pp. 328–35).

No.29 (fol. 153v): Friday, 15 February 1516

Experts in masonry from Chartres, Beauvais, Harfleur, Carentan and elsewhere, invited to Rouen, declare that the foundations could support a stone tower, which would be the best option.

1. "*Harefloto*" refers to the town of Harfleur, the most important sea port of northern France until the sixteenth century, when it was superseded by Le Havre. The city's main church, St-Martin, was begun in 1477 and features an ambitious tower. "*Charentona*" is more difficult to identify: a village called Carentan exists in the west of Bretagne, and has a late fifteenth-century church, but this is a rather modest building.

2. Johannes Le Lieur was born in 1496 and became canon in 1496. His brother Jacques was a notary and secretary to the king, and he himself acted as the *doyen* (head) of the chapter after 1500 (Tabbagh, *Fasti ecclesiae gallicanae*, vol. 2, p. 256).

3. In this case the term "*cum pictura*" would refer to the technique of *lavis*, the handling of diluted ink with the brush, used by Villard de Honnecourt in his architectural drawings and later established as a fundamental technique of architectural draughtsmanship (see above Chapter III, 'Describing Drawings').

[De turre ecclesie]
Ea die prefati domini per juramentum congregati habita inter eos matura deliberacione super modo constructionis turris ecclesie actentis relacionibus et oppinionibus multorum expertorum in arte lathomia ex civitatibus Charnotensis et Beluarensis ac opidis de Harefloto et de Charentonio ac eciam huius civitatis qui convenerint in hoc quod fundamenta dicte turris in quantum ex oculari eorum inspeccione constare potest sunt sana integra valida et sufficientes ad portandum et sustinendum unam turrim ex lathomia proporcionata quodque si ita fiat erat in maxima sumptuositate et manificentia ecclesie prefati domini in seguendo eorum opiniones concluserunt dictam turrim construi et consummari debere ex lathomia ad quod se opposuerunt dicti domini Le Lieur Challenge et Voysin.

[Regarding the church tower]
On that day the said lords gathered under oath having thoroughly discussed how to build the church tower, with relevant explanations and opinions of several experts in the art of masonry from the cities of Chartres, Beauvais and the towns of Harfleur, "Charenton"[1] and also this city, who all have the same opinion on this: that the foundations of the said tower insofar as is possible to verify from visual inspection are healthy, complete, strong, and sufficient to carry and sustain a tower of well-sized masonry, and that if this was done the church would be extremely sumptuous and magnificent. The said lords, following these opinions, decided that the said tower should be built and concluded in stone, to which resolution the said Lords Le Lieur,[2] Challenge, and Voysin were opposed.

No.30 (fol. 162r): Saturday, 8 March 1516

Roulland le Roux presents to the chapter a painted likeness of the tower, in accordance with the previous deliberation.

[De protractu super constructione turris]
Ea die magister Roulandus lathomus ecclesie capitulariter exhibuit protractum per eum factum cum pictura super constructione turris ecclesie iuxta novissimam conclusionem quo per dominos viso eundem lathomum exortati fuerant quatenus ipsam conclusionem quantum poterit insequatur nec in eodem edificio aliquid ultra addat quod preiudicare possit.

[Regarding the likeness of the construction of the tower]
On that day master Roulland, mason of the church, showed the chapter a drawing made by him, with painting,[3] regarding the construction of the church tower, according to a completely new termination, and once this drawing had been inspected by the lords, they ordered the same mason to follow as much of this design as possible, without adding anything to the building that might cause damage.

No.31 (fol. 253r): Monday, 23 February 1517

The works are suspended, the masonry is covered, there is opposition to the completion of the tower in stone.

1. This is a French term used in the Latin text. It is still used today to indicate monolithic slabs of stone.

[*De turre ecclesiae*]
Ea die repetito de edificio turris si debeat perfici et continuari ex lapidibus actento rumore aliquorum qui dicunt idem non posse aut debere fieri super quo habita deliberacione concluserunt prefati domini quod pro nunc perficiantur les dalles gallice et gradus quo facto cooperatur edificium et sic remaneat pro tempore / quousque super hoc habeatur consilum ab expertis / Et interim videatur si magister lathomus expresseat fines novissime conclusionis / Nichilus tum dicti domini le Lyeur Challenge et Voysin formaliter se opposerunt ne proficiatur ex lapidibus.

[Regarding the church tower]
On that day, having discussed again the building of the tower and whether it should be completed and continued in stone, the opinion of those who say that it cannot be nor should be having captured everyone's attention, the said lords concluded that for the moment, the step and what in French are called *dalles*[1] (slabs) should be completed, and having finished these the building should be covered and remain so for sometime, until the opinion of experts could be had on this. And in the meantime, should the master mason once again exceed the limits of the conclusion... Nevertheless the said Lords Le Lyeur Challenge and Voysin formally declared their opposition to its completion in stone.

Bibliography

Abbé Sauvage, 'Note sur un dessin original du XVe siècle appartenant au chapitre de Rouen', *Revue de l'Art chrétien*, vol. 7, no. 39 (1889), pp. 1–15

Ackerman, James S., '"Ars Sine Scientia Nihil Est": Gothic Theory of Architecture at the Cathedral of Milan', *The Art Bulletin*, vol. 31, no. 2 (1949), pp. 84–111

— *Origins, Imitations, Conventions* (Cambridge, Mass., 2002)

Allais, Henri, Charles de Robillard de Beaurepaire, Georges Dubosc, Julien Félix, Jules Hédou, Henri de Lapommeraye and François Lalanne, *Rouen pittoresque* (Rouen, 1886)

Arminjon, Catherine, and Sandrine Berthelot (eds.), *Chefs-d'œuvre du Gothique en Normandie: sculpture et orfèvreries du XIIIe au XVe siècle*, exh. cat., Musée de Normandie, Caen, and Ensemble conventuel des Jacobins, Toulouse (Milan, 2008)

L'Art des frères d'Amboise, exh. cat., Musée national du Moyen Âge, Paris, and Musée national de la Renaissance, Écouen (Paris, 2007)

Bailé, Maylis (ed.), *L'architecture normande au Moyen Âge* (Caen, 1997)

Bardati, Flaminia, 'A Building Site in Early Sixteenth-Century Normandy: the Castle of Gaillon, Organization, Workers, Materials and Technologies', in Malcolm Dunkeld, James W. P. Campbell, Hentie Louw, Michael Tutton, Bill Addis and Robert Thorne (eds.), *Proceedings of the Second International Congress on Construction History*, vol.1 (Exeter, 2006)

— 'Avignon and Rouen: Tales of Sixteenth-century Italian Travellers,' *Città e storia*, vol. 8, no. 1 (2012), pp. 159–81

Baudoin, Jacques, *La sculpture flamboyante en Normandie et Ile-de-France* (Florat, 1992)

Beaurepaire, Charles de Robillard de (ed.), *L'entrée de François Premier, roi de France, dans la ville de Rouen, au mois d'août 1517* (Rouen, 1867)

— *Inventaire-sommaire des archives départementales anterieures à 1790* (Paris, 1874)

— *Notes sur le parvis de la cathédrale de Rouen* (Rouen, 1883)

— 'Notes sur le Grand Portail de la Cathédrale de Rouen', *Bulletin de la Commission des antiquités de la Seine-Maritime*, vol. 10 (1894), pp. 138–58

— 'Notes sur les architectes de Rouen: Jean Richier, Les Pontifs, Jacques Le Roux, Guillaume Duval, Pierre le Signerre et Autres (seconde moitié du XVe siècle)', *Bulletin des amis des monuments rouennais* (1903), pp. 47–72

— 'Les architectes de Rouen dans la première moitié du XVIe siècle', *Bulletin des amis des monuments rouennais* (1904), pp. 119–33

Beck, Bernard, Pierre Bouet, Claire Étienne and Isabelle Lettéron (eds.), *L'Architecture de la Renaissance en Normandie. I: Regards sur les chantiers de la Renaissance. Actes du colloque de Cerisy-la-Salle (30 septembre–4 octobre 1998)* (Caen, 2003)

Bikker, Jonathan, 'Cologne, the "German Rome", in Views by Berckheyde and Van der Heyden and the Journals of Seventeenth-Century Dutch Tourists', *Simiolus: Netherlands Quarterly for the History of Art*, vol. 32, no. 4 (2006), pp. 273–90

Block, Elaine C., and Frédérick Billie (eds.), *Les Stalles de la cathédrale de Rouen* (Rouen, 2003)

Böker, Hans Josef, *Architektur der Gotik: Bestandskatalog der weltgrössten Sammlung an gotischen Baurissen (Legat Franz Jäger) im Kupferstichkabinett der Akademie der bildenden Künste Wien: mit einem Anhang über die mittelalterlichen Bauzeichnungen im Wien Museum Karlsplatz* (Salzburg, 2005)

— *Architektur der Gotik. Ulm und Donauraum: ein Bestandskatalog der mittelalterlichen Archtekturzeichnungen aus Ulm, Schwaben und dem Donaugebiet* (Salzburg, 2011)

— *Architektur Der Gotik. Ein Bestandskatalog der mittelalterlichen Architekturzeichnungen: Rheinlande* (Salzburg, 2013)

Booton, Diane E., *Manuscripts, Market and the Transition to Print in Late Medieval Brittany* (Farnham, 2010)

Bork, Robert, *Geometry of Creation: Architectural Drawing and the Dynamics of Gothic Design* (Farnham, 2001)

— 'Into Thin Air: France, Germany, and the Invention of the Openwork Spire', *The Art Bulletin*, vol. 85, no. 1 (2003), pp. 25–53

— *Great Spires: Skyscrapers of the New Jerusalem* (Cologne, 2003)

Bottineau-Fuchs, Yves, 'Maîtres d'œuvre, maître d'ouvrage: les Le Roux et le chapitre cathédral de Rouen', in Xavier Barral i Altet (ed.), *Artistes, artisans et production artistique au Moyen Âge: colloque international*, vol. 1 (Paris, 1986–90)

— *Haute-Normandie gothique* (Paris, 2001)

— *Georges 1er d'Ambroise, 1460–1510 : un prélat normand de la Renaissance* (Rouen, 2005)

Boyd, Louis, 'Constructions for Posterity: The Architectural Drawings of Cologne Cathedral' (MA dissertation, Courtauld Institute of Art, 2014)

Branner, Robert, 'Villard de Honnecourt, Reims and the Origin of Gothic Architectural Drawing', *Gazette des Beaux-Arts*, vol. 61 (1963), pp. 129–46

— 'A Fifteenth-century French Architectural Drawing from the Cloisters', *Metropolitan Museum of Art Journal*, vol. 11 (1976), pp. 133–36

Bresc-Bautier, Geneviève, Thierry Crépin-Leblond and Elisabeth Taburet, *France 1500: entre Moyen Âge et Renaissance*, exh. cat., Grand Palais, Paris (Paris, 2010)

Bucher, François, *Architector: The Lodge Books and Sketchbooks of Medieval Architects* (Norwalk, Conn., 1979)

Buchotte, M., *Les Règles du dessin et du lavis pour les plans particuliers des ouvrages et des bâtimens* (Paris, 1722)

Burckard, François, *Guide des Archives de la Seine Maritime* (Rouen, 1990)

Buringh, Eltjo, *Medieval Manuscript Production in the Latin West: Explorations with a Global Database* (Leiden, 2010)

Carment-Lanfry, Anne-Marie, *La Cathédrale de Rouen* (Rouen, 2010)

Carpo, Mario, and Frédérique Lemerle (eds.), *Perspective, Projections and Design: Technologies of Architectural Representation* (Abingdon, 2013)

Chaline, Jean-Pierre (ed.), *L'abbaye Saint-Ouen de Rouen, des origines à nos jours* (Rouen, 2009)

Chapelot, Odette (ed.), *Du Projet au chantier. Maîtres d'ouvrage et maîtres d'œuvre* (Paris, 2001)

Chastillon, Claude, *Topographie francoise ou Representations de plusieurs villes, bourgs, chasteaux, plans, forteresses, vestiges d'antiquité, maisons modernes et autres du royaume de France: la pluspart sur les desseings de deffunct Claude Chastillon, ingenieur du Roy* (Paris, 1655)

Chatenet, Monique (ed.), *Le Gothique de la Renaissance: actes des quatrième Rencontres d'architecture européenne, Paris, 12–16 juin 2007* (Paris, 2011)

Chirol, Pierre, 'La Tour de Beurre [de la Cathédrale] et son architecte Guillaume Pontifs', *Précis Analytique de l'Académie de Rouen* (1939), pp. 83–101

Congrès archéologique de France. Rouen et Pays de Caux (Paris, 2006)

Crossley, Paul, 'The Return to the Forest: Natural Architecture and the German Past in the Age of Dürer', in *Künstlerischer Austausch: Artistic exchange, Akten des XXVIII internationalen Kongresses für Kunstgeschichte* (Berlin, 2003)

D'Orgeix, Emilie, 'The Goldschmidt and Scholz Scrapbooks in the Metropolitan Museum of Art: A Study of Renaissance Architectural Drawings', *Metropolitan Museum Journal*, vol. 36 (2001), pp. 169–206

Dackerman, Susan (ed.), *Painted Prints: The Revelation of Color in Northern Renaissance & Baroque Engravings, Etchings, & Woodcuts*, exh. cat., The Baltimore Museum of Art, Baltimore (University Park, Penn., 2002)

Davis, Michael, '"Troys Portaulx et Deux Grosses Tours": The Flamboyant Façade Project for the Cathedral of Clermont', *Gesta*, vol. 22, no. 1 (1983), pp. 67–83

De Beatis, Antonio, *The Travel Journal of Antonio de Beatis: Germany, Switzerland, the Low Countries, France and Italy, 1517–8*, ed. John Rigby Hale (London, 1979)

De Hamel, Christoper, *Scribes and Illuminators* (Toronto, 1992)

Delisle, Léopold, 'Charles de Robillard de Beaurepaire (1828–1908)', *Bibliothèque de l'école des chartes*, vol. 70, no. 1 (1909), pp. 209–46

Delville, Achille, 'Lettre addressée à Monsieur Alavoine', *Précis analytique des travaux de l'Academie des sciences, belles-lettres et arts de Rouen* (1831), pp. 174–95

Descubes, Jean-Charles (ed.), *Rouen: Primatiale de Normandie* (Strasbourg, 2012)

Desportes, Jean Philippe, 'Alavoine et la flèche de la cathédrale de Rouen', *Revue de l'art*, 13 (1971), pp. 48–61

Deville, Achille, *Revue des architectes de la cathédrale de Rouen, jusqà la fin du XVIe siècle* (Rouen, 1848)

Dictionnaire du moyen français (1330–1500) – ATILF – CNRS & Université de Lorraine, http://www.atilf.fr/dmf

'Documents', *Mémoires de la Société Archéologique de Montpellier*, vol. 2 (1841)

Du Cange et al., *Glossarium mediæ et infimæ latinitatis* (Niort, 1883–87)

Esquieu, Yves (ed.), *Du Gothique à la Renaissance. Architecture et décor en France (1470–1550)* (Aix-en-Provence, 2003)

Fallue, Léon, 'Construction de la tour de la cathédrale dite Tour de Beurre', *Précis Analytique de l'Académie de Rouen* (1848), pp. 209–20

Filarete, *Filarete's Treatise on Architecture*, ed. John R. Spencer (Ann Arbor, Mich., 1990)

Frankl, Paul, *Gothic architecture*, intro., biblio., and notes by Paul Crossley (New Haven, 2001)

Frondeville, Henri de, and Alexandre Bigot Monville, *Les présidents du Parlement de Normandie, 1499–1790. Recueil généalogique établi sur la base du manuscrit Bigot, de la Bibliothèque de Rouen* (Rouen, 1953)

Frothingham, Arthur L., 'Le Modèle de l'église Saint-Maclou à Rouen', *Monuments et mémoires de la fondation Eugène Piot*, vol. 12, no. 2 (1905), pp. 211–24

Gaehtgens, Thomas W., 'Bombing the Cathedral of Reims,' *The Getty Iris*, 23 January 2015, http://blogs.getty.edu/iris/bombing-the-cathedral-of-rheims/

Gay, Victor, *Glossaire archéologique du Moyen Age et de la Renaissance* (Paris, 1887)

Gersaint, Edme-François, *Catalogue raisonné d'une collection considérable de diverses curiosités en tous genres contenues dans les cabinets de Feu Monsieur Bonnier de La Mosson, Bailly et Captaine des chasses de la Varenne des Thuilleries & Ancien Colonel du regiment dauphin* (Paris, 1744)

Gervase of Canterbury, 'Tractatus de combustione et reparatione cantuariensis ecclesiae (c. 1200)', in *Gervasii cantuariensis opera historica*, ed. William Stubbs, vol. 1 (London, 1897)

Grasset-Morel, Louis, *Les Bonnier, ou Une Famille de financiers au XVIIIe siècle: Joseph Bonnier, M. de La Mosson, la Duchesse de Chaulnes, le Président d'Alco* (Paris, 1886)

Guiot, Joseph-André, *Les Trois Siècles palinodiques, ou, Histoire générale des palinods de Rouen, Dieppe, Etc.*, ed. Albert Tougard (Rouen, 1898)

Gulliver, Katrina, and Heléna Tóth (eds.), *Citiscapes in History: Creating the Urban Experience* (Farnham, 2014)

Hamon, Étienne, *Un chantier flamboyant et son rayonnement: Gisors et les églises du Vexin français* (Besançon, 2008)

— *Une capitale flamboyante: la création monumentale à Paris autour de 1500* (Paris, 2011)

— , Dominique Paris-Poulain, and Julie Aycard (eds.), *La Picardie flamboyante: arts et reconstruction entre 1450 et 1550* (Rennes, 2015)

Henriet, Jacques, *A l'aube de l'architecture gothique* (Besançon, 2005)

Hérold, Michel, and Martine Plouvier, 'L'orfèvrerie amiénoise au XVIe siècle: Jehan de Graval et la châsse de sainte Godeberthe de Noyon', *Revue de l'Art*, vol. 67, no. 1 (1985), pp. 77–84

Huppert, Ann C., 'Envisioning New St. Peter's: Perspectival Drawings and the Process of Design', *Journal of the Society of Architectural Historians*, vol. 68, no. 2 (2009), pp. 158–77

Joubert, Fabienne (ed.), *L'artiste et le clerc: commandes artistiques des grands ecclésiastiques à la fin du Moyen Âge* (Paris, 2006)

Jullien, Henri, 'Clé de voute de a chapelle de la Vierge à Caudebec-en-Caux', *Les Monuments historiques de la France*, vol. 1, no. 3 (1955), pp. 116–20

Kavaler, Ethan, 'Renaissance Gothic: Pictures of Geometry and Narratives of Ornament', *Art History*, vol. 29, no. 1 (2006), pp. 1–46

— *Renaissance Gothic: Architecture and the Arts in Northern Europe, 1470–1540* (New Haven, 2012)

Kurmann, Paul, 'Filiation ou parallele? A propos des façades et des tours de Saint-Guy de Pragues et de Saint-Ouen de Rouen', *Umení*, vol. 49, no. 3–4 (2001), pp. 211–19

Lamont, Tom, 'Renzo Piano: My Inspiration for the Shard', *The Guardian*, 30 December 2012, http://www.theguardian.com/artanddesign/2012/dec/30/shard-renzo-piano-inspiration

Langlois, Eustache Hyacinthe, *Notice sur l'incendie de la Cathédrale de Rouen: occasionné par la foudre, le 15 septembre 1822, et sur l'histoire monumentale de cette église: ornée de six planches* (Rouen, 1822)

La Quérière, M. E. de, *Saint-Laurent, église paroissiale de Rouen, supprimée en 1791* (Rouen, 1866)

Le Cacheux, Paul, *Répertoire numérique des archives départementales anterieures à 1790: Archives Ecclésiastiques, Série H* (Rouen, 1938)

Le Lieur, Jacques, *Le Livre enchaîné; ou, Livre des fontaines de Rouen; manuscrit de la Bibliothèque de Rouen, 1524–1525*, ed. Victor Sanson (Rouen, 1911)

Lemagnen, Sylvette and Philippe Manneville (eds.), *Chapitres et cathédrales en Normandie* (Caen, 1997)

Lescroart, Yves, *Rouen: La cathédrale Notre Dame* (Paris, 2001)

Lewis, Charlton T., and Charles Short, *A Latin Dictionary. Founded on Andrews' edition of Freund's Latin dictionary, revised, enlarged, and in great part rewritten by. Charlton T. Lewis, Ph.D. and. Charles Short, LL.D.* (Oxford, 1879)

Martens, Pieter, 'An Early Sixteenth-Century Drawing of Two Bulwarks at Arras,' *Fort*, vol. 27 (1999), pp. 67–92

Masson, André, *L'église abbatiale Saint-Ouen de Rouen* (Paris, 1927)

Meredith Cohen and Fanny Madeline (eds.), *Space in the Medieval West: Places, Territories, and Imagined Geographies* (Farnham, 2014)

Meunier, Florian, 'Architectes et commande artistique en normandie à la fin du moyen age: l'église Saint-Ouen de Pont-Audemer d'apres les archives municipales', *Bibliothèques de l'École des chartes*, vol. 162 (2004), pp. 191–216

— 'Une rencontre au sommet: les maîtres maçons des cathédrales de Rouen, Beauvais et Chartres réunis en 1516', in Agnès Bos, Xavier Dectot, Jean-Michel Leniaud, and Philippe Plagnieux (eds.), *Materiam superabat opus: Hommage à Alain Erlande-Brandenburg* (Paris, 2006)

— 'Tours et clochers gothiques flamboyants: les XVe et XVIe siècles en Normandie et en France septentrionale', in *Revue archéologique de Bordeaux*, special issue: Samuel Drapeau and Philippe Araguas (eds.), *Les clochers-tours gothiques de l'arc atlantique de la Bretagne à la Galice*, vol. 104 (2013), pp. 11–20

— *Martin et Pierre Chambiges: architectes des cathédrales flamboyantes* (Paris, 2015)

Millon, Henry, and Vittorio Magnago Lampugnani (eds.), *The Renaissance from Brunelleschi to Michelangelo: The Representation of Architecture*, exh. cat., Palazzo Grassi, Venice (London, 1994)

Mollat, Michel (ed.), *Histoire de Rouen* (Toulouse, 1979)

Monga, Luigi, *Un mercante di Milano in Europa: diario di viaggio del primo Cinquecento* (Milan, 1985)

Müller, Theodor, Wilhelm Reissmüller and Siegfried Hofmann, *Ingolstadt: Die Herzogsstadt, Die Universitätsstadt, Die Festung* (Ingolstadt, 1974)

Murray, Stephen, 'The Gothic Facade Drawings in the "Reims Palimpsest"', *Gesta*, vol. 17 (1978)

— *Building Troyes Cathedral: The Late Gothic Campaigns* (Bloomington, 1987)

Neagley, Linda, 'Elegant Simplicity: The Late Gothic Plan Design of St.-Maclou in Rouen', *The Art Bulletin*, vol. 74, no. 3 (1992), pp. 395–422

— *Disciplined Exuberance: The Parish Church of Saint-Maclou and Late Gothic Architecture in Rouen* (University Park, Penn., 1998)

— 'A Late Gothic Architectural Drawing at The Cloisters' in Elizabeth Sears and Telma Thomas (eds.), *Reading Medieval Images: The Historian and The Object* (Ann Arbor, Mich., 2002), pp. 91–99

— 'Late Gothic Architecture and Vision: Representation, Scenography, and Illusionism' in Matthew Reeve (ed.), *Reading Gothic Architecture* (Turnhout, 2008), pp. 37–55

Le Palais de justice de Rouen (Rouen, 1977)

Parcell, Stephen, *Four Historical Definitions of Architecture* (Montreal and London, 2012)

Pereda, Felipe, 'The Shelter of the Savage: "From Valladolid to the New World"', *Medieval Encounters*, vol. 16, nos. 2–4 (2010), pp. 268–359

Perkinson, Stephen, *The Likeness of the King: A Prehistory of Portraiture in Late Medieval France* (Chicago, 2009)

Peters, Gretchen, *The Musical Sounds of Medieval French Cities: Players, Patrons, and Politics* (Cambridge, 2012)

Pevsner, Nikolaus, 'The Term 'Architect' in the Middle Ages', *Speculum*, vol. 17, no. 4 (1942), pp. 549–62

— 'Terms of Architectural Planning in the Middle Ages', *Journal of the Warburg and Courtauld Institutes*, vol. 5 (1942), pp. 232–37

Picot, Émile, 'Artus Fillon, chanoine d'Évreux et de Rouen, puis évéque de Senlis', *Recueil de la société d'agriculture, sciences, arts et belles-lettres du département de l'Eure*, vol. 7 (1910), pp. 1–56

Pommeraye, Jean-François, *Histoire de l'abbaye royale de S. Ouen de Rouen* (Rouen, 1662)

Recht, Roland (ed.), *Les bâtisseurs des cathédrales gothiques*, exh. cat., Musées de Strasbourg, Strasbourg (Strasbourg, 1989)

La Renaissance à Rouen, exh. cat., Musée des Beaux-Arts, Rouen (Rouen, 1980)

Roriczer, Matthäus and Hanns Schmuttermayer, *Gothic Design Techniques: The Fifteenth-Century Design Booklets of Mathes Roriczer and Hanns Schmuttermayer*, ed. Lonnie Royce Shelby (Carbondale, 1977)

Rossiter, Henry Preston, 'Maximilian's Triumphal Arch', *Bulletin of the Museum of Fine Arts*, vol. 49, no. 278 (1951), pp. 95–98

Rykwert, Joseph, *On Adam's house in Paradise: the idea of the primitive hut in architectural history* (New York, 1972)

Salamagne, Alain, 'Deux plans inédits d'Arras', *Histoire et Mémoire*, no. 26 (2001), pp. 2–3

Sanabria, Sergio, 'A Late Gothic Drawing of San Juan de Los Reyes in Toledo at the Prado Museum in Madrid', *The Journal of the Society of Architectural Historians*, vol. 51, no. 2 (1992), pp. 161–63

Sandron, Dany, 'Un projet de flèche gothique pour la cathédrale d'Orléans (vers 1530) chez Robert de Cotte', *Hommages au professeur Claude Mignot* (Paris, forthcoming)

Sangouard, Antoniette and Jacques Sangouard, 'Les sources normandes dans l'achèvement de la cathédrale d'Albi à la fin du Moyen Âge', *Bulletin Monumental*, vol. 169, no. 4 (2011), pp. 319-34

The Shard, accessed November 7, 2015, http://www.the-shard.com/shard/the-vision/

Silver, Larry and Elizabeth Wyckoff (eds.), *Grand scale: monumental prints in the age of Dürer and Titian*, exh. cat., Davis Museum and Cultural Center, Wellesley (New Haven, Conn., 2008)

Spagnesi, Gianfranco (ed.), *L'architettura della basilica di San Pietro: storia e costruzione* (Rome, 1997)

Spiro, Annette, and David Ganzoni (eds.), *The Working Drawing: The Architect's Tool* (Zürich, 2014)

Stanford, Charlotte A., 'Architectural Rivalry as Civic Mirror: The Dominican Church and the Cathedral in Fourteenth-Century Strasbourg', *Journal of the Society of Architectural Historians*, vol. 64, no. 2 (2005), pp. 186-203

Strauss, Walter and Tracie Felker (eds.), *Drawings Defined* (New York, 1987)

Tabbagh, Vincent, 'Trésors et trésoriers des paroisses de Rouen (1450-1530)', *Revue d'histoire de l'Église de France*, vol. 77, no. 198 (1991), pp. 125-35

— *Le diocèse de Rouen* (*Fasti ecclesiae gallicanae*, vol. 2) (Turnhout, 1998)

Tessari, Cristiano (ed.), *San Pietro che non c'è* (Milan, 1996)

Timmermann, Achim, *Real Presence: Sacrament Houses and the Body of Christ, c. 1270-1600* (Turnhout, 2009)

— 'Microarchitecture in the Medieval West, 800-1550', in *The Cambridge History of Religious Arcihtecture of the World* (New York and Cambridge, forthcoming)

Toker, Franklin, 'Gothic Architecture by Remote Control: An Illustrated Building Contract of 1340', *The Art Bulletin*, vol. 67, no. 1 (1985), pp. 67-95

Tollet, Robert, (ed.), *Représentations architecturales dans les vitraux: colloque international, Bruxelles, Palais des académies, 22-27 août 2002* (Liège, 2002)

Trachtenberg, Marvin, *Dominion of the Eye: Urbanism, Art, and Power in Early Modern Florence* (Cambridge, 2008)

Le Trésor de la Cathédrale de Rouen, exh. cat., Musée des antiquités de la Seine-Maritime, Rouen (Rouen, 1993)

Vasari, Giorgio, *The Lives of the Artists*, trans. Julia Conway Bondanella and Peter Bondanella (Oxford, 1991)

Verdier, François, 'Le Beurre et la Couronne', *In Situ*, no. 1 (2001)

Vincent, Catherine, and Jacques Pycke (eds.), *Cathédrale et pèlerinage aux époques médiévale et moderne* (Louvain-la-Neuve, 2010)

©Vroom, Wim, *Financing Cathedral Building in the Middle Ages: The Generosity of the Faithful* (Amsterdam, 2010)

Wilson, Christopher, *The Gothic Cathedral: The Architecture of the Great Church, 1130-1530* (London, 1990)

Zerner, Henri, *Renaissance Art in France* (Paris, 2003)

Photographic Credits